EDITED BY MAIA-MARI SUTNIK

JOSEF SUDEK

The Legacy of a Deeper Vision

HIRMER

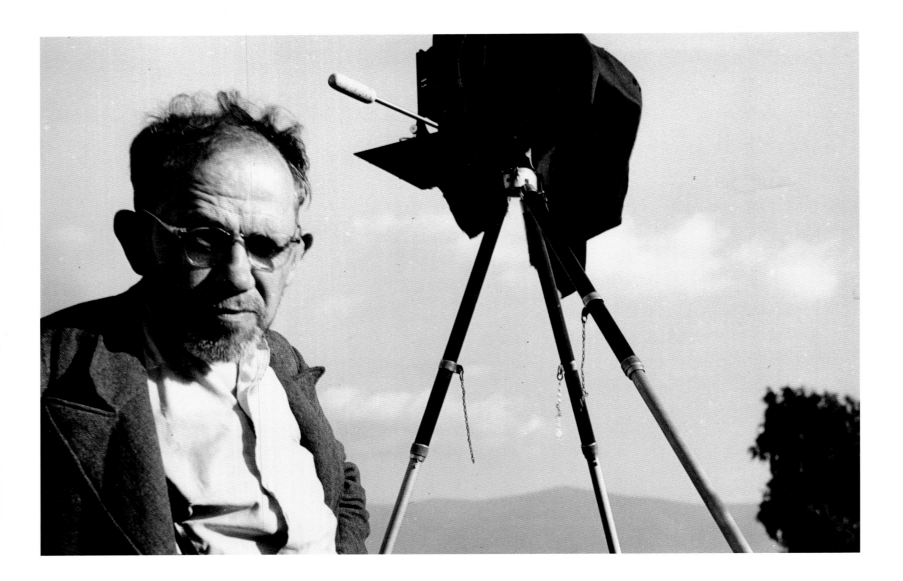

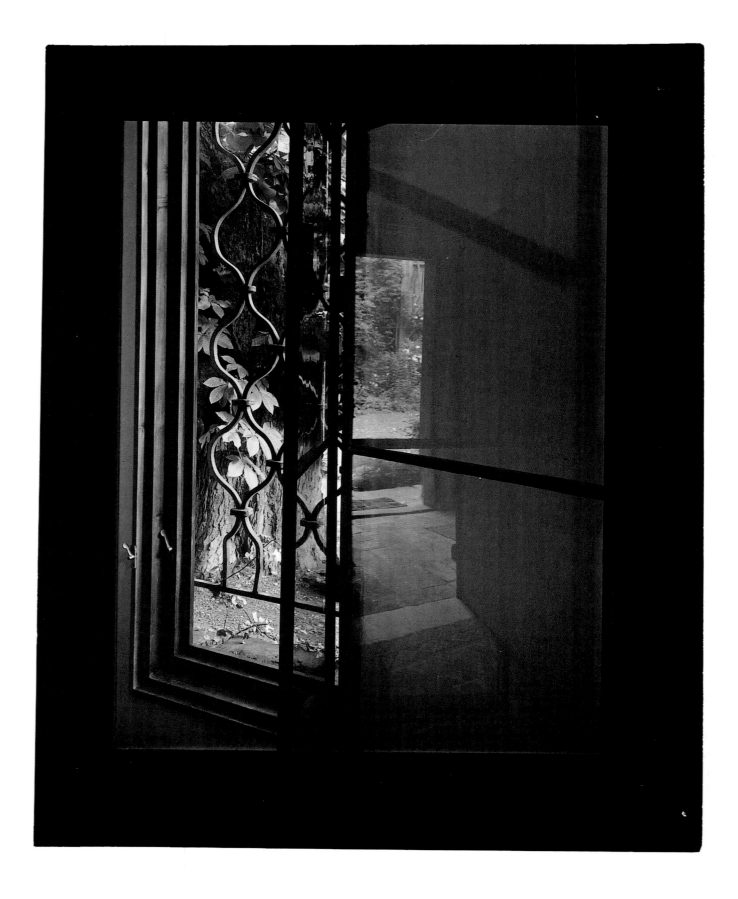

Director's Foreword

A private man who was largely unknown outside Europe until the 1970s, Josef Sudek is now regarded as one of the masters of twentieth-century photography. His career spanned some 60 years and coincided with photography's evolution from a pastime for many to an art tradition broadly accepted as the key visual language of the latter half of the twentieth century. It was a career born out of misfortune after he lost his arm during World War I, yet photography would become for him a vehicle of self-expression that permeated his solitary world.

Sudek seldom travelled, instead immersing himself in his studio or walking through the streets of Prague with camera in hand. Early on, Sudek photographed in the spirit of the Romantic painters and Impressionists, celebrating the landscape of his home and the adjoining countryside. By the late 1920s and early 1930s, his work shifted to reflect varied influences from the early experiments of photographic modernism.

Works by the Soviet avant-garde and the teachings of Bauhaus became evident in his new interest in precision close-ups, introducing into his work a crisper geometric style. Other trends in European painting and sculpture, notably Surrealism, moved Sudek to integrate strange "still life" objects into his imagery. During World War II, Sudek focused on views from his studio and on his large collection of objects and memorabilia. He then returned enthusiastically to photographing Prague, this time with a more sequential and sustained view and using an older Kodak Panoramic camera.

This book takes you on a complex autobiographical journey of the legendary photographer's art, life and indomitable spirit. In addition to more than 175 photographs from the Art Gallery of Ontario's (AGO) collection, it features essays from the foremost writers on Sudek's work: photography historian and curator Dr. Antonín Dufek; critic and editor Richard Rhodes; photographer Geoffrey James; and AGO Curator of Special Photography Projects Maia-Mari Sutnik. The book also includes excerpts from John Banville's *Prague Pictures: Portraits of a City* and a chronology by the late Anna Fárová, in whose memory the exhibition is dedicated.

This project began with a generous and transformational gift from a private collector and was nurtured with admirable care by Maia-Mari Sutnik. To my mind there is no greater custodian and champion for photography in this country than Maia, and this exhibition is the result of her sustained commitment. I acknowledge her leadership, as well as the contributions of Dufek, Rhodes, James and Banville. I would also like to extend my gratitude to The Volunteers of the Art Gallery of Ontario, who are the generous supporters of this publication and its accompanying exhibition. The AGO's collection of nearly 1,000 original Sudek prints, which ranks as one of the most significant in North America, originates from Sudek's estate and was passed on by descent to Anna Fárová from Sudek's sister Božena Sudková. Another group of prints comes from Dr. J.V. Brumlik, Sudek's close friend and advocate with whom he maintained regular correspondence.

In this first major presentation of his work in Canada, Sudek's visual world is palpable and powerfully communicated. It is a world of light and shadow which addresses the careful acts of looking and cherishing more than chronicling or documenting, while the poetic sensibility of his photographs serves to slow time and exalt in the rhythms of contemplation and reflection.

Matthew Teitelbaum
MICHAEL AND SONJA KOERNER DIRECTOR, AND CEO
ART GALLERY OF ONTARIO

Gabina Fárová
Portrait of Anna Fárová, 1977
Reproduced courtesy of photographer

From 1967 onward, Sudek and I began to talk increasingly about "mystery," about something uncommon, hard to communicate, something recondite and non-descriptive in photography, about its magic quality, its going beyond objective reality, about its other kind of content, about what, according to him, was "around the corner."
—Anna Fárová, 2007

The prospect of meeting a legend fills you with both excitement and nervousness. Anna Fárová was certainly one to stir such sensations. A renowned scholar and influential writer on Czech and international photography – evident in the hundreds of books, articles and reviews she published from the mid-1950s onward – she earned a reputation as a historian and curator that was larger than life. In 2007 her publisher, Viktor Stoilov, had arranged for his driver to take me to the historic town of Slavonice, several hours outside of Prague, where Anna lived, so that we could talk about Josef Sudek. To many, Josef Sudek and Anna Fárová are synonymous – and I had set my hopes on collaborating with her on the Art Gallery of Ontario's Sudek exhibition. Anna and I had corresponded periodically since 2005, but mostly about her new series on Sudek's themed works, which included many photographs from the AGO collection. And every so often I received a generous package of photography books in the mail from her, but this was to be our first actual meeting. There are those "first moments" of an anticipated meeting which can become etched in one's memory. As I admired the silver chain around Anna's neck, adorned with small 19th-century photographic portrait lockets, and as she looked at the ambrotype portrait pin on my lapel, we both knew instantly that there would be more common ground between us than Sudek. How delightful that she too cherished these small memorial trinkets!

To spend time with Anna Fárová was to be in the presence of a triumph of personality. I recalled reading a biographical profile, which remarked that the aura of her personality overshadowed the significance of her contributions as a historian, a curator and a woman of steadfast personal courage. Having been a signatory to the Charta 77 on January 18, 1977, her job and professional status were eliminated by state authorities. When I asked about her repressed years, she responded that she was awarded the key to the City of Arles that same year, but more importantly, the consequence of her repression impelled her to organize Sudek's studios after his death in late 1976. The Sudek estate contained more than 60 years of his work. Anna spent more than twelve years sorting, cataloguing and mapping his life, and made sure his photographic legacy would be safely housed at Prague's Museum of Decorative Arts, in the name of his sister Božena Sudková, the executor of his estate, a responsibility passed on to Anna. The end result was Anna's remarkable monograph, *Josef Sudek,* published in 1999 by Torst.

When I recall pictures of Sudek's studio, overflowing with his personal effects, and then marvel at the immediacy of Anna's early Renaissance dwelling with its massive windowsills and perfectly spaced furniture and art, it seemed as if all chaos had been left behind. Though still eager to put the finishing touches on Sudek's legacy, Anna was also ambitious about moving on to new accomplishments. In conversation her reflective insights revealed a passion for ever so many topics, but even more so, her generosity of spirit in offering guidance to help me unravel the complexity of Sudek's work was genuine. When Anna died on February 27, 2010, the world lost a brilliant presence. I believe that her indomitable spirit and life achievements will continue to be appreciated – not only for her dedication to Sudek, but also for the many other artists she promoted who owe their distinguished reputations to her. This publication and the accompanying exhibition foreground some of the ideas and relationships that Anna Fárová suggested to me. I am deeply touched to have known her and to have learned from her.

Maia-Mari Sutnik

Prague, Hradčany Viewed from Charles Bridge, 1946–1955

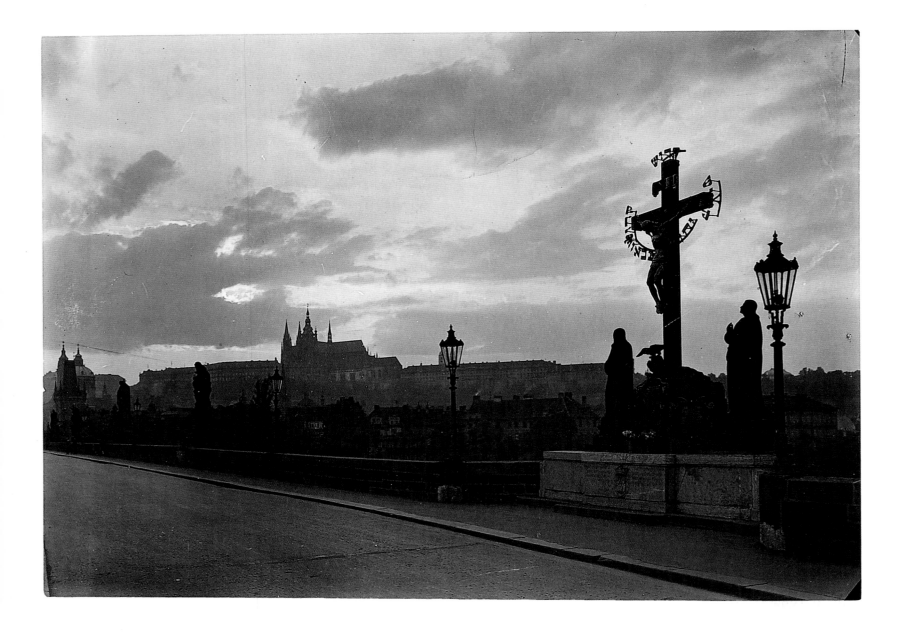

Recollections from *Prague Pictures**

BY JOHN BANVILLE

*Excerpted from pp. 7–10, 11–12, 32–33 and 69–70 of John Banville's *Prague Pictures: Portraits of a City,* reprinted with the kind permission of John Banville © Bloomsbury Publishing, London, 2003

I had something more than a visitor's curiosity. Some years previously I had written a novel partly set in Prague at the turn of the seventeenth century. When I was working on the book I did not regard the inventing of a city I had never seen as any more of a challenge than, for example, having to re-create the early 1600s – all fiction is invention, and all novels are historical novels – but I was interested to know what level of verisimilitude, or at least of convincingness, I had achieved. Many readers had complimented me on the accuracy with which my book had "caught the period," to which I was too grateful and too polite to respond by asking how they could possibly know; I understood that what they were praising was the imaginative feat they felt I had performed in persuading them that this was just how it had been then. But fancy does sometimes summon up the concrete, as anyone who has had a prophetic dream will know. There have been a number of eerie instances when this or that character or happening that I thought entirely my invention subsequently turned out to be historically real. In another novel, set long ago in what is now Poland, I had fashioned – forged, perhaps, would be the better word – a minor character, a soldier, whose presence the plot had demanded, but whose real existence I learned of when, after the book had been published, I received a biographical sketch of him from a helpful Polish historian. The making of fiction is a funny business.

The Charles Bridge was deserted that morning, a thing the latter-day visitor will find hard to credit, since that statued stone span must now be one of the world's most densely peopled spaces, all day long, and throughout most of the night. Frost glittered in the air over the river, just as it had that morning in sixteen-hundred-and-something when my protagonist, the astronomer Johannes Kepler, arrived here from Ulm on a barge, to present the first printed copies of the *Tabulae Rudolphinae* to the Emperor after whom he had so hopefully named his almanac. There, looming above me now as it had loomed above my disembarking astronomer, was the great, blank fortress of Hradčany, and over there was Malá Strana, the Little Quarter, where Kepler would live when he took up his appointment as Rudolf's imperial mathematician. Yes, I had got it right, to a startling degree. Why was I not pleased? In part because, standing there surveying my handiwork, I was struck yet again by the essential fraudulence of fiction. Conjure a winter morning, a river and a castle and a traveller disembarking with a book under his arm, and for the space of a page or two an implied world comes to creaky life. It is all a sleight of the imagination, a vast synecdoche. And yet one goes on doing it, spinning yarns, trying to emulate blind Fate herself.

Much has been written on the beauty of Prague, but I am not sure that beauty is the right word to apply to this mysterious, jumbled, fantastical, absurd city on the Vltava, one of Europe's three capitals of magic – the other two being Turin and Lyon. There is loveliness here, of course, but a loveliness that is excitingly tainted. In his book *Magica Praha*, that ecstatic paean of *amor urbi,* Angelo Maria Ripellino figures the city as a temptress, a wanton, a she-devil. "The antiquary coquetry with which she pretends to be nothing more than a still life, a silent succession of glories long since past, a dead landscape in a glass ball, only increases her sorcery. She slyly works her way into the soul with spells and enigmas to which she alone holds the key." Ripellino's Prague is not that miraculously preserved museum piece of noble prospects and Biedermeier frontages which in the seventies and eighties of the last century earned some desperately needed hard currency as a backdrop for Hollywood movies set in the never-never time of Mozart and Salieri; his is the city of "surreptitious passages and infernal alleys…still smelling of the Middle Ages," of cafés and *Kaffeehäuser* – "in our time," Kafka writes, "the catacombs of the Jews"– low dives such as The Poison Inn, The Old Lady, The Three Little Stars, although he does sometimes escape the "sinister narrowness of those lanes, the stranglehold of those baleful alleys" by fleeing to "the green islands, the efflorescent districts, the parks, belvederes and gardens that surround Prague on all sides." This is the old Prague, wistful, secretive, tormented, which survived the communist takeover of 1948, and even the Russian invasion twenty years later, but which, irony of ironies, finally succumbed to the blow delivered to it by a velvet fist in a velvet glove in the revolution of 1989.

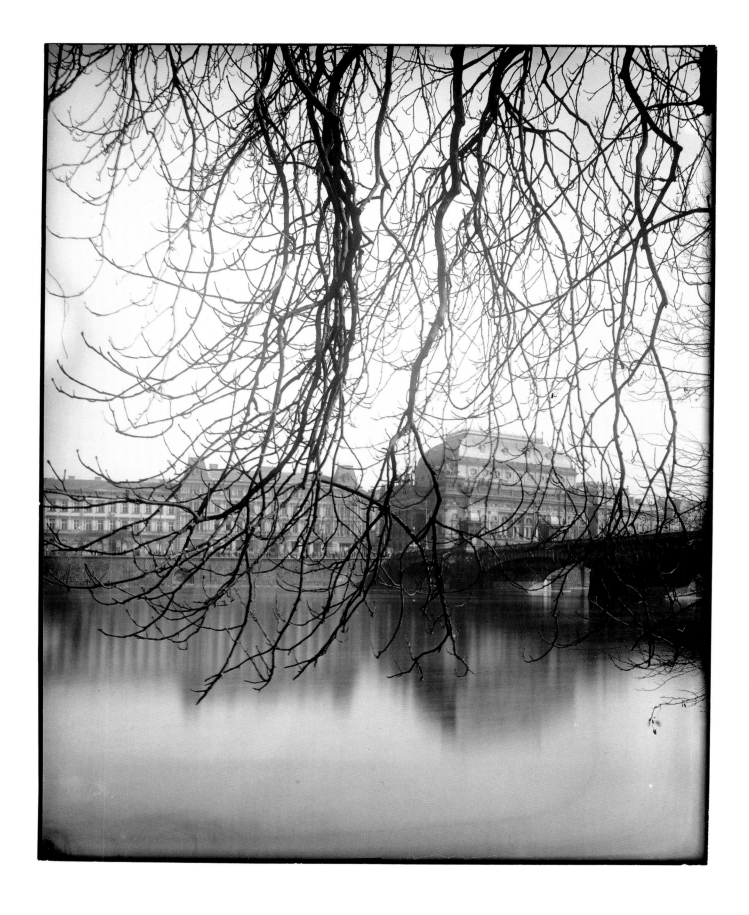

Ripellino's vast effort of recuperation is an attempt not so much to express the city as to ingest it, to make that metamorphosis of world into self that Rilke tells us is our task on earth. It is analogous to the effort every serious visitor must make. One will not know a city merely by promenading before its sites and sights, *Blue Guide* in hand. Yet how can one know an entity as amorphously elusive as Prague, or any other capital, for that matter? What *is* Prague? Does its essence inhere in the pretty Old Town Square, with its cafés and its famous clock, or, on the far contrary, in the smouldering concrete suburbs, where the majority of Praguers live their decidedly unbohemian lives? Time lays down its layers like strata of rock, the porous limestone of the present over the granite of the communists over the ashes-and-diamonds of the Habsburgs over the basalt of the Přemyslids…Where, in what era, may one station oneself to find the best, the truest view? When I was young I thought that to know a place authentically, to take it to one's heart, one must fall in love there. How many cities have seemed to spread themselves out before me in the very contours of the beloved's limbs. Solipsism. There are as many Pragues as there are eyes to look upon it – more: an infinity of Pragues. Confused and suddenly glum I make my way back toward the hotel. The frost has turned my face to glass.

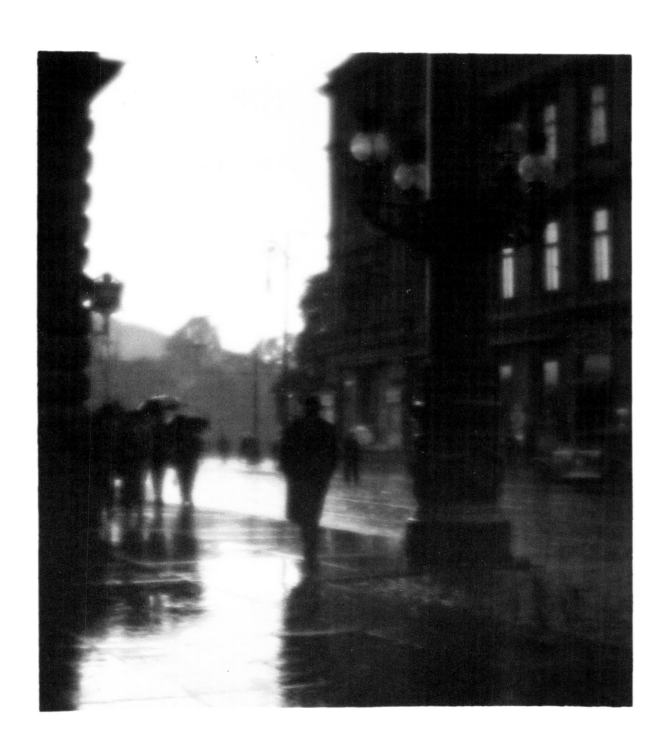

In place of a museum, the Professor offered to show us St. Vitus's Cathedral. We climbed to the hill of Hradčany once more, laboring up the shallow granite steps, "each one the width of four bodies laid head to foot," the novelist Gustav Meyrink notes in his accustomed cheery fashion. The sun was gone now, and a sky bearing a bellyful of snow loured over the afternoon. The great church reared above us, "ornate and mad," in Philip Larkin's fine description of churches in general, like a vast, spired ship run aground and sunk here in the midst of the castle complex, clamoured about on all sides by the reefs of Baroque palaces, coral-coloured. The cathedral is yet another of the gifts lavished on Prague by the munificent Charles IV. Work began on it in 1344, and was not completed until 1929, if such a building can ever be said to be finished. The first architect was Matthew of Arras. Here is the Golden Portal, held aloft on the delicate webbing of Peter Parléř's three Gothic arches. When one looks up, the entire building seems to be speeding massively through the brumous air, going nowhere. See the gargoyles, "these caricatures, these apings-at," as Rilke, another of Prague's unwilling sons, has it; I always feel a pang of pity for gargoyles. In "View from the Charles Bridge," [Jaroslav] Seifert writes:

These are days when the Castle
and its Cathedral
are gloomily magnificent,
when it seems
they were built of dismal rock
brought back from the Moon

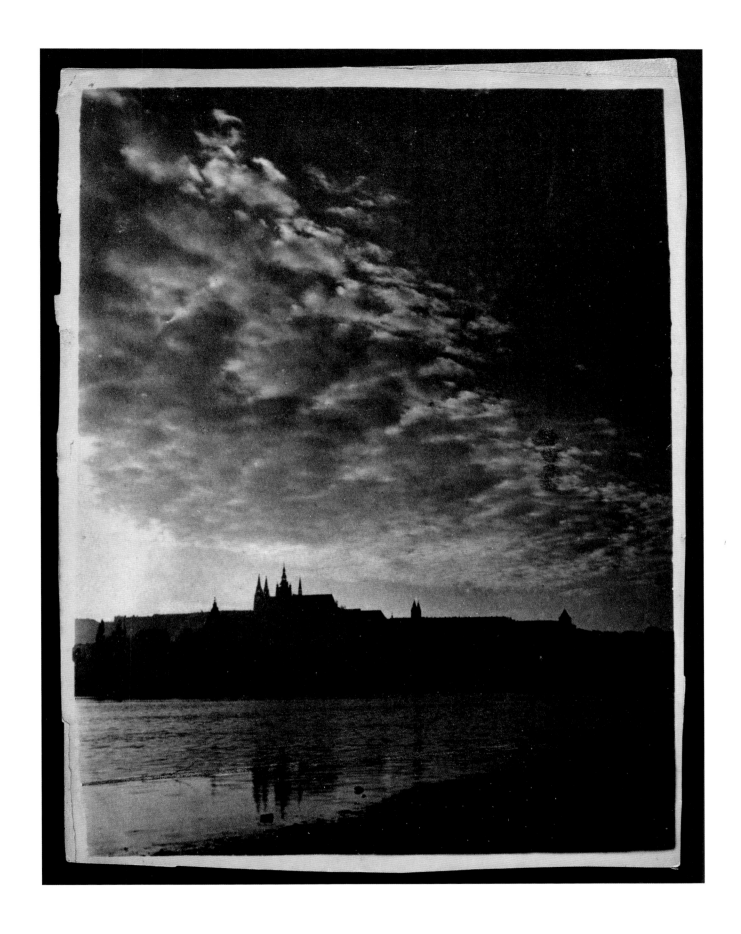

Sudek's aesthetic was simple, and can be summed up in this statement from him, recorded by Sonja Bullaty: "Discovery – that's important. First comes the discovery. Then follows the work. And then sometimes something remains from it." Prague has more famous sons, but none of them, not even Kafka, managed to capture so movingly the essence of the place, its mystery and weary charm, its tragic beauty, its light and shadow, and that something in between, the peculiar, veiled radiance of this city on the Vltava.

When I think back to those days, and nights, in Prague, I am not sure whether what I am summoning up are images from my memory, or from the photographs of Josef Sudek, so thoroughly has his work become for me an emblem of the place.

Gardens of Troia Castle, 1953

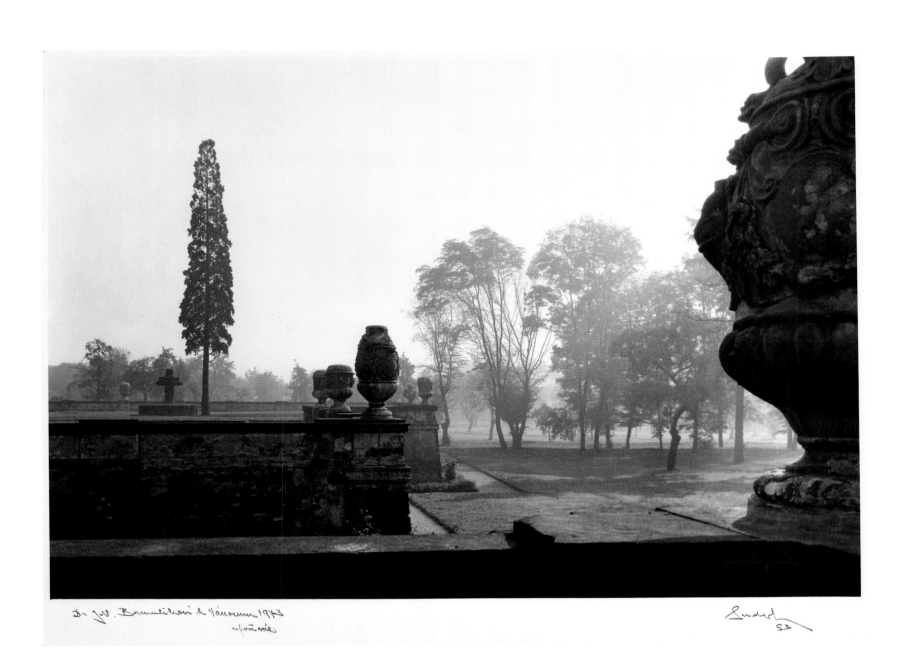

Prague Street (Tram), 1958

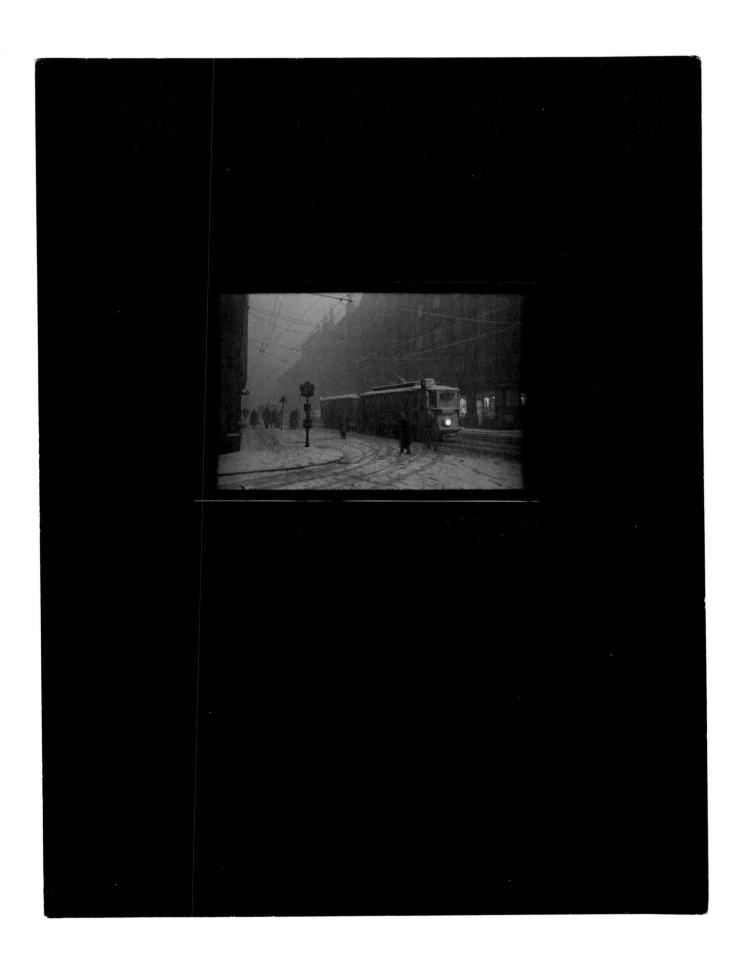

Plates

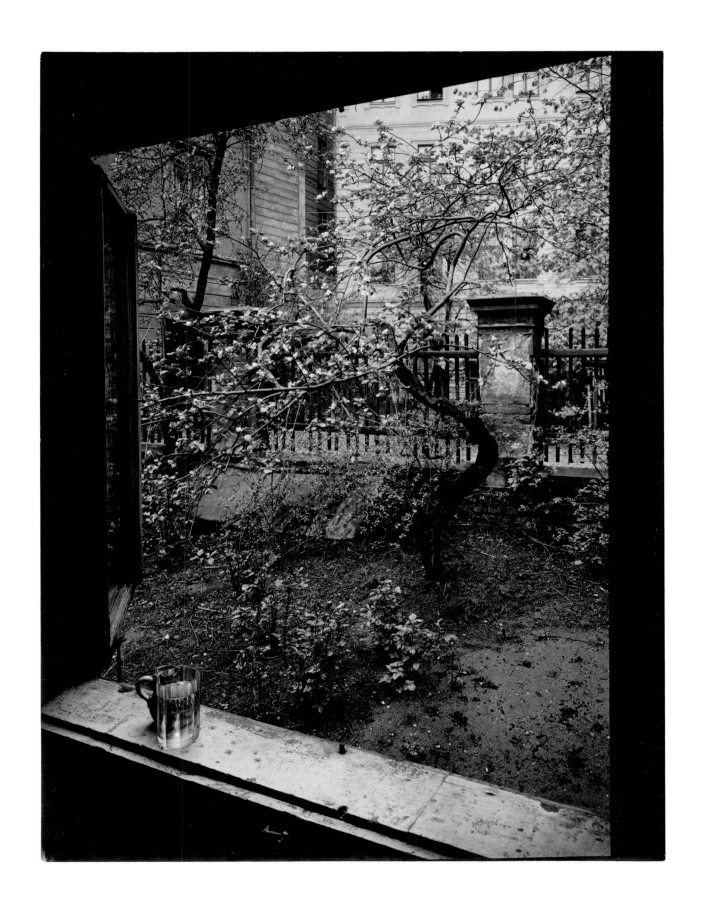

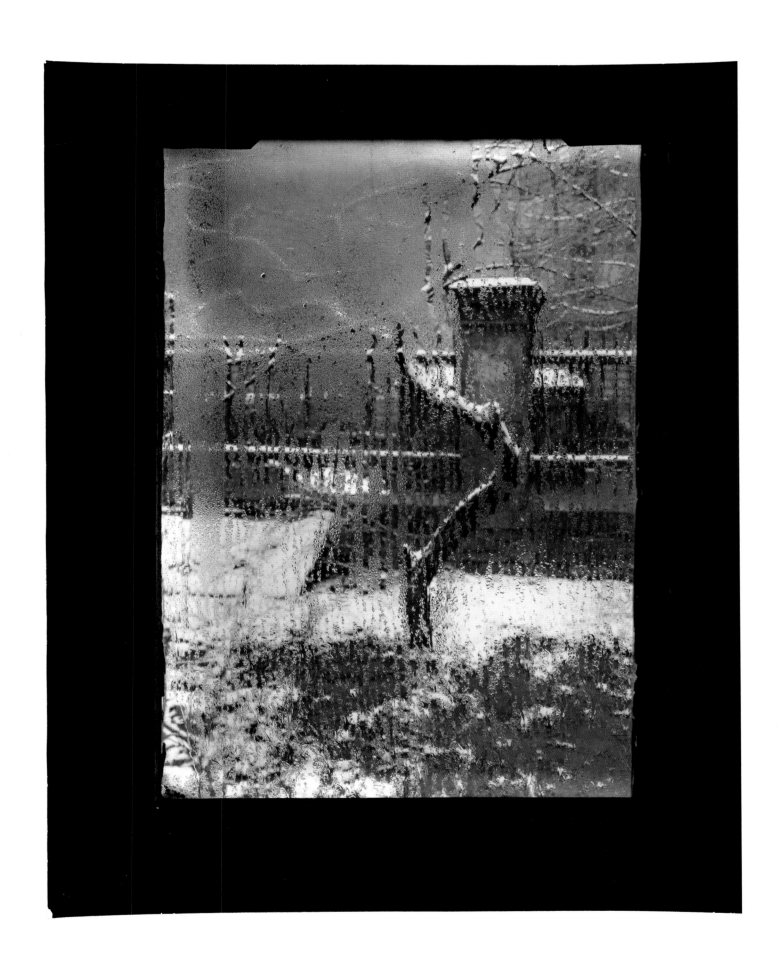

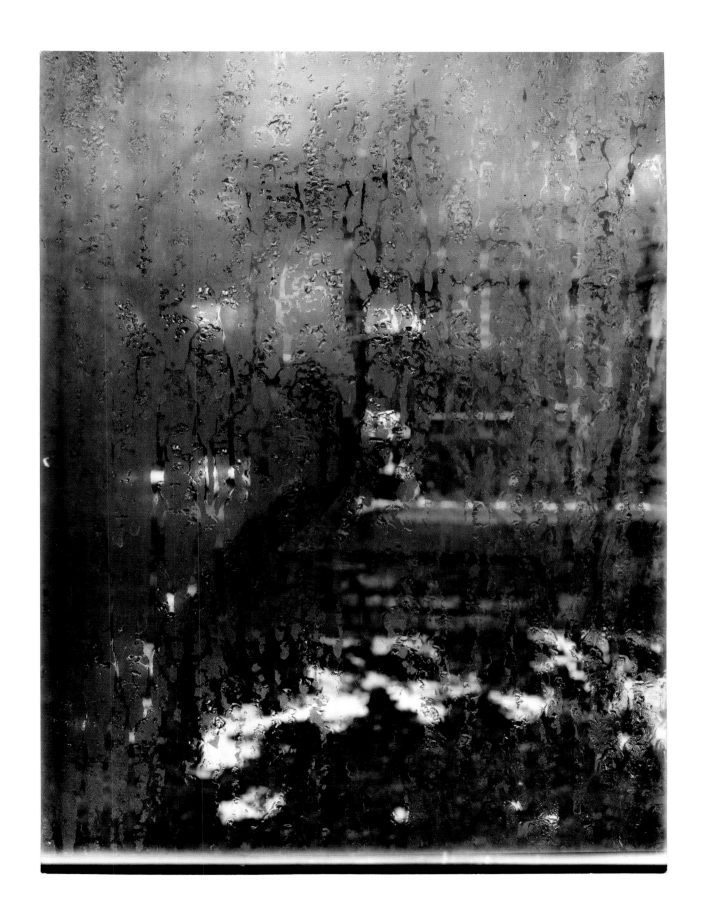

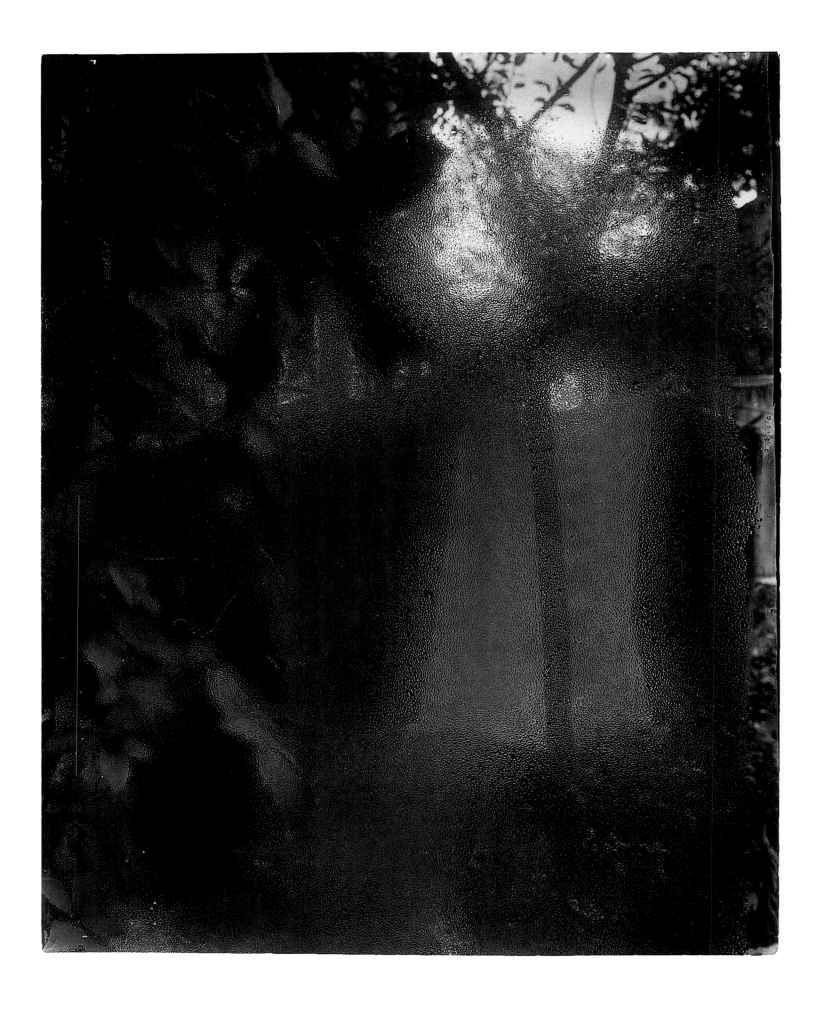

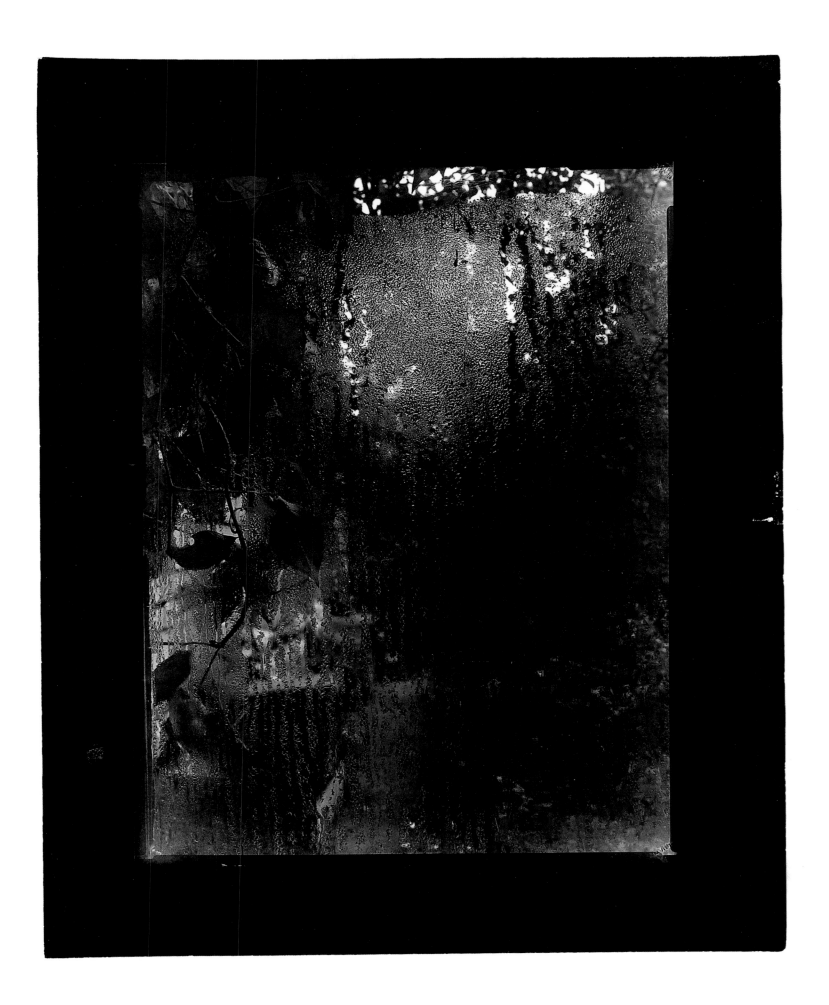

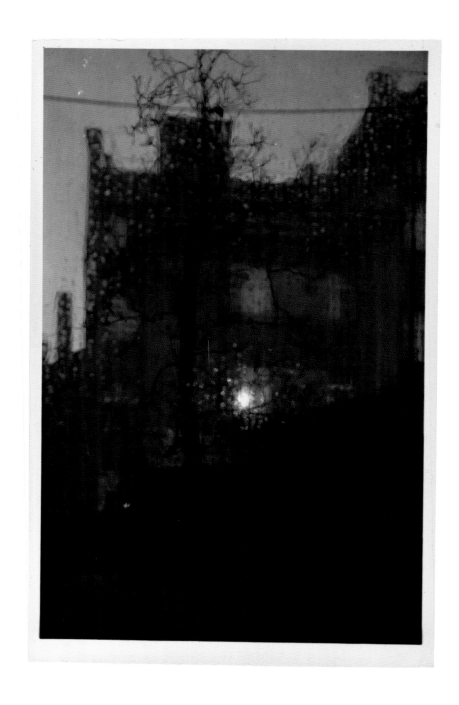

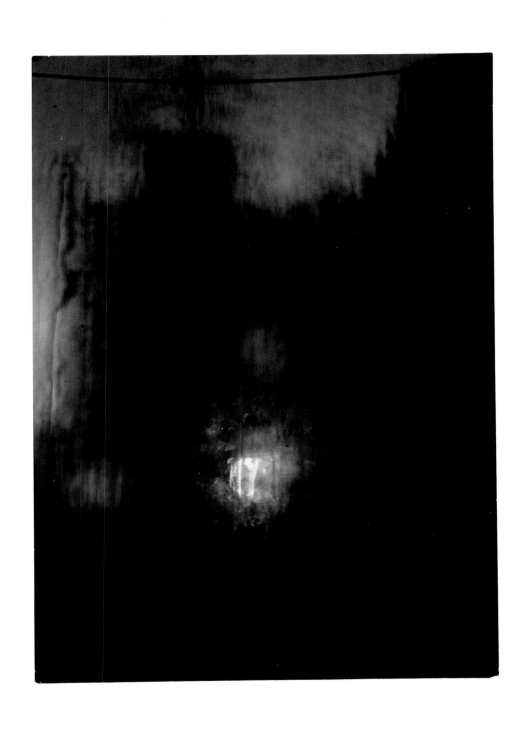

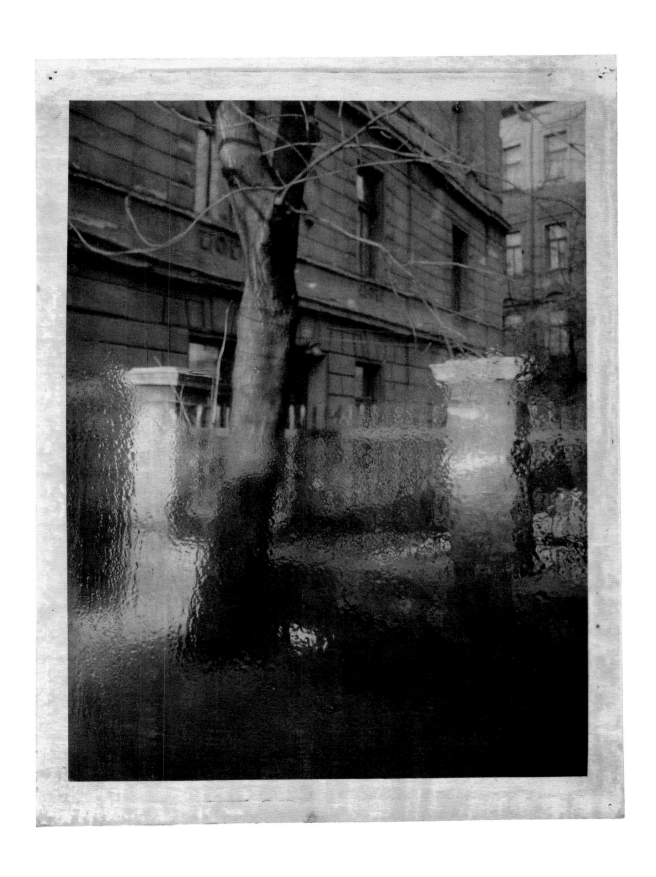

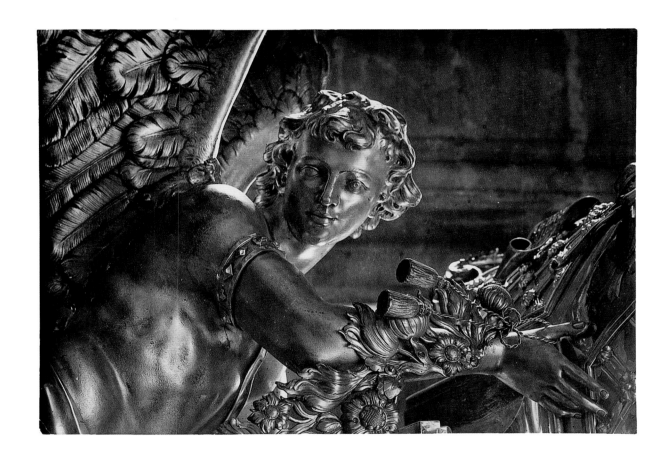

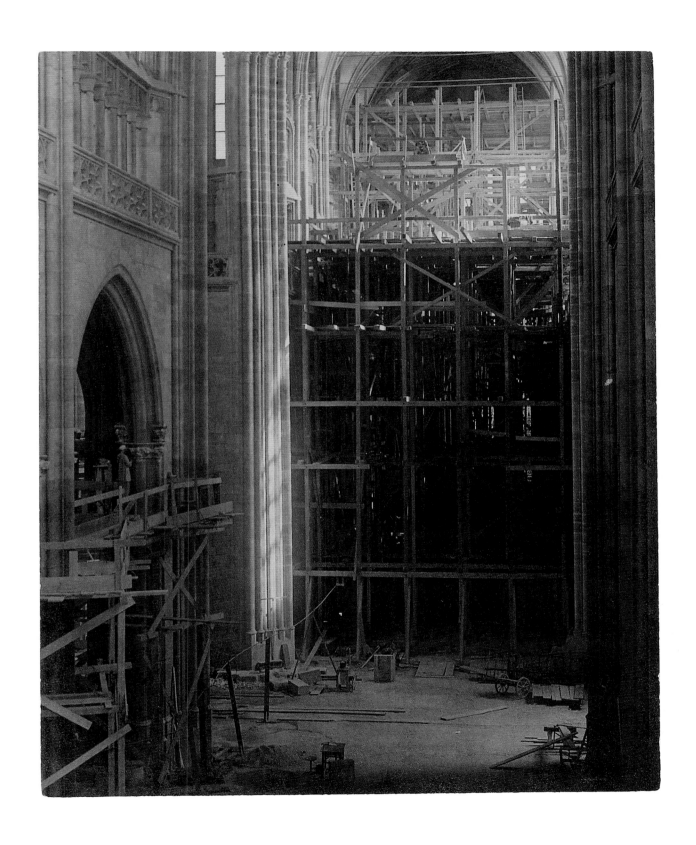

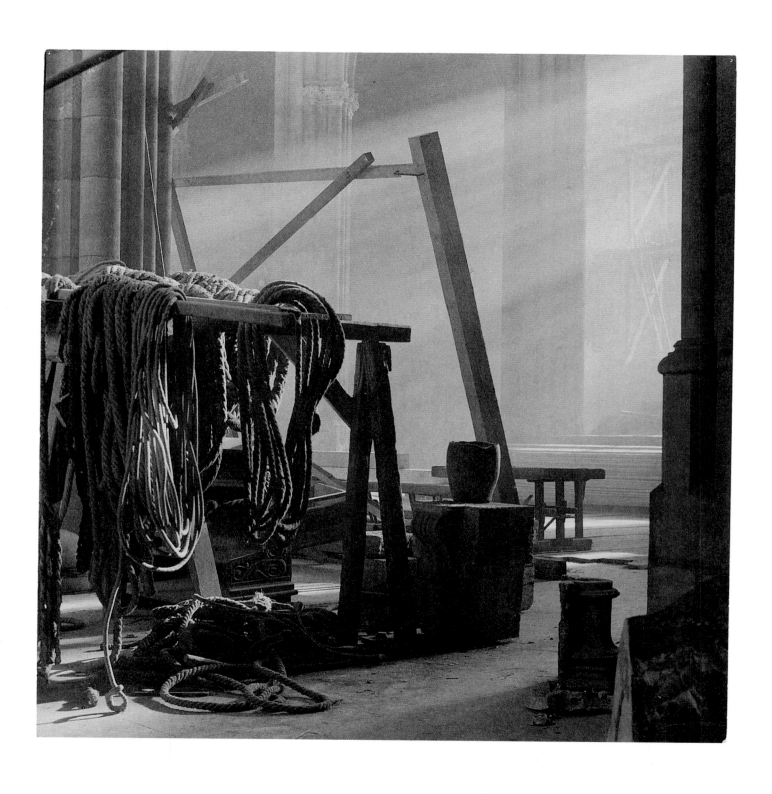

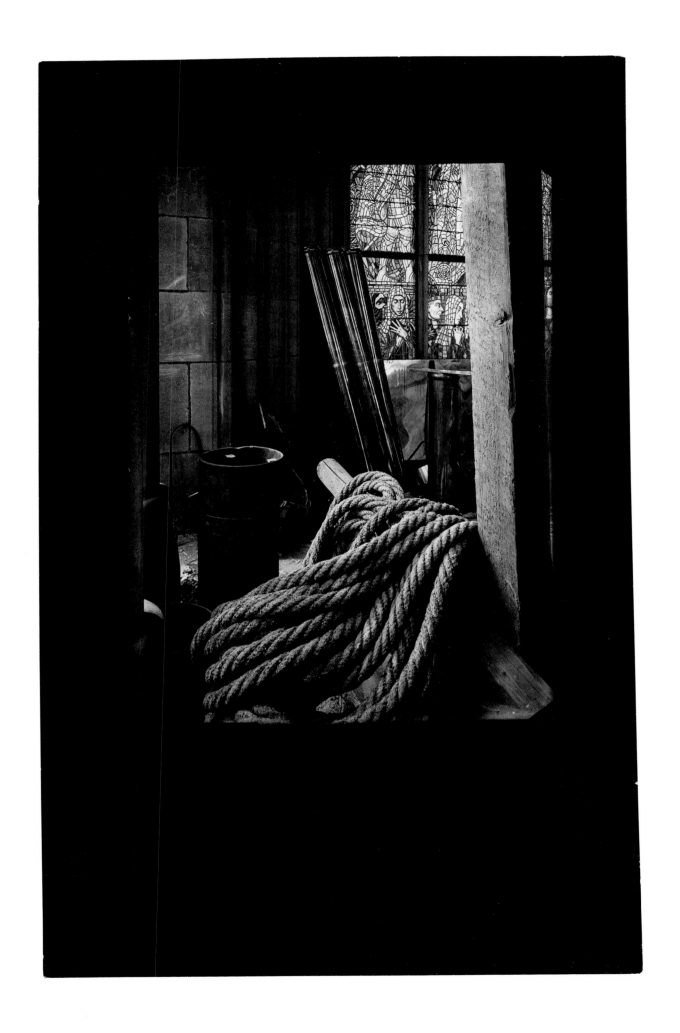

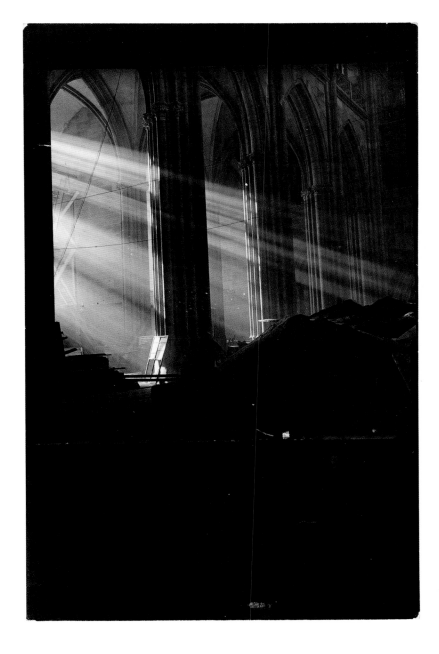
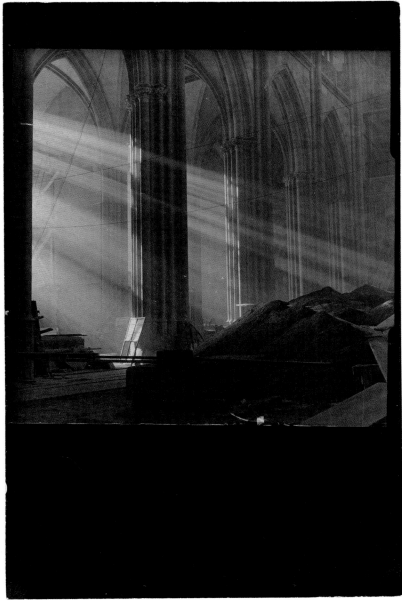

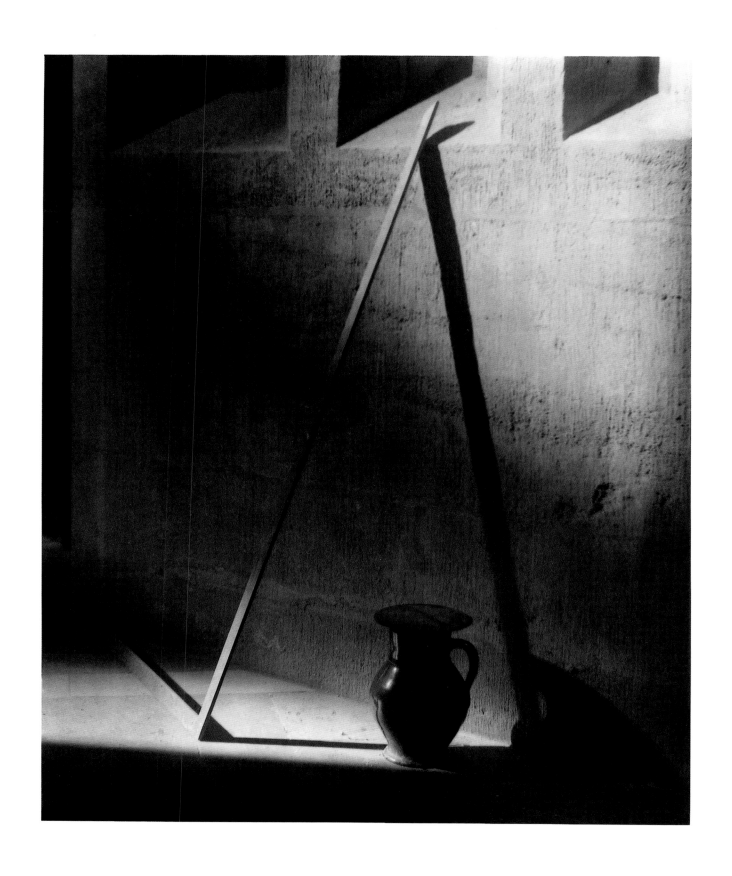

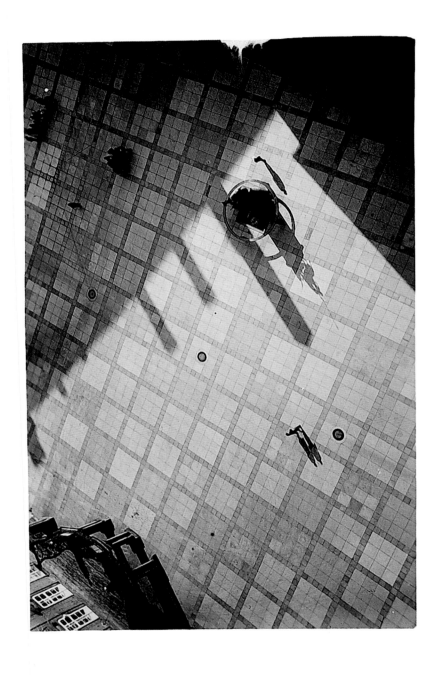

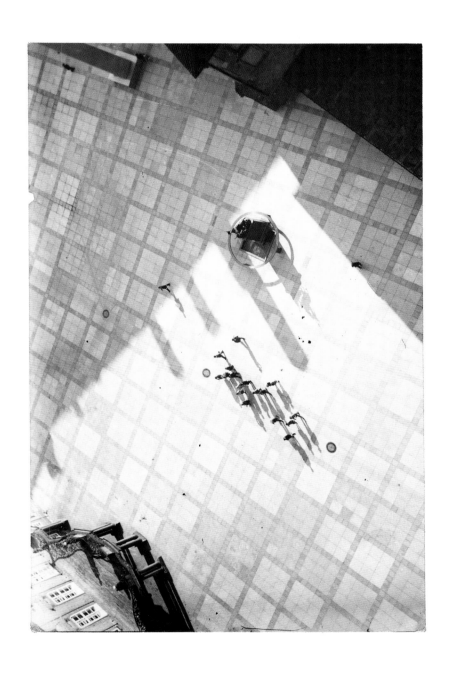

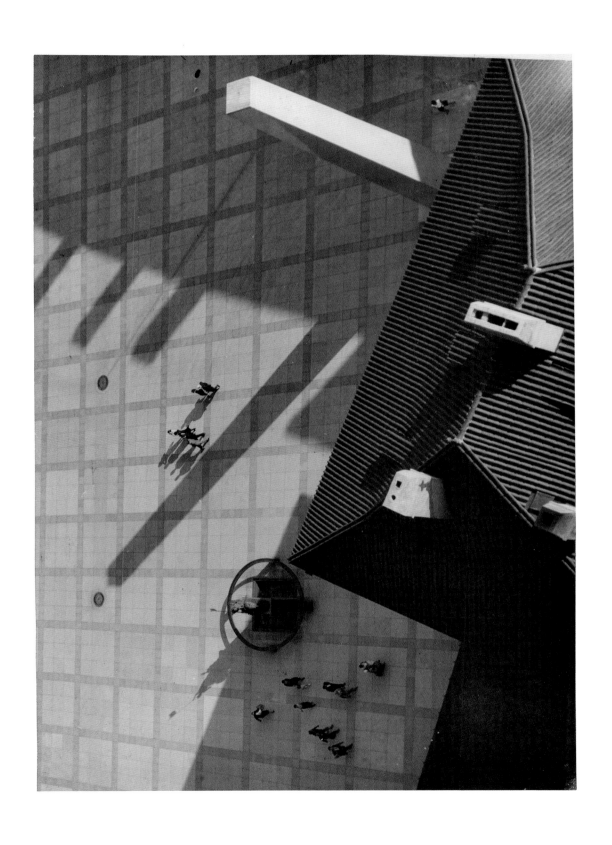

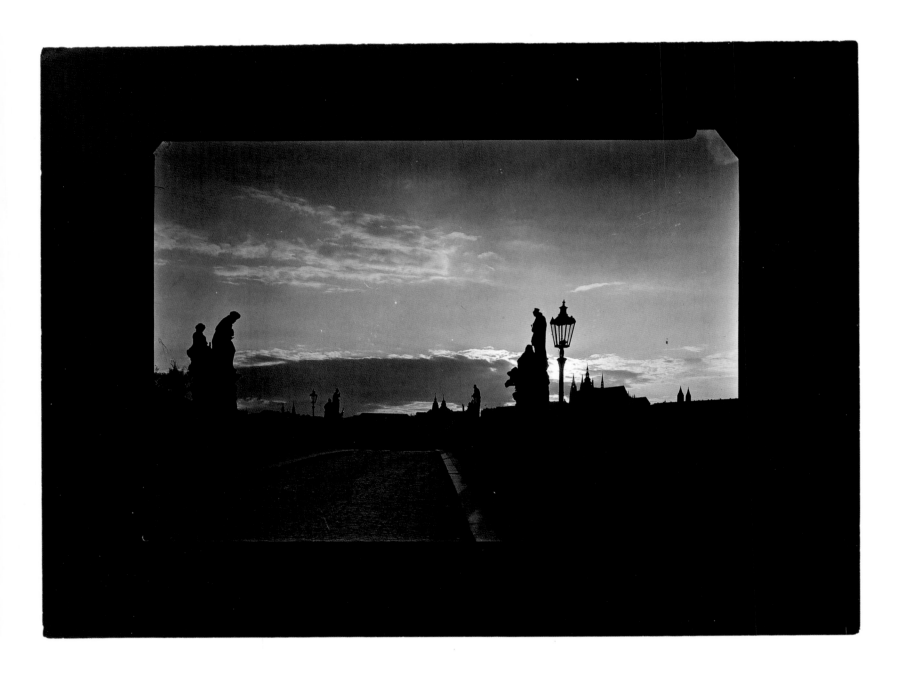

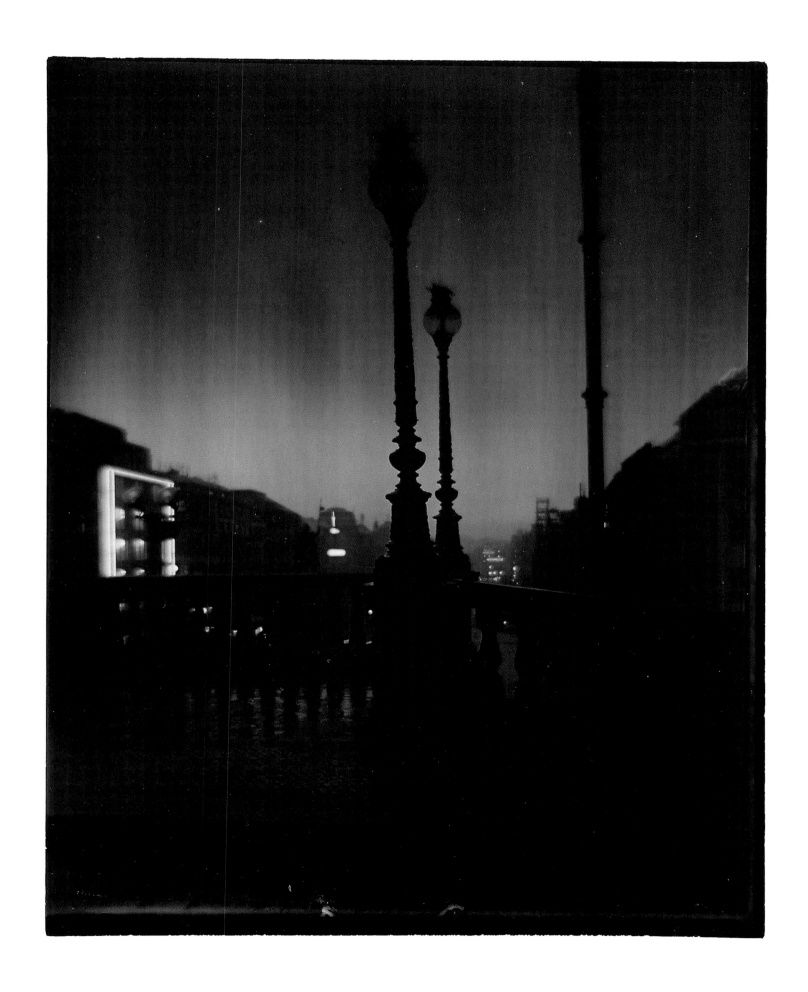

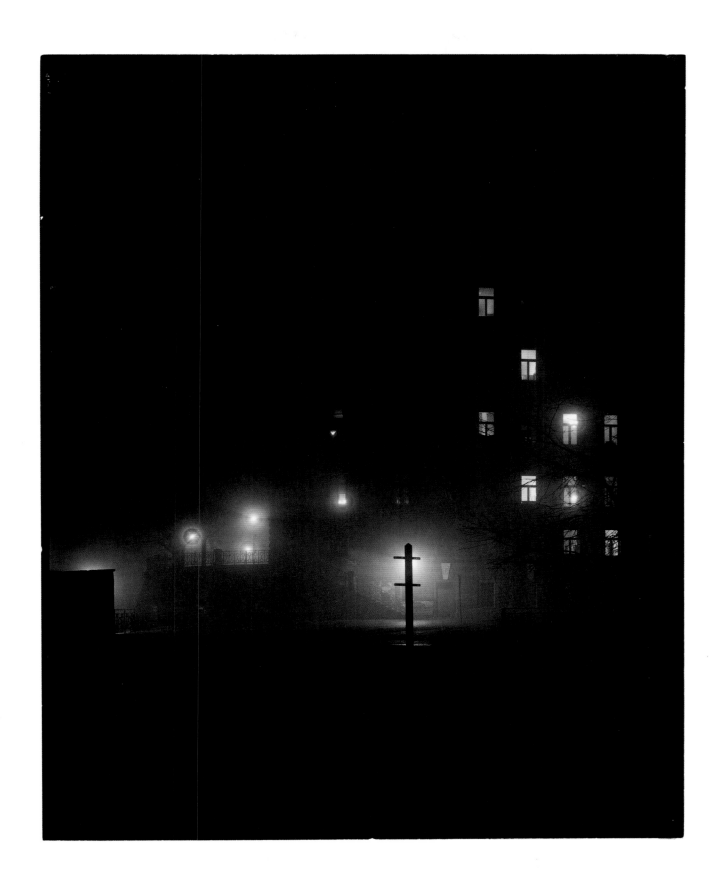

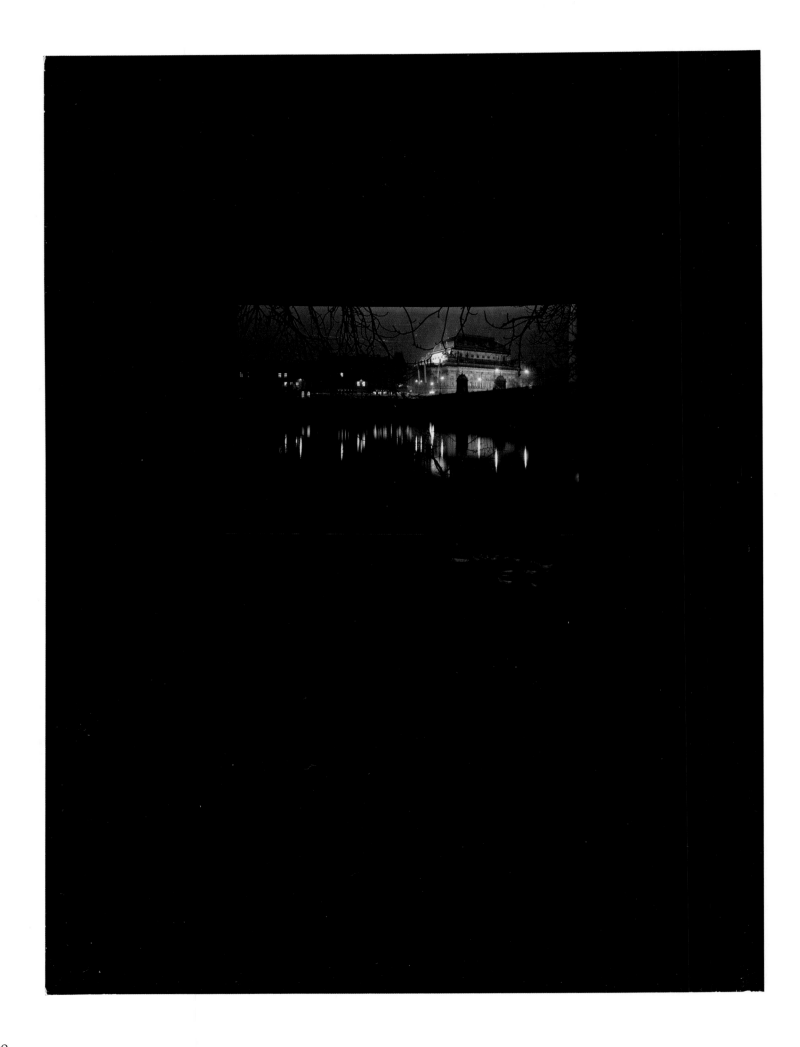

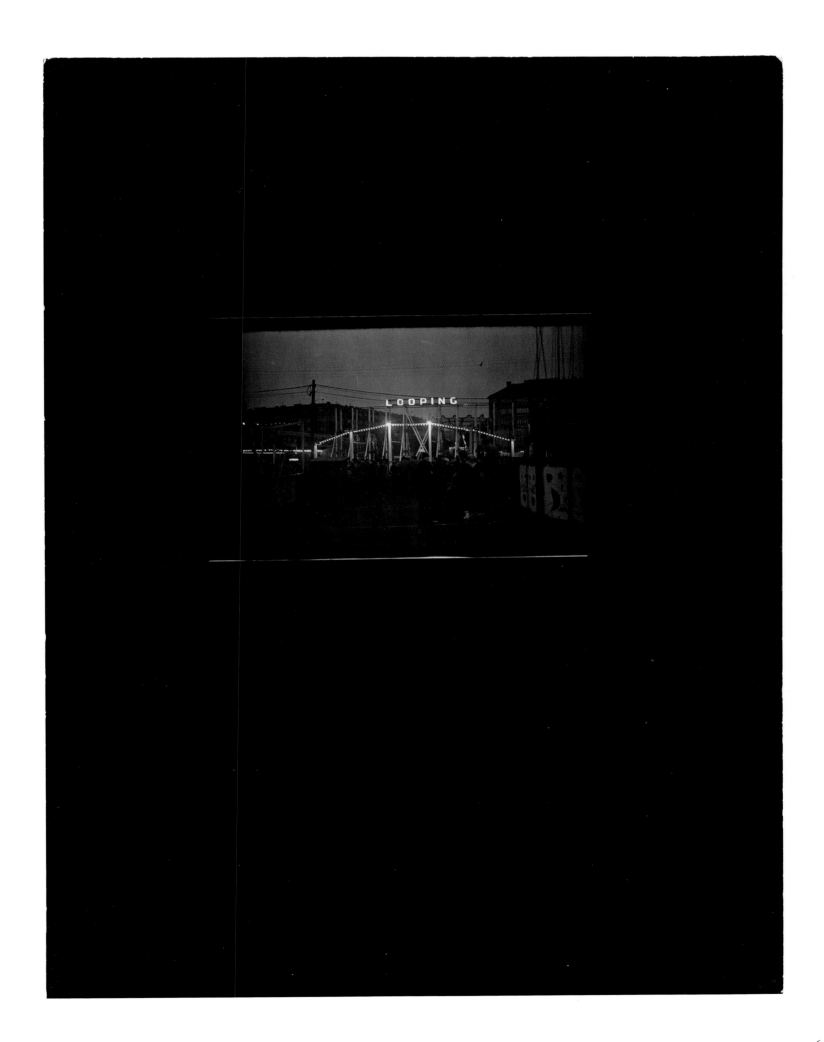

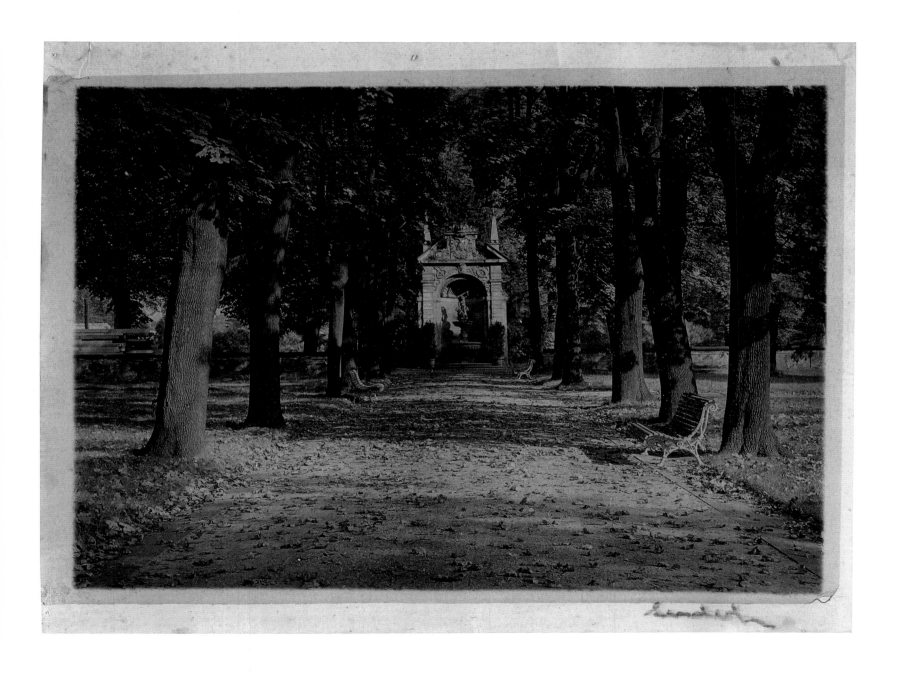

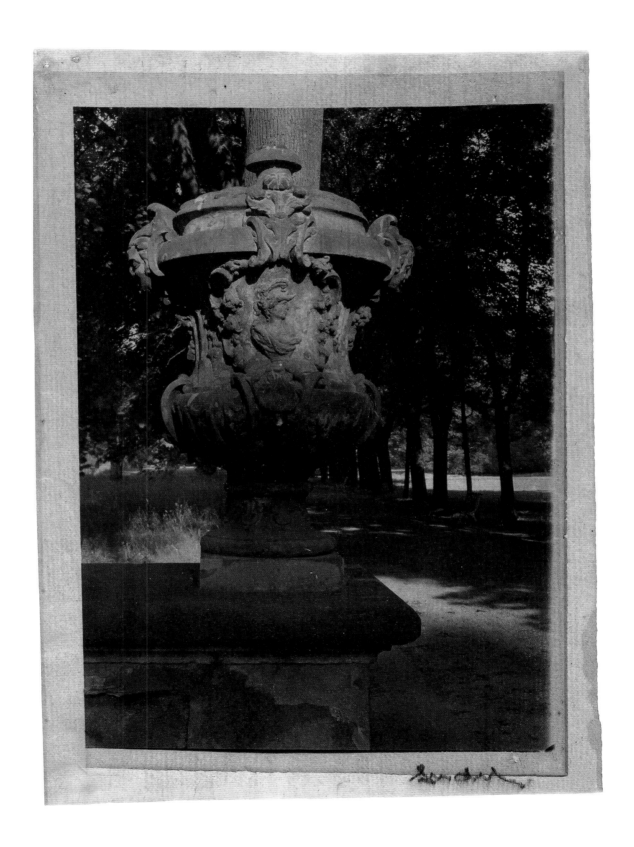

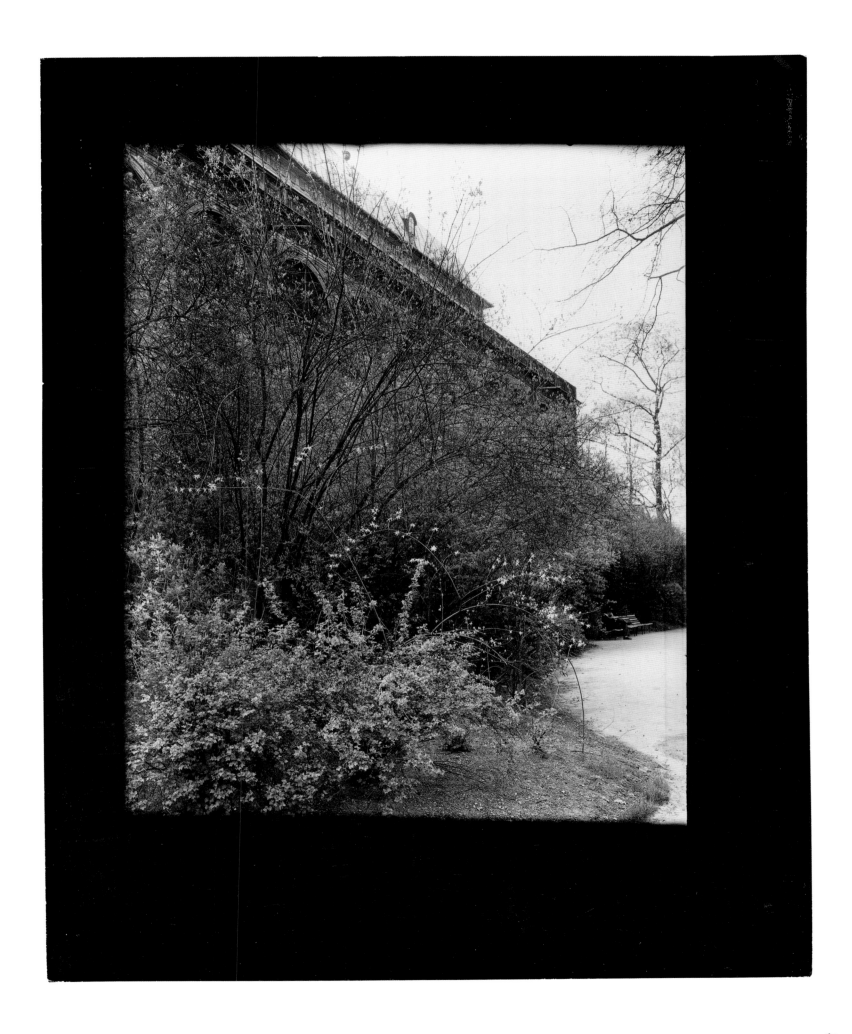

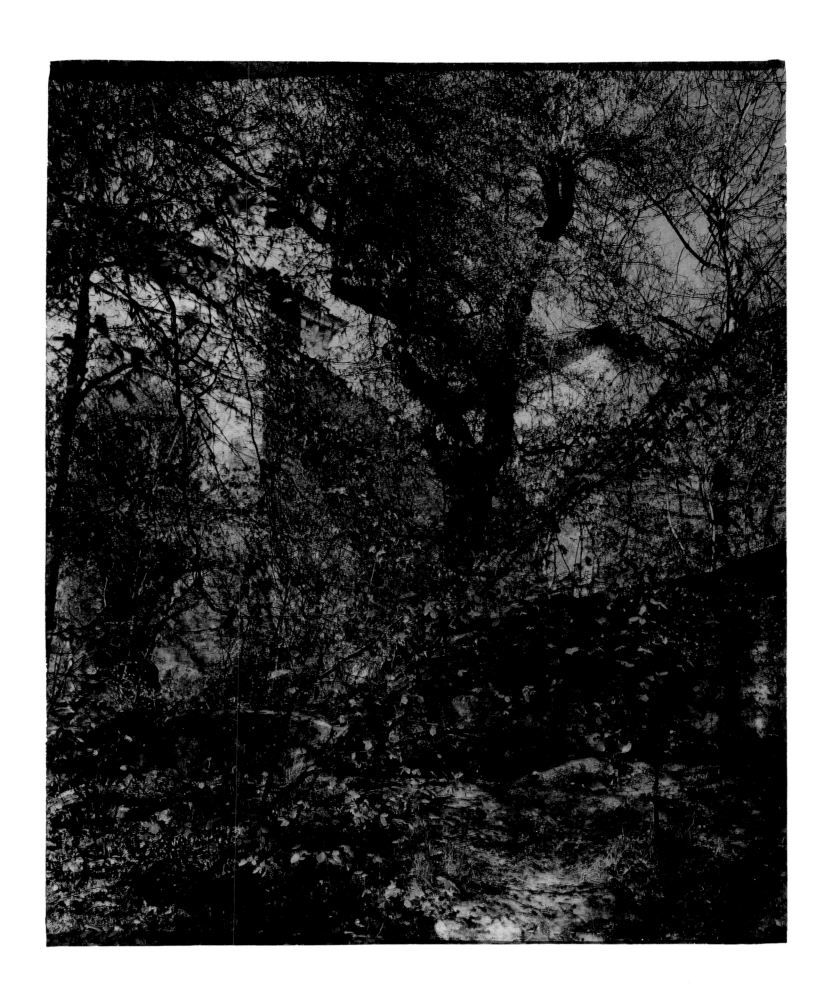

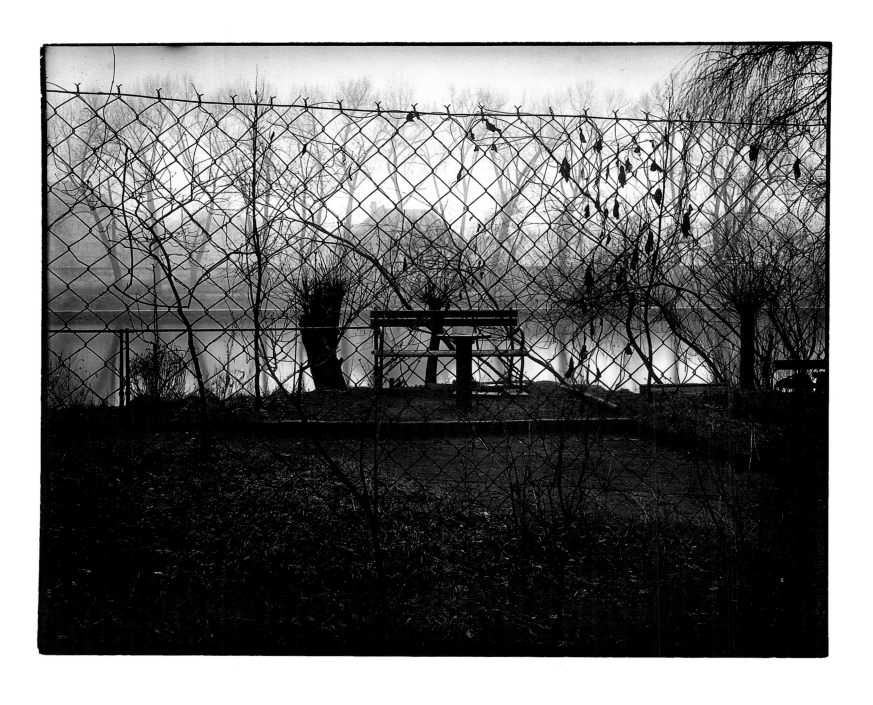

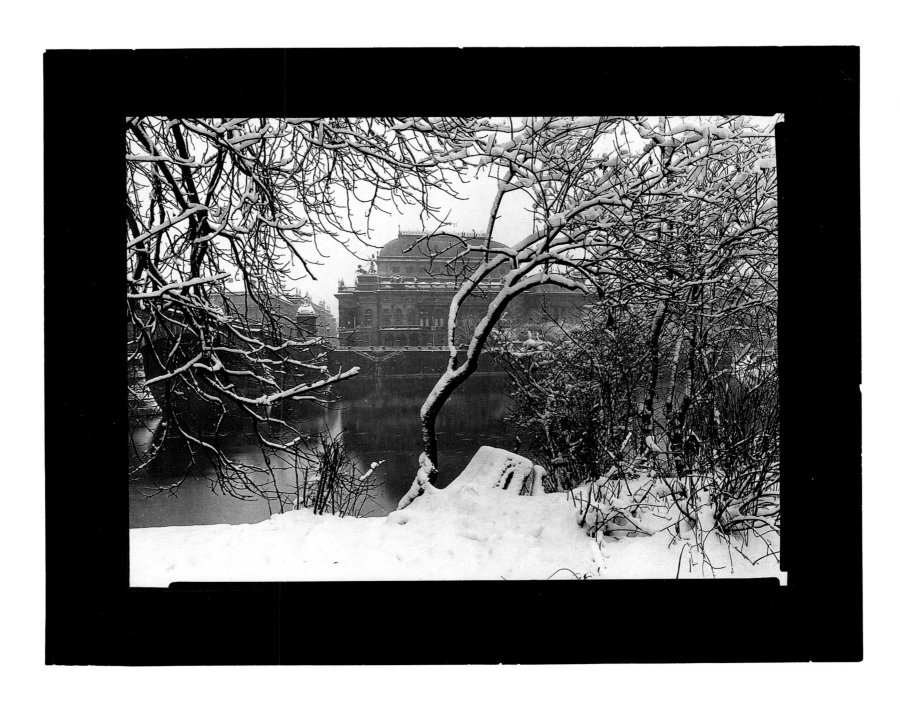

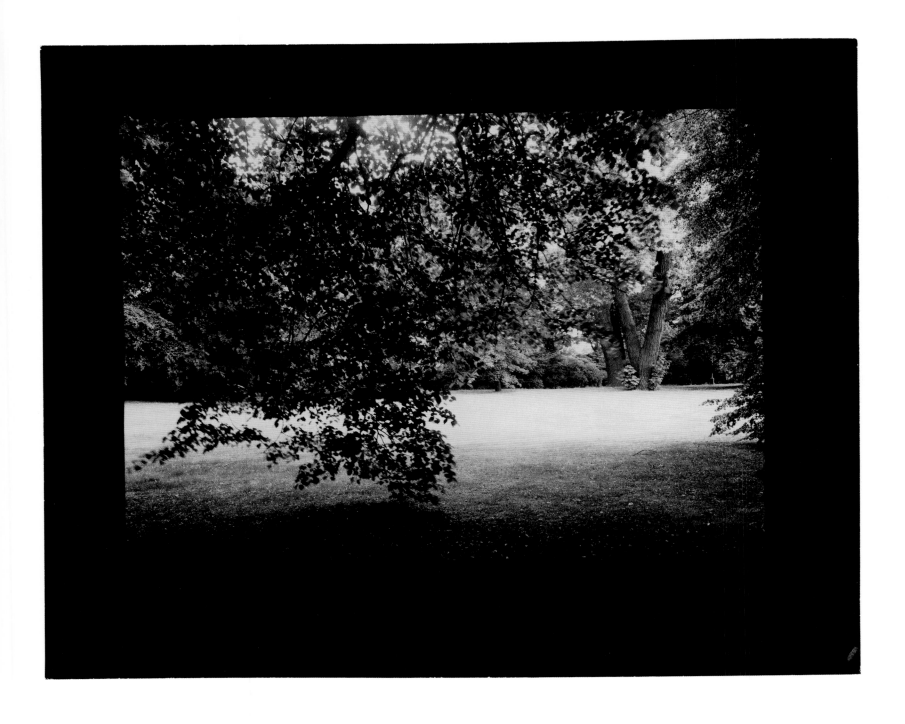

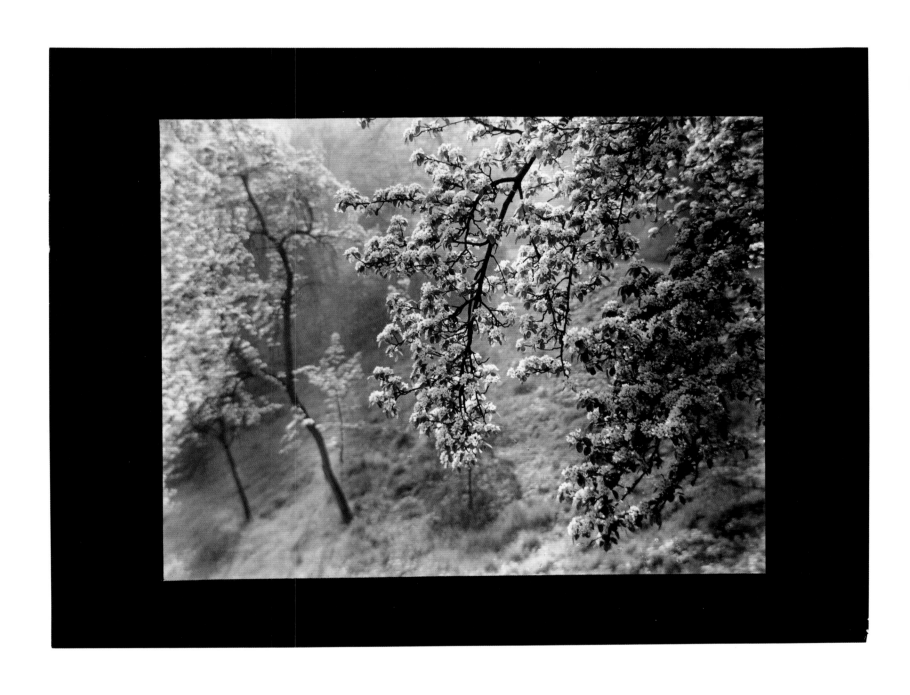

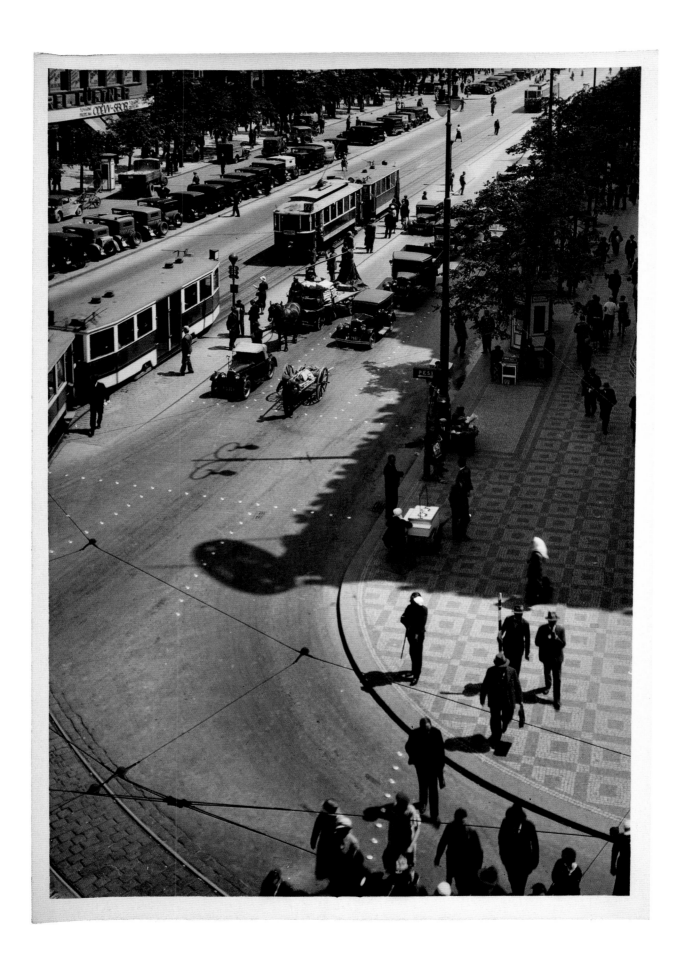

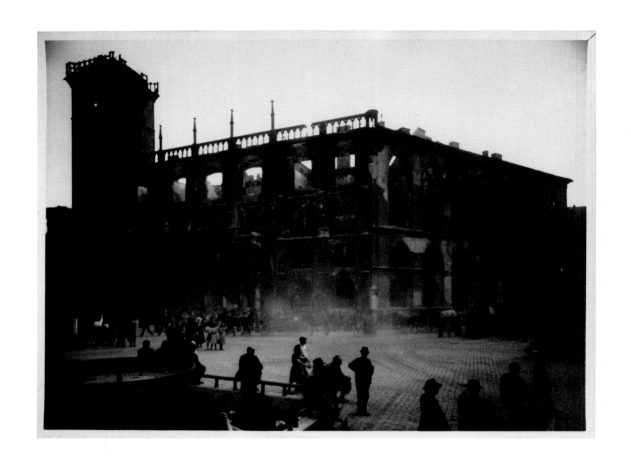

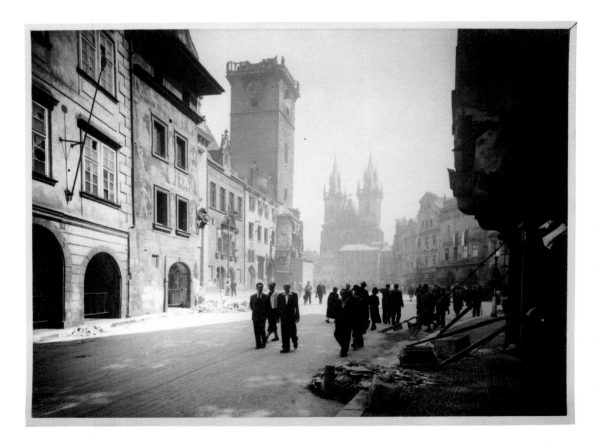

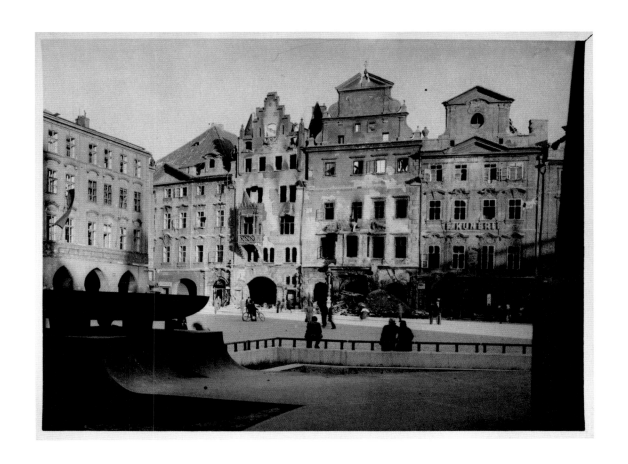

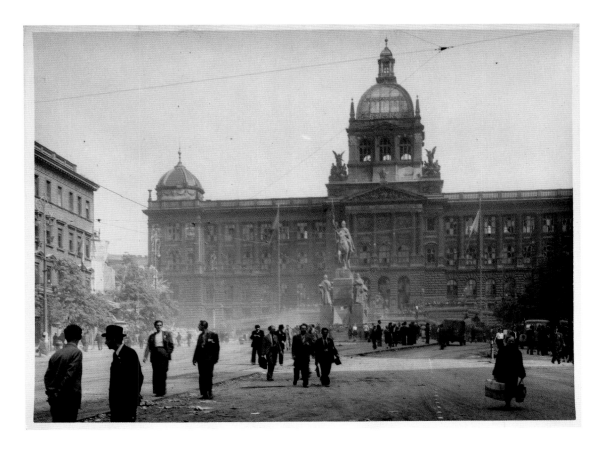

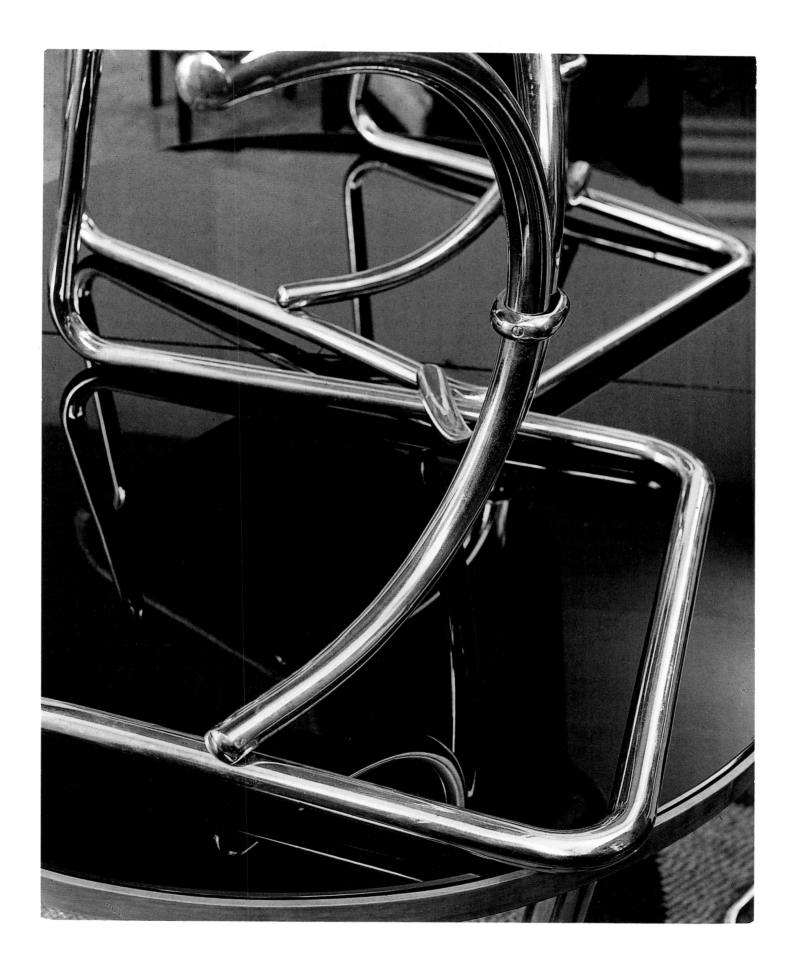

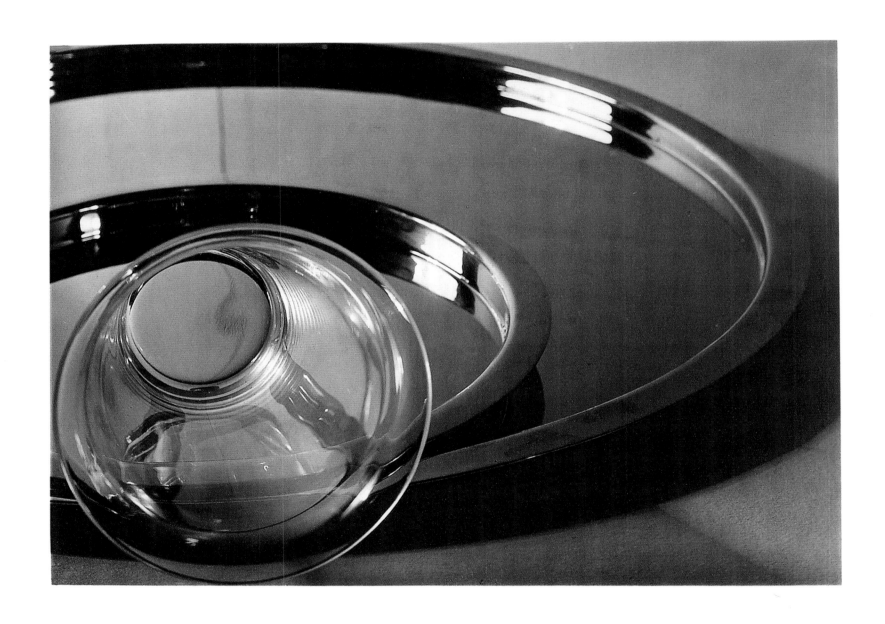

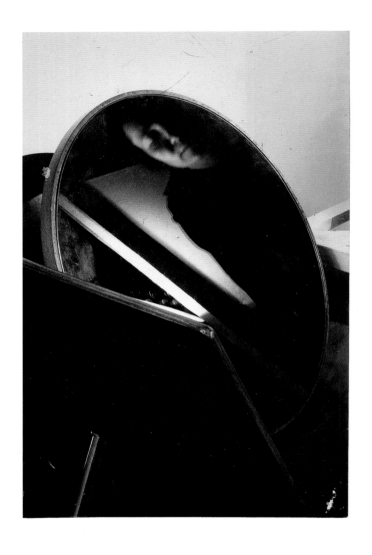

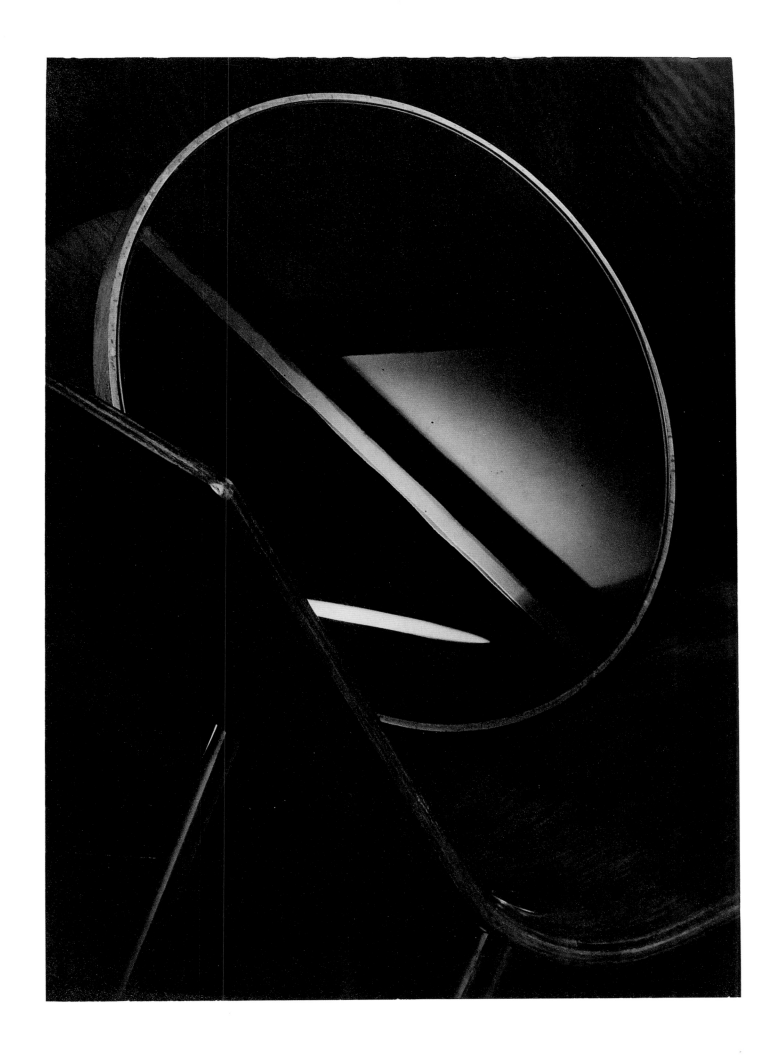

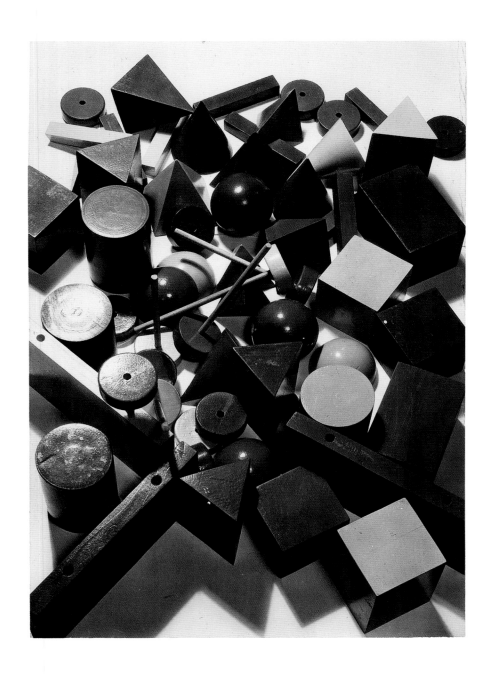

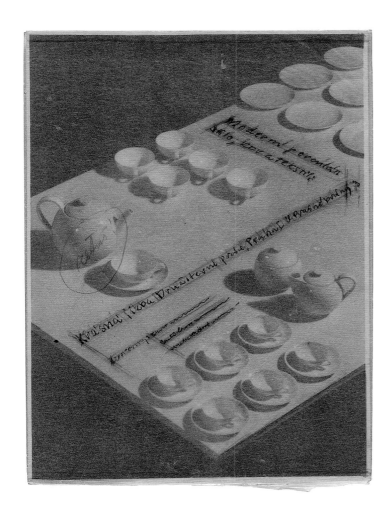

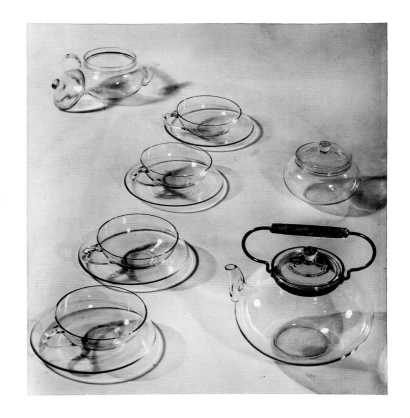

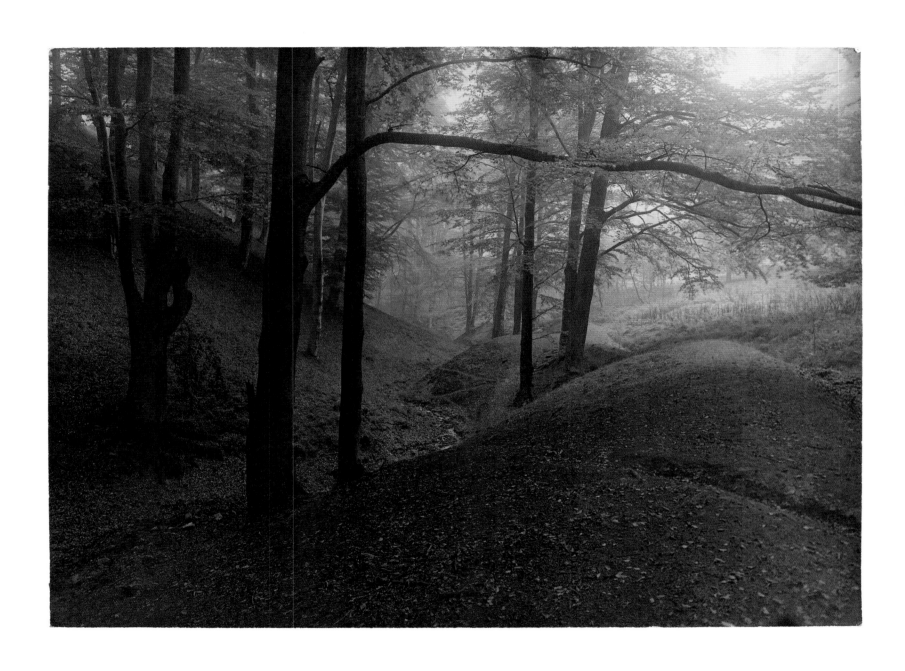

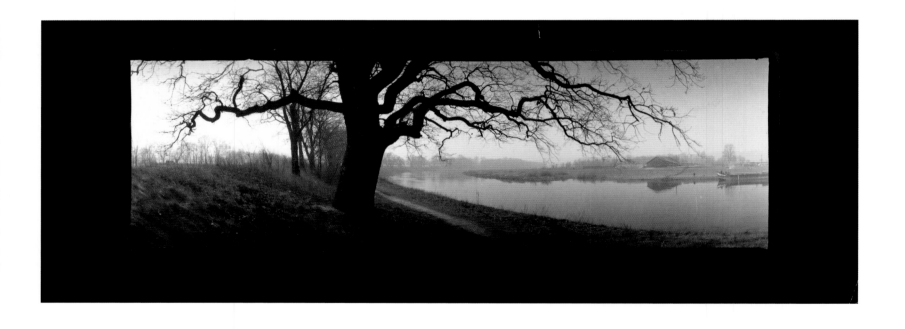

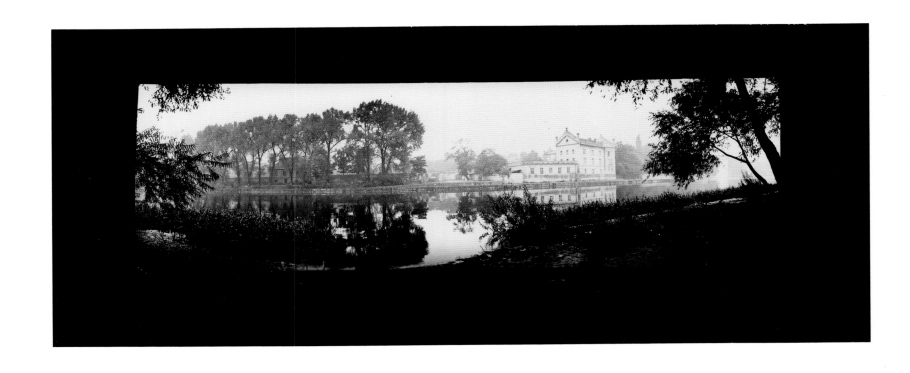

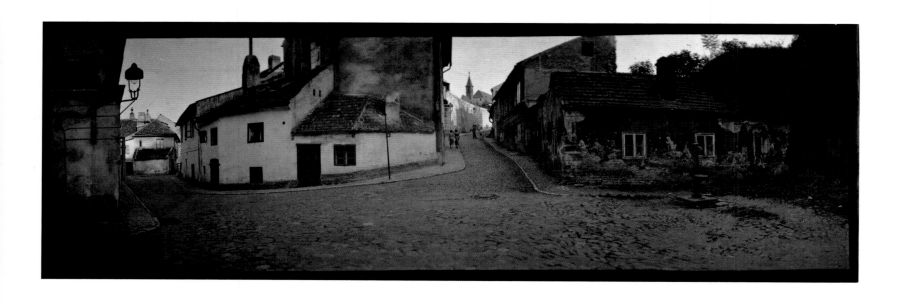

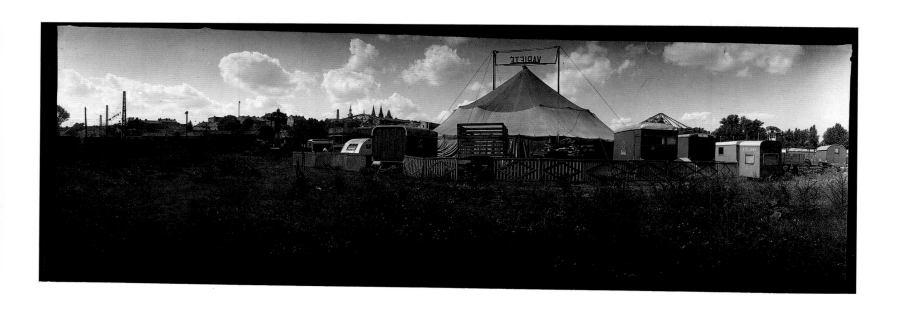

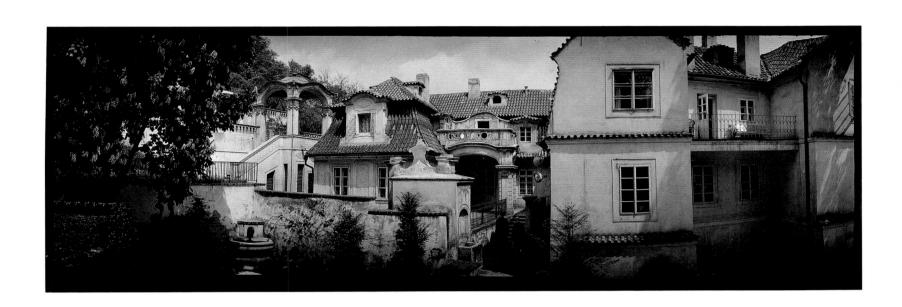

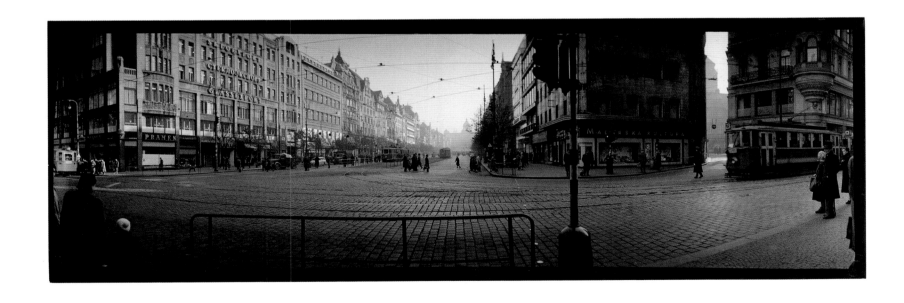

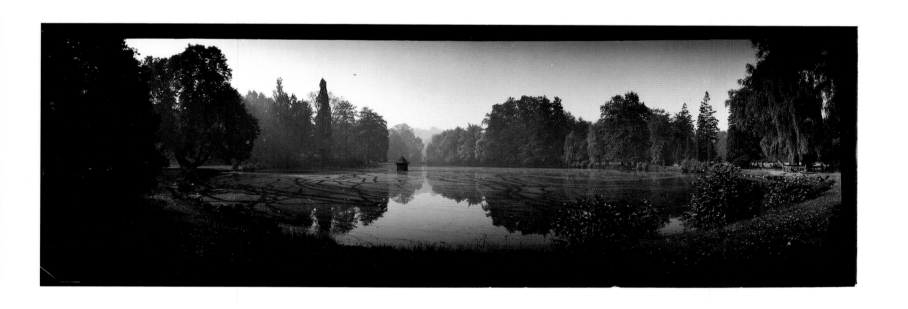

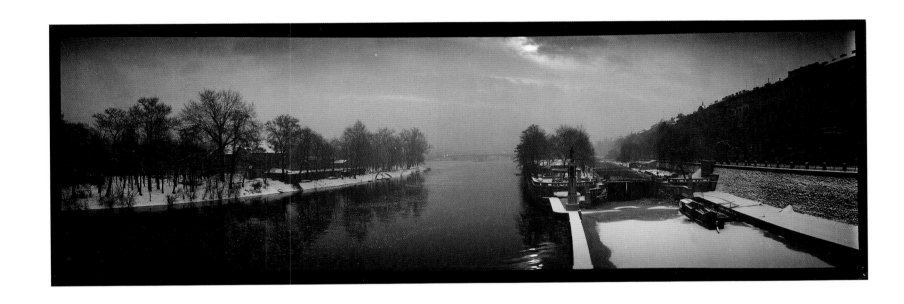

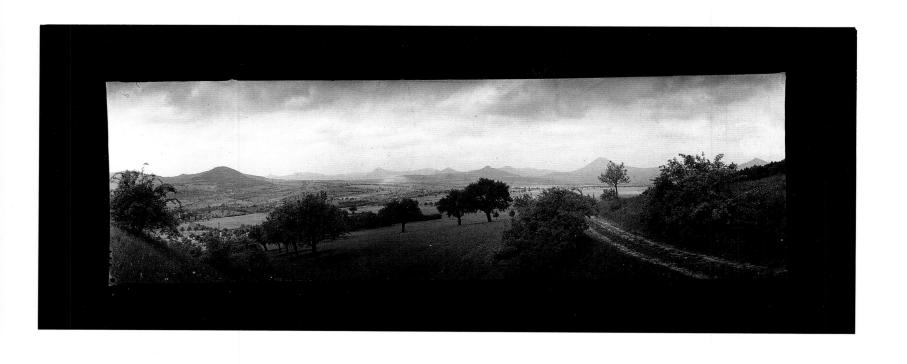

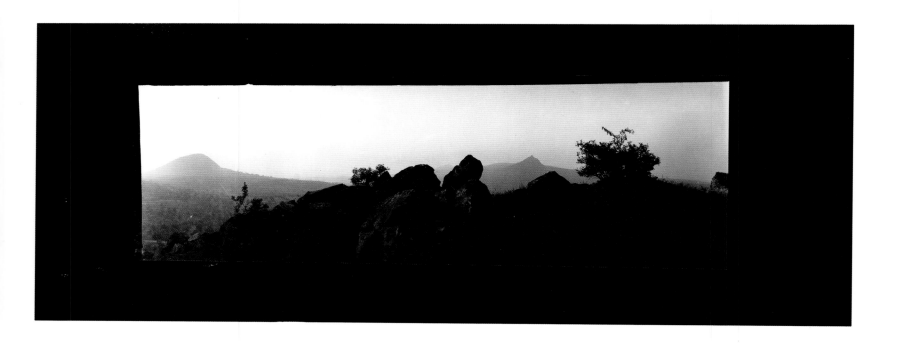

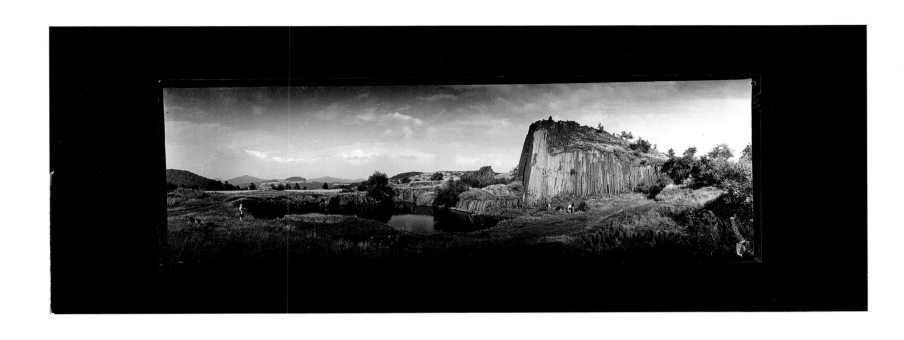

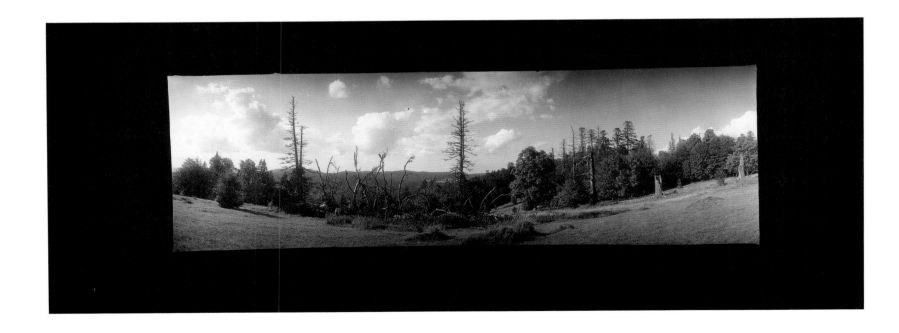

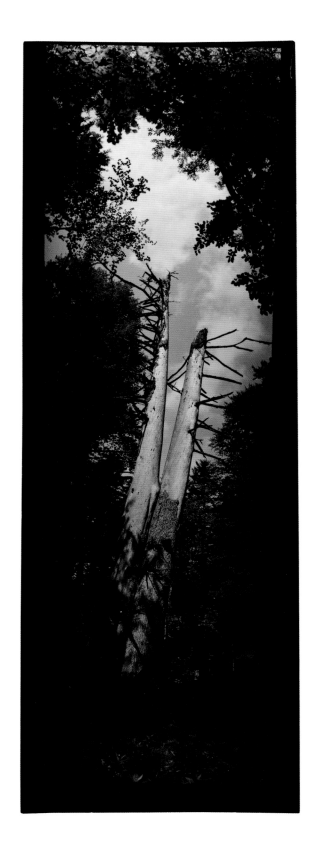

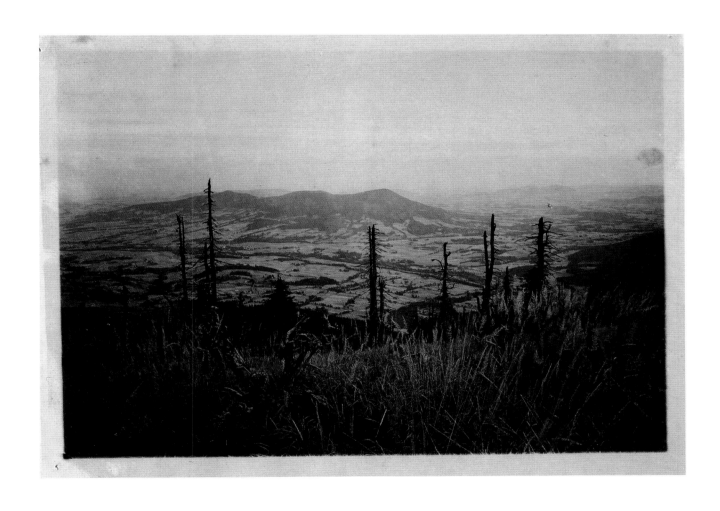

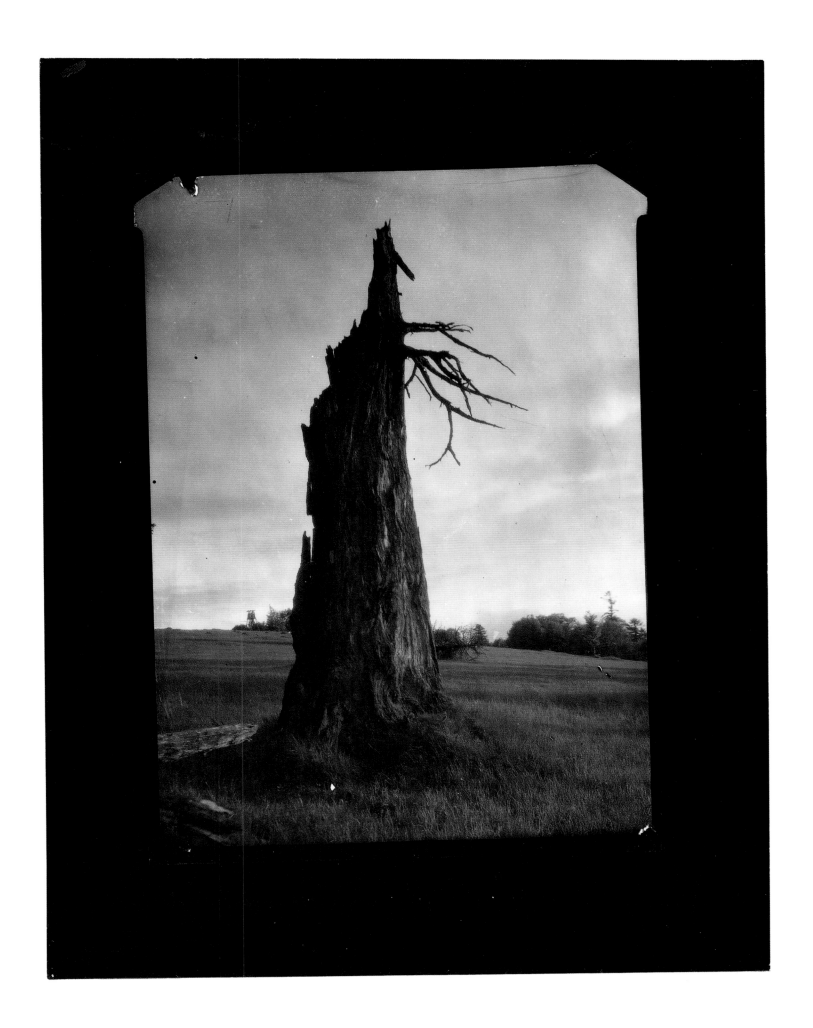

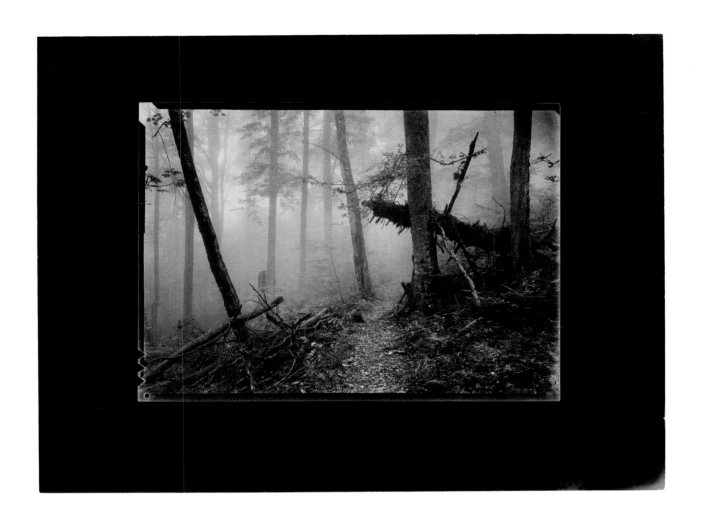

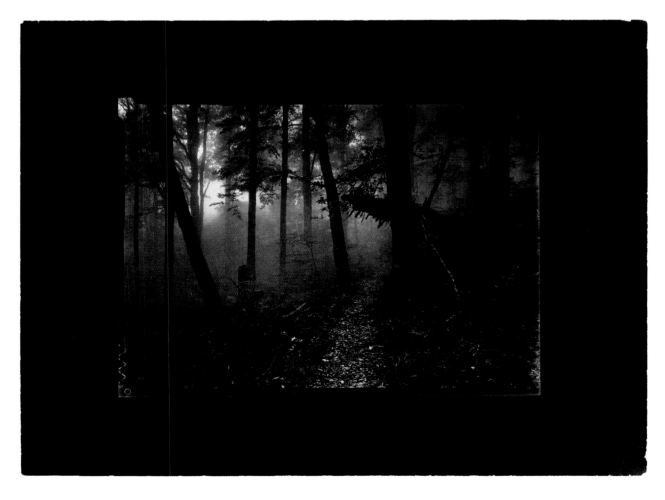

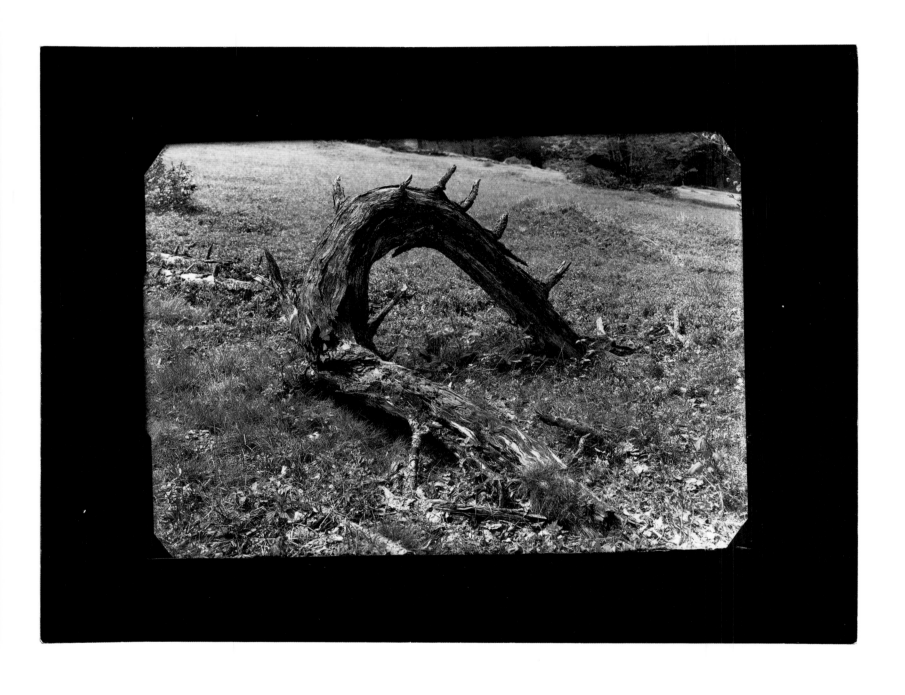

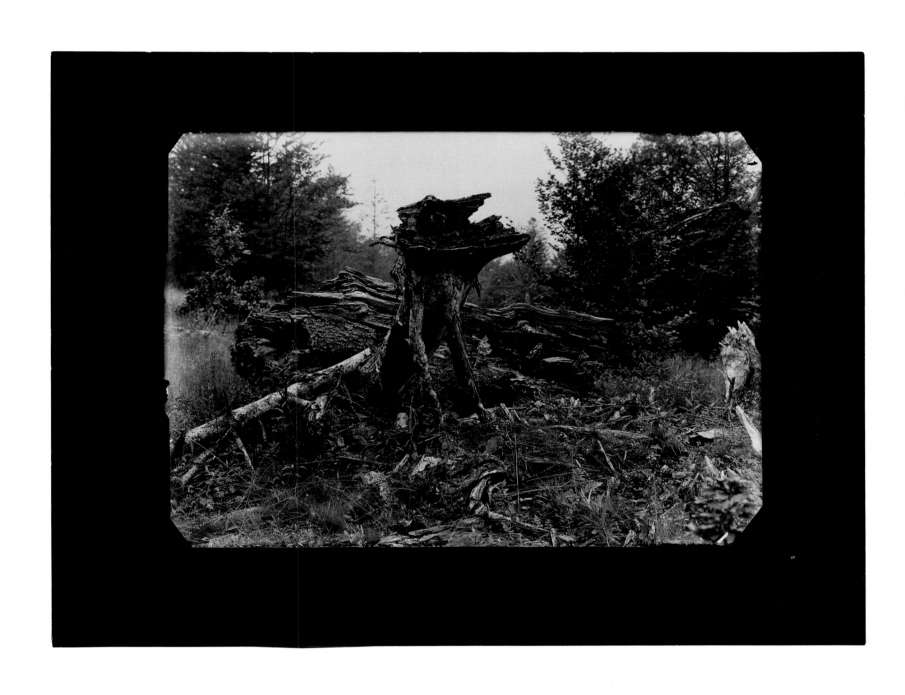

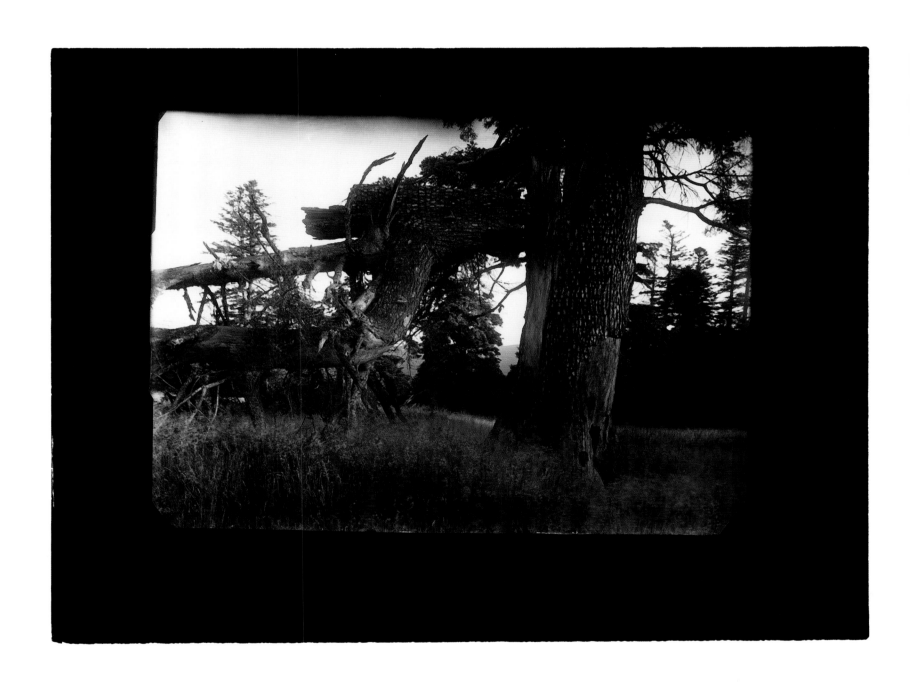

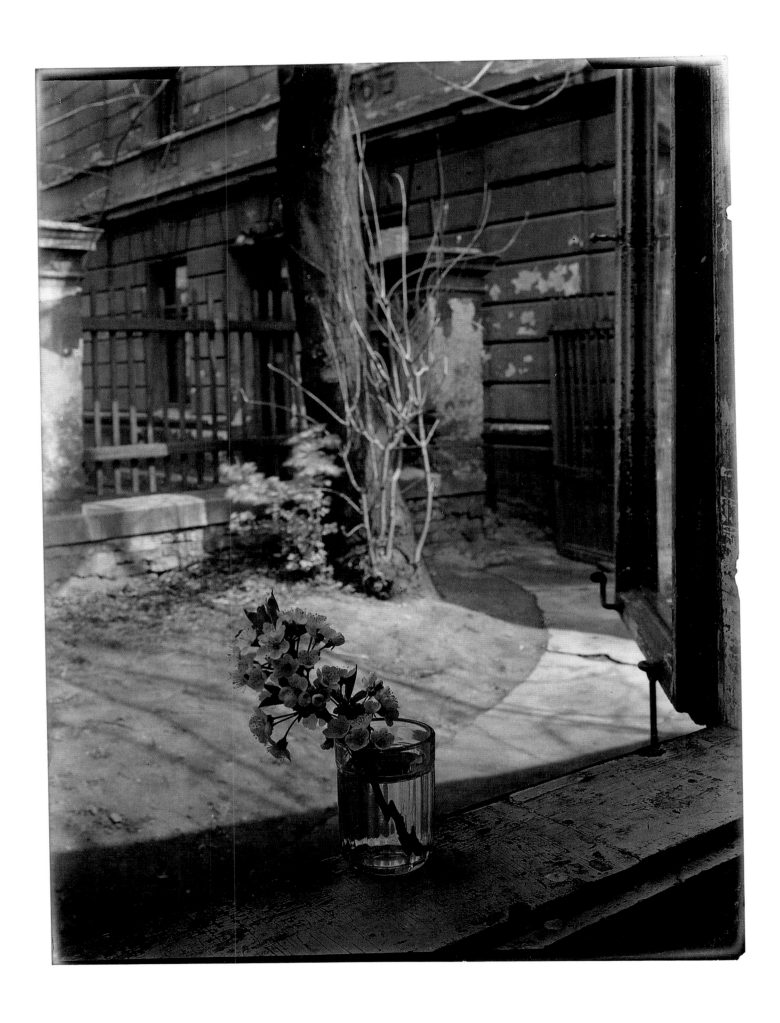

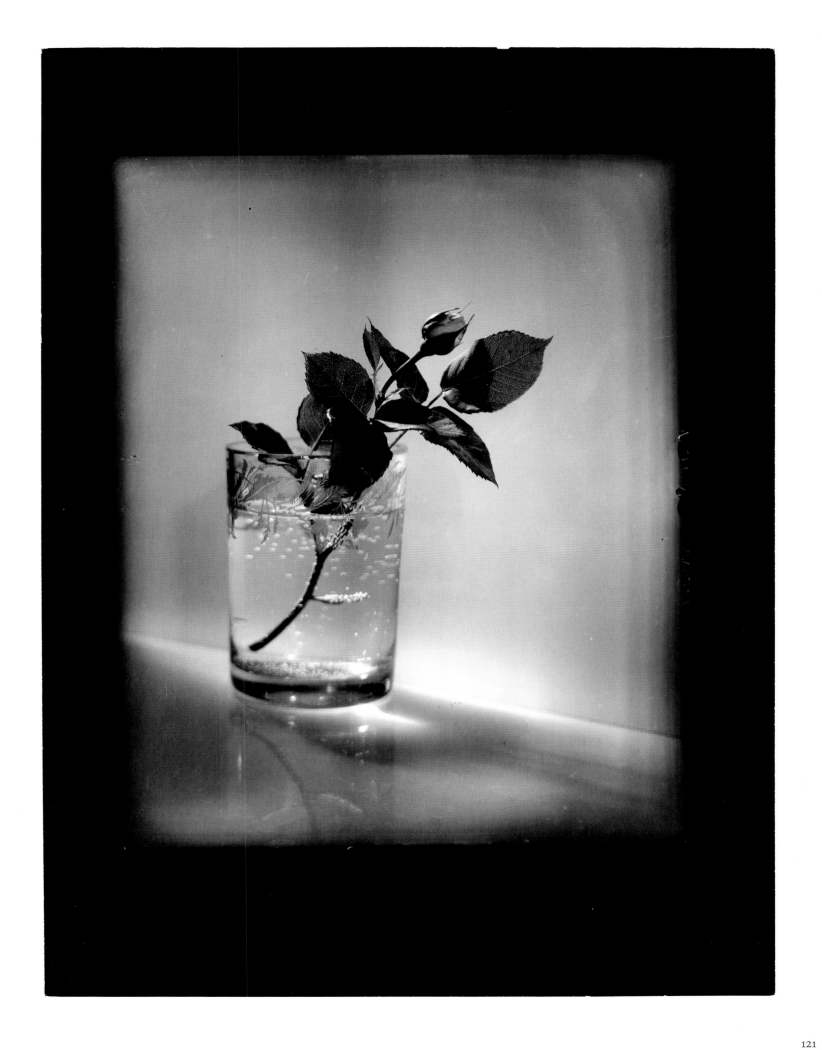

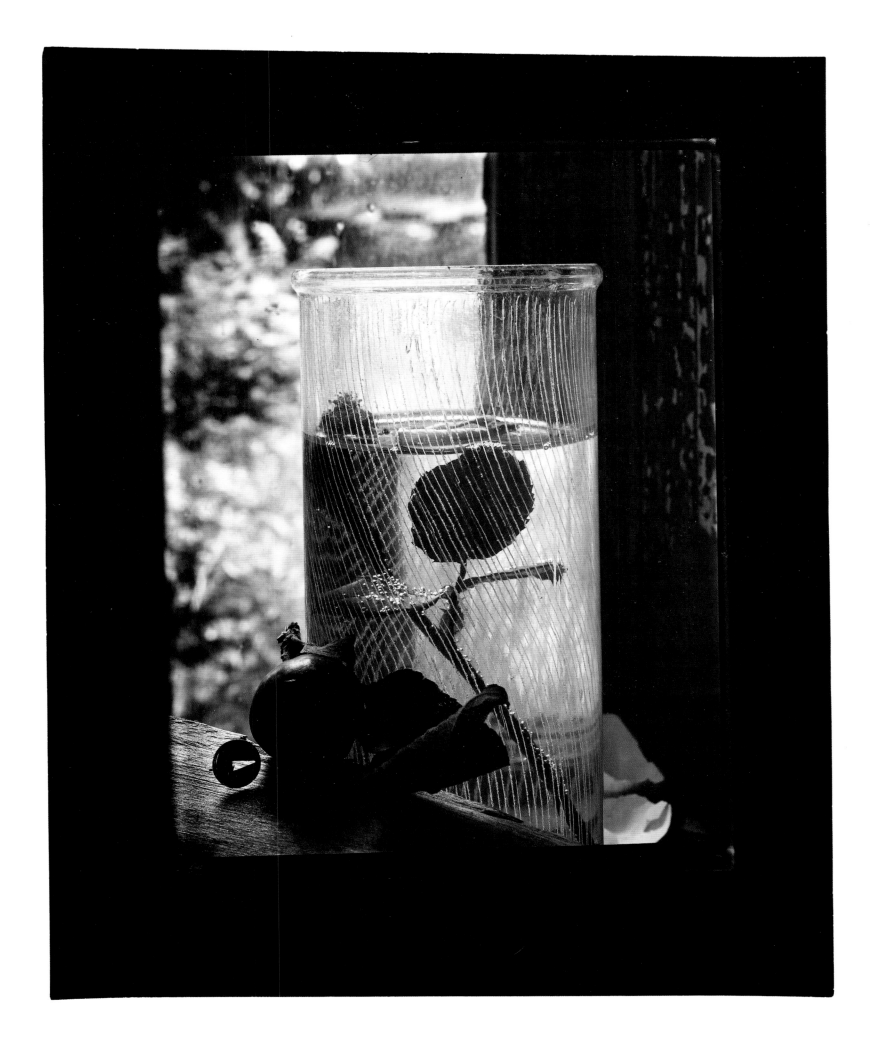

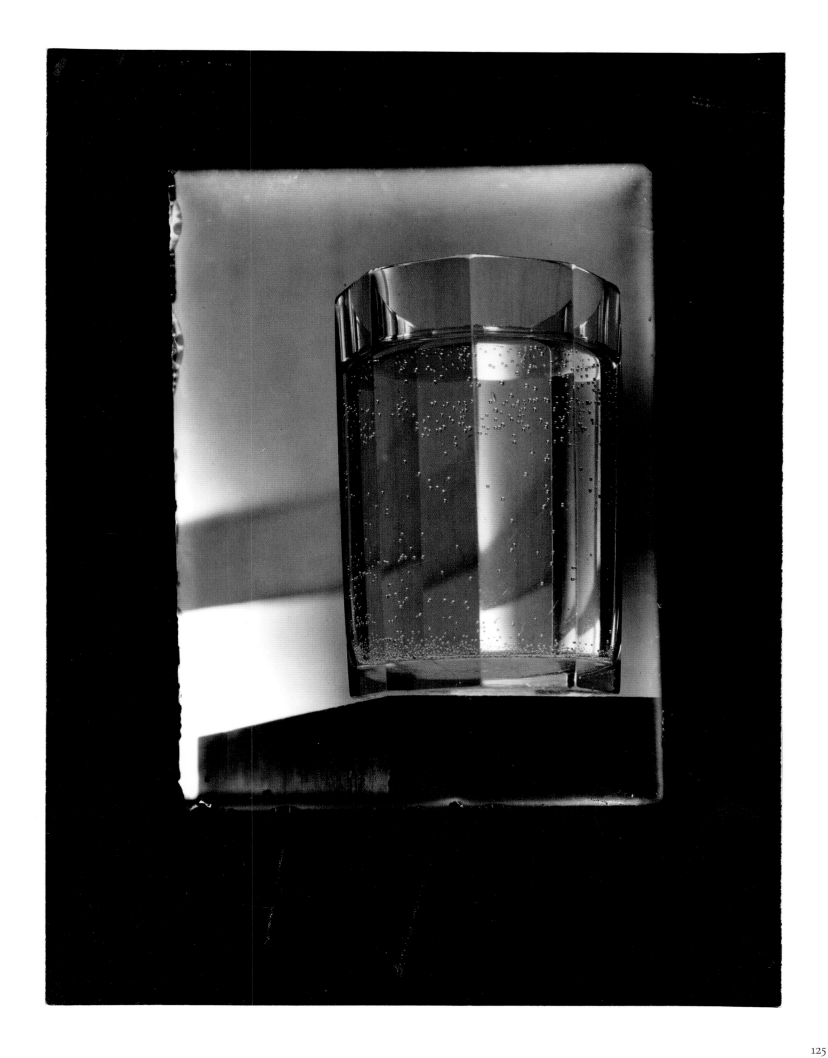

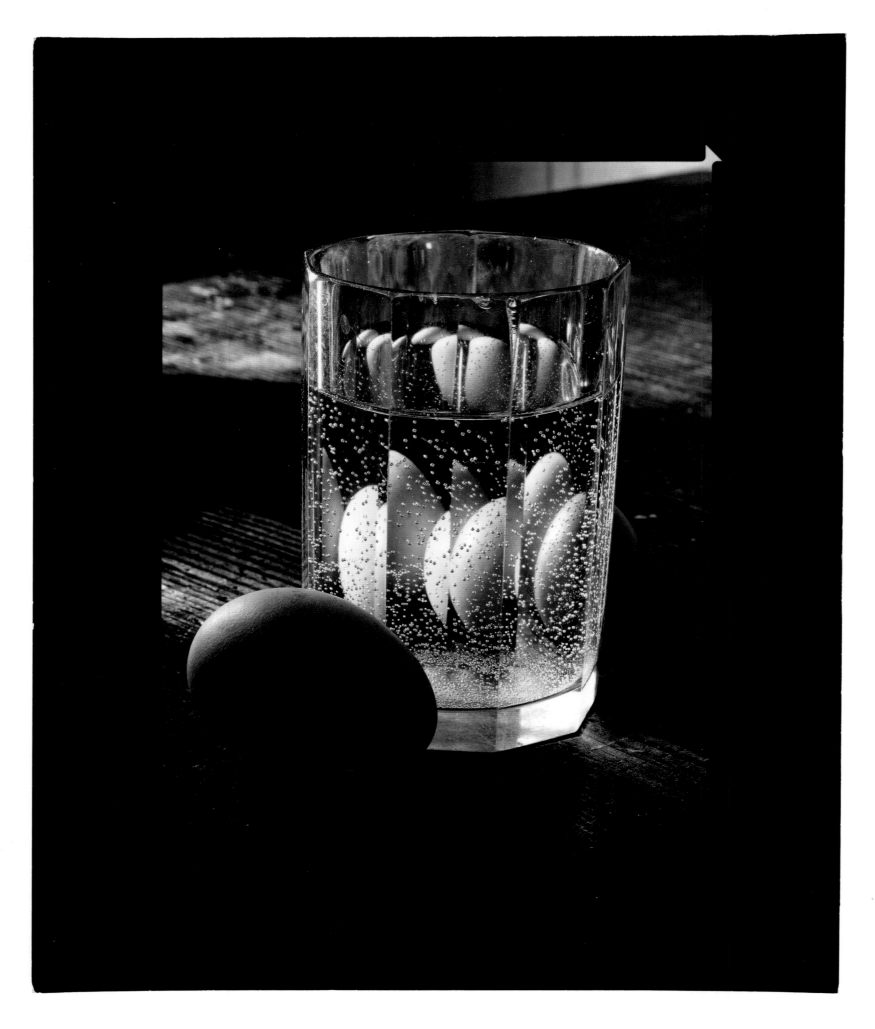

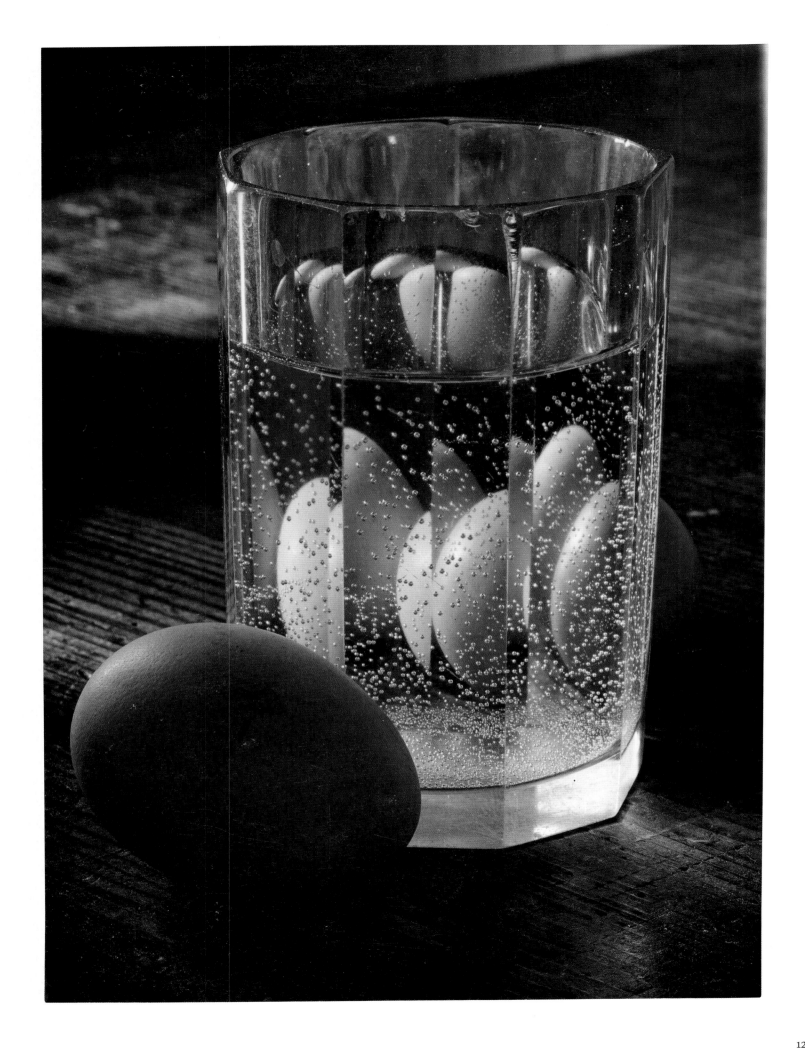

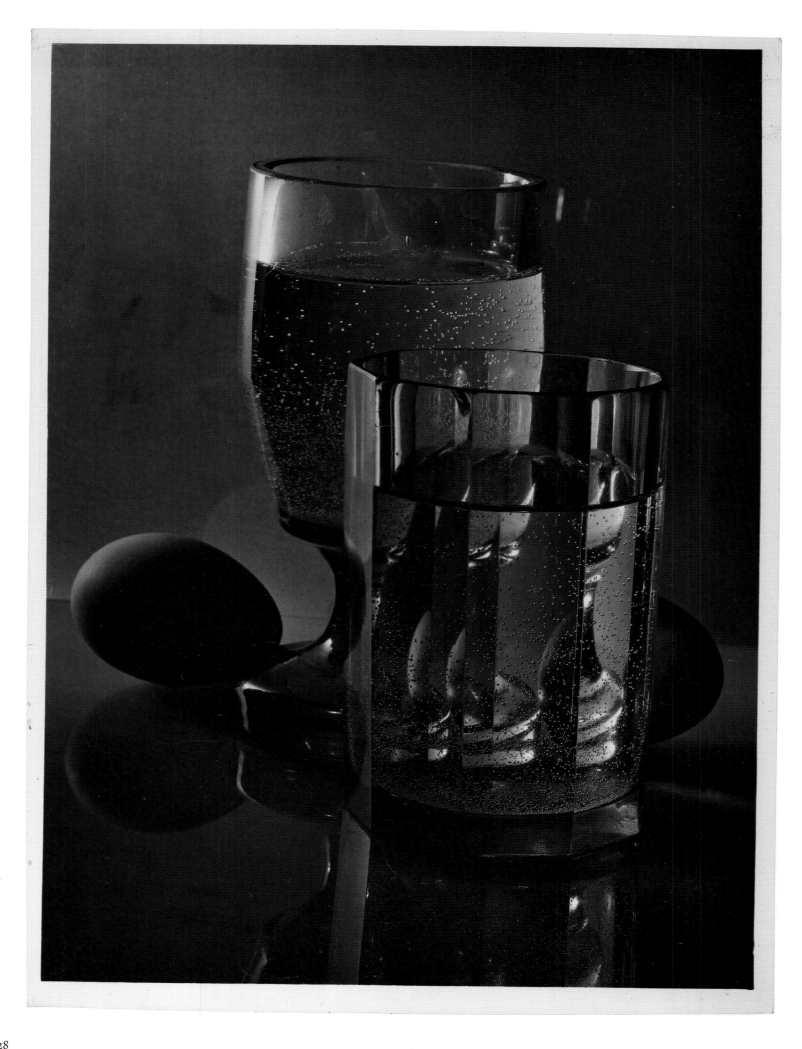

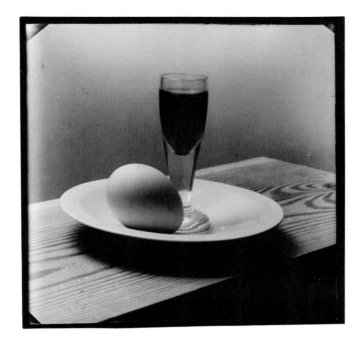

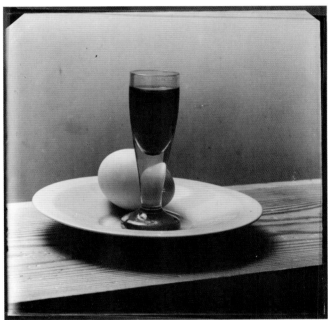

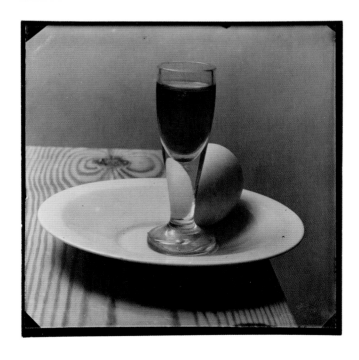

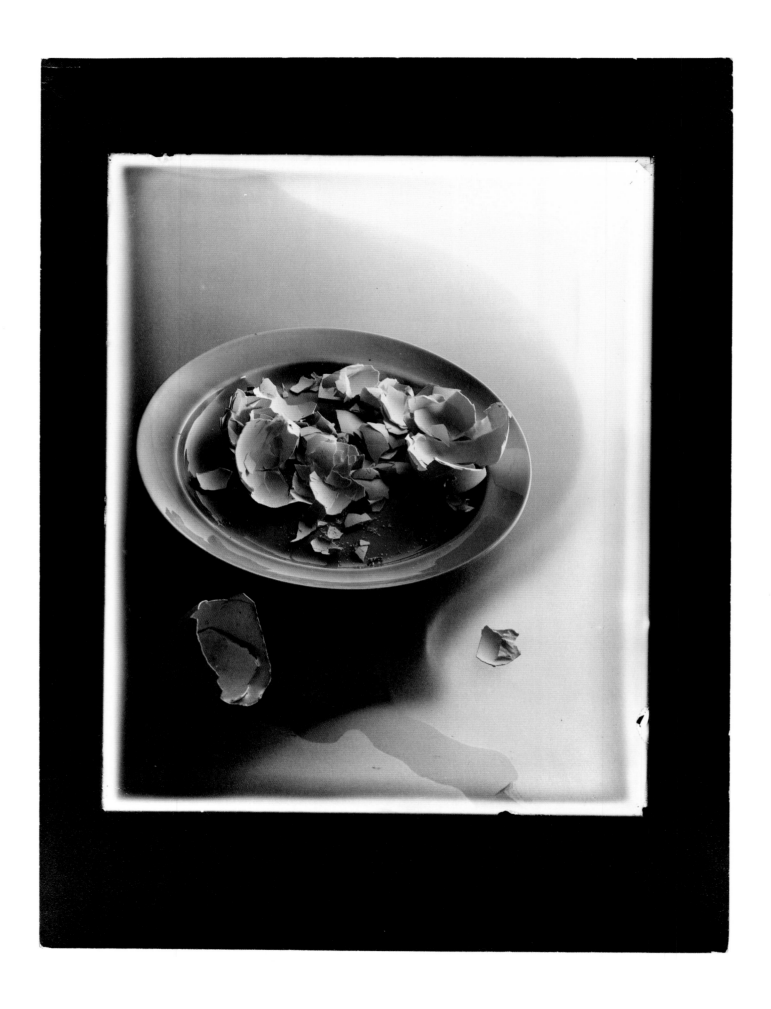

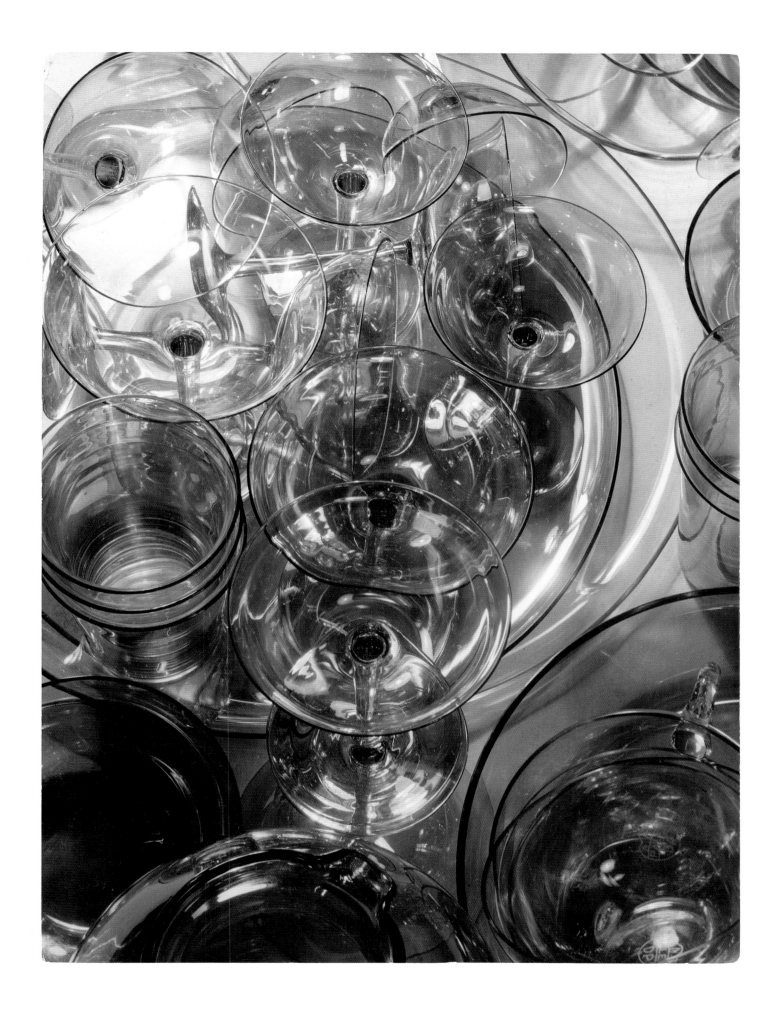

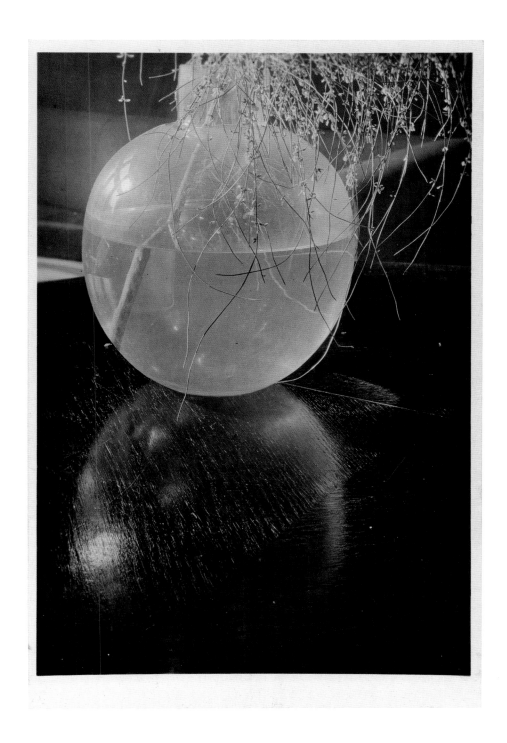

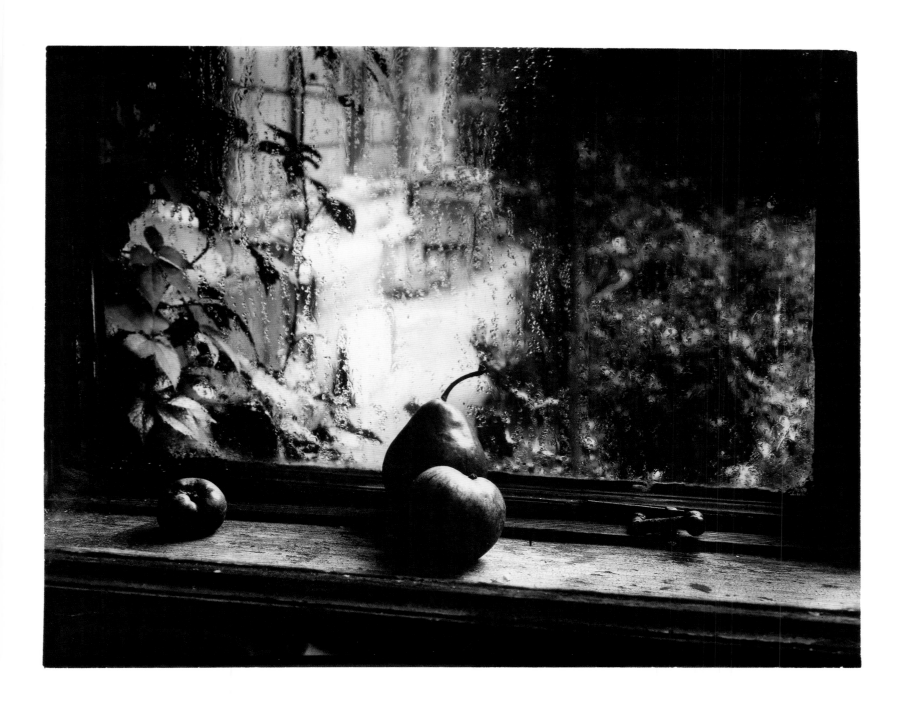

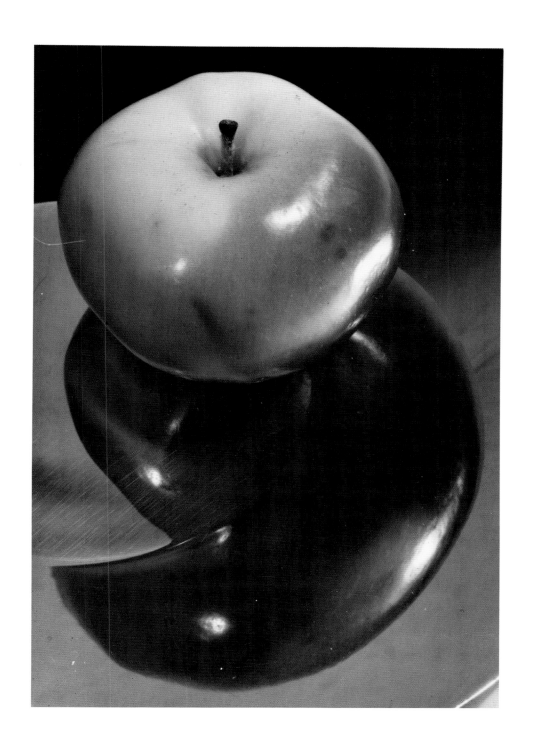

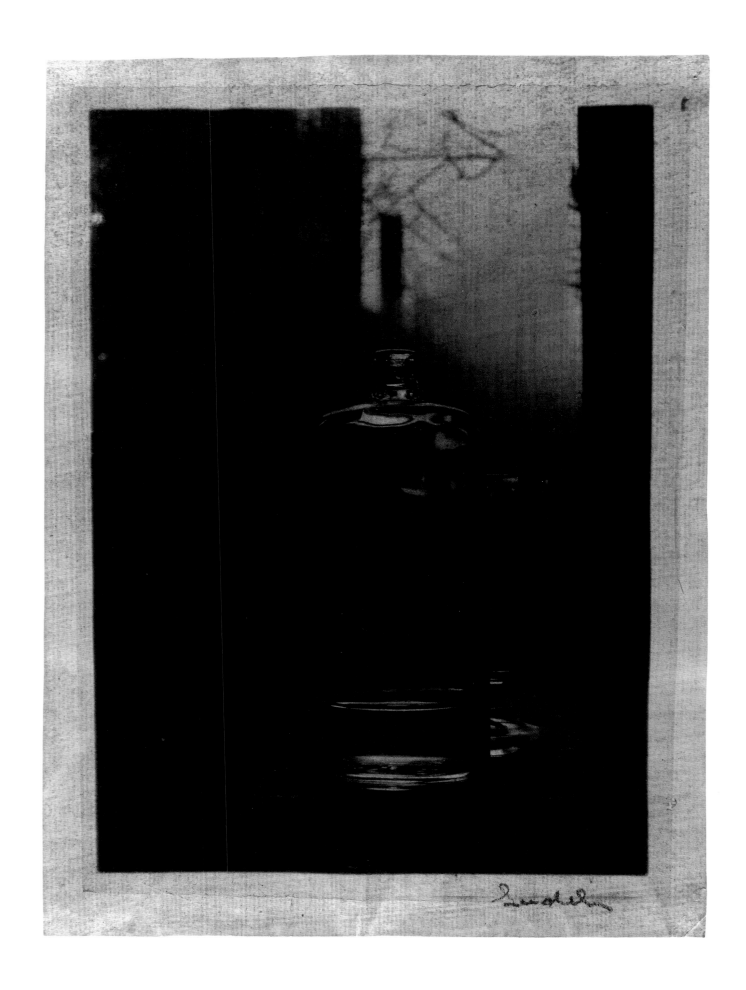

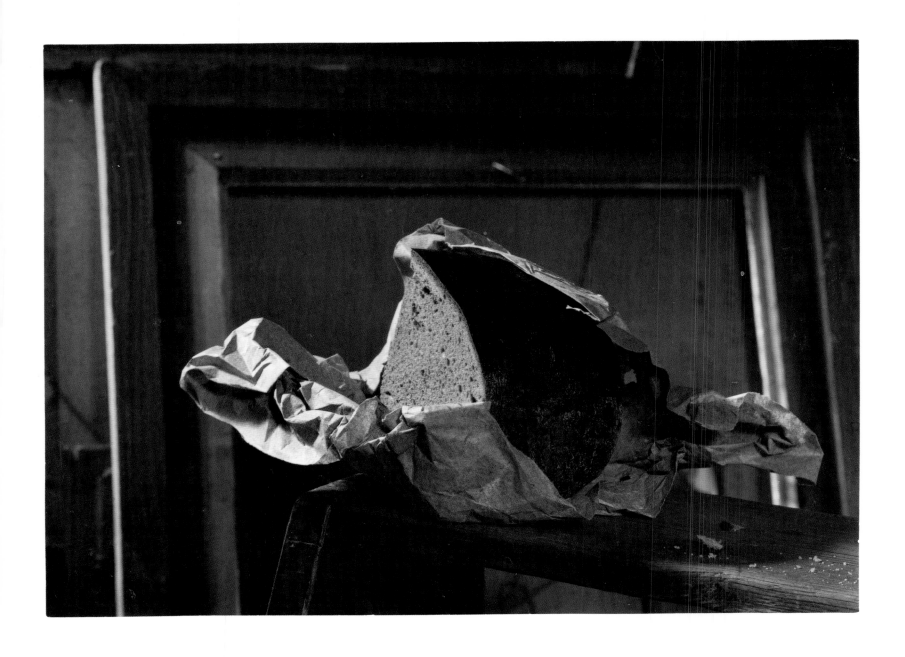

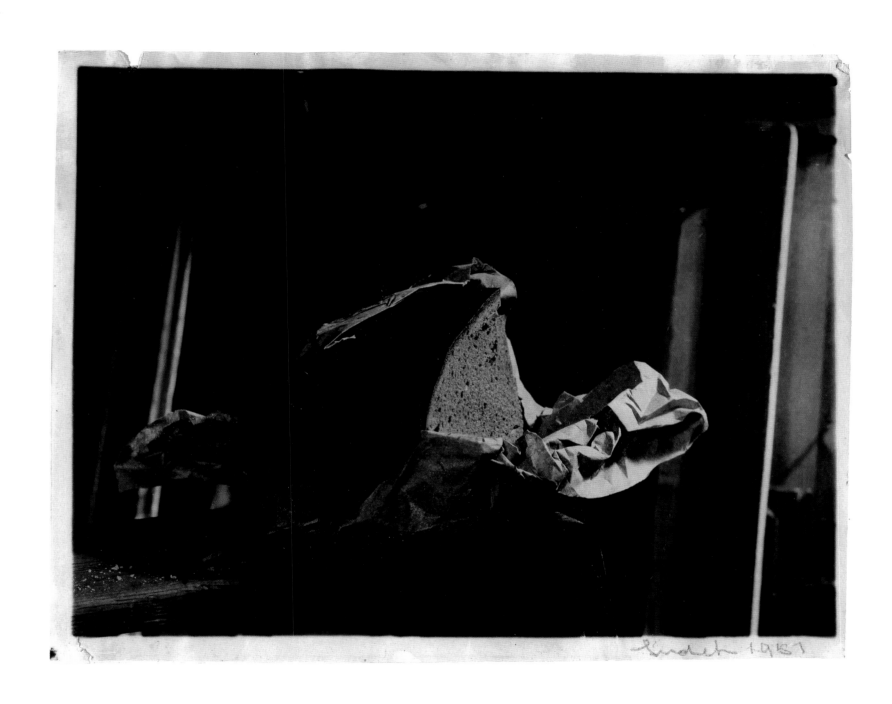

141

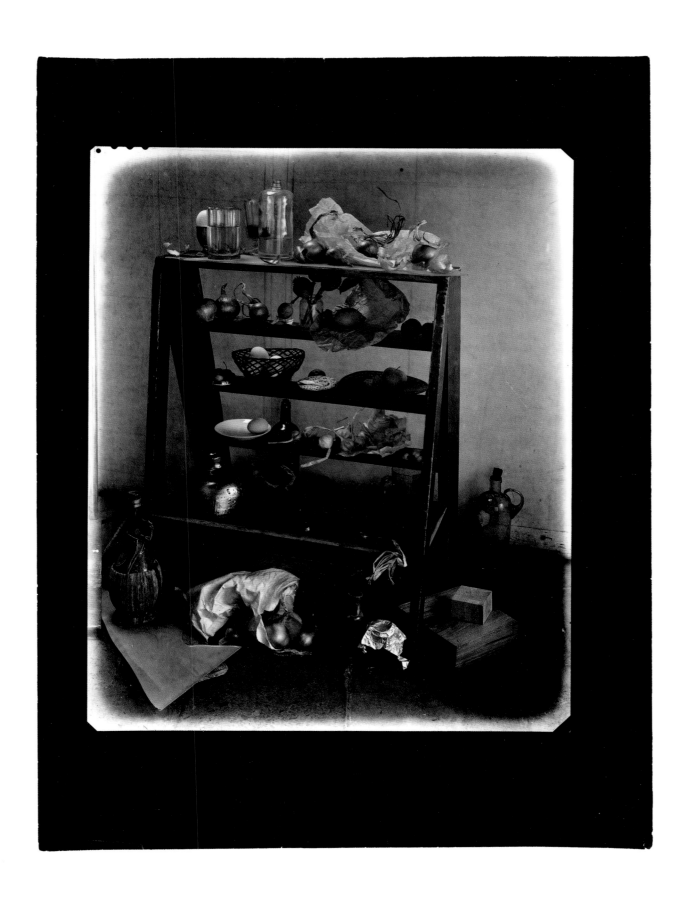

143

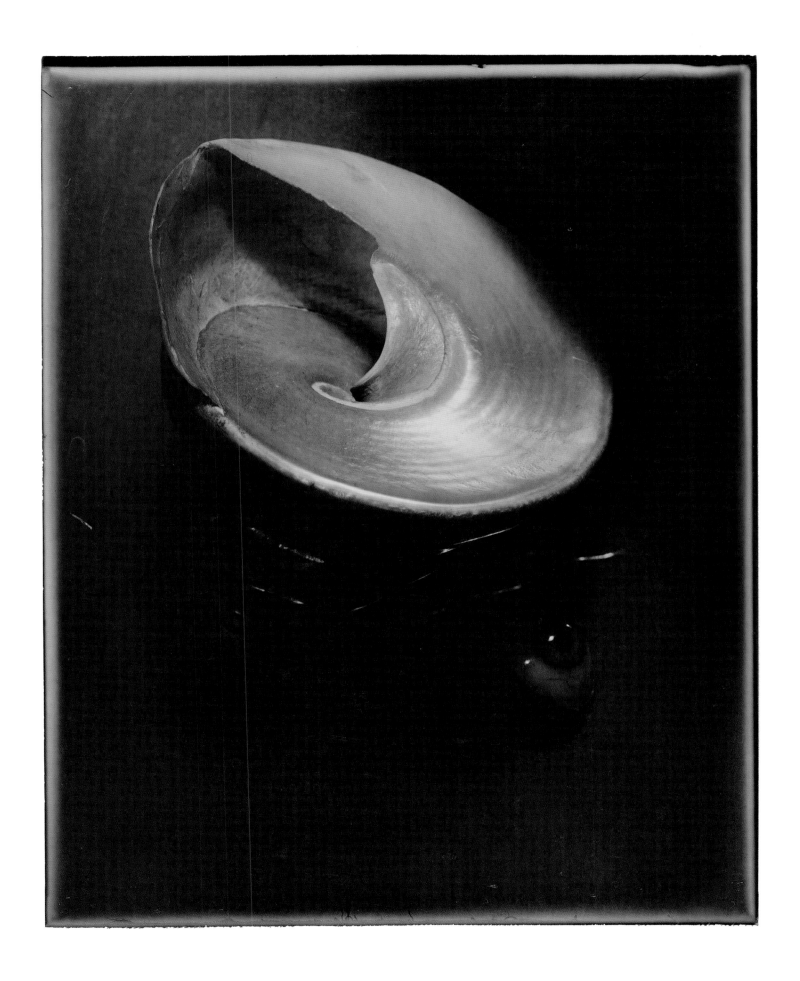

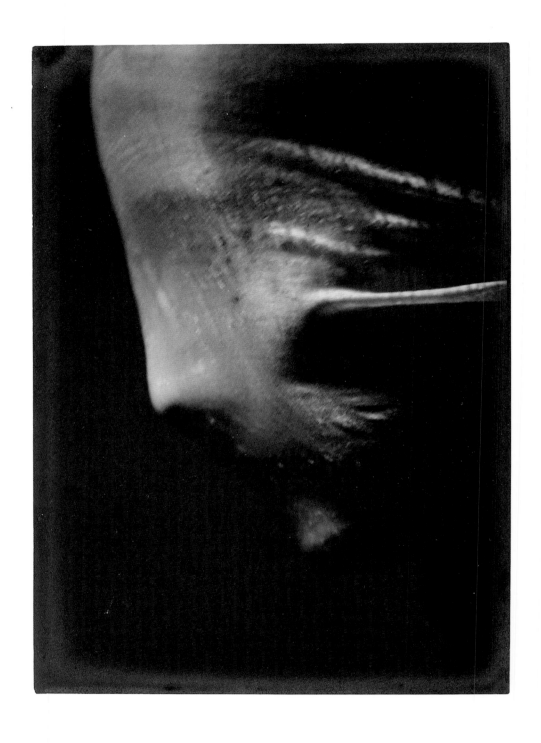

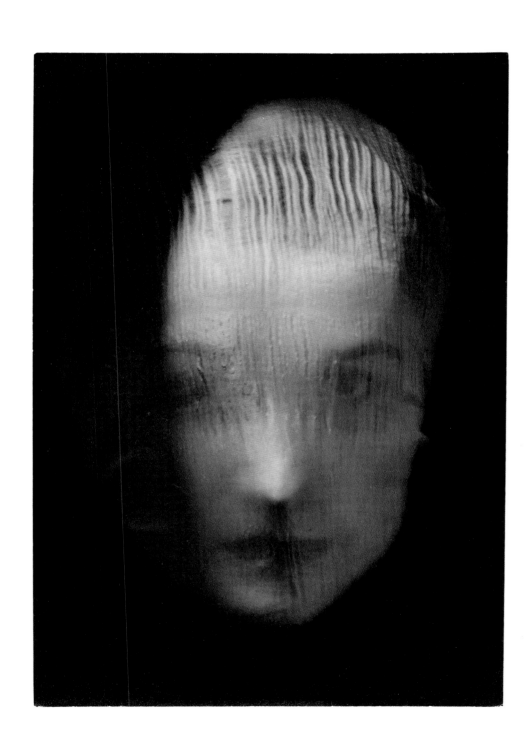

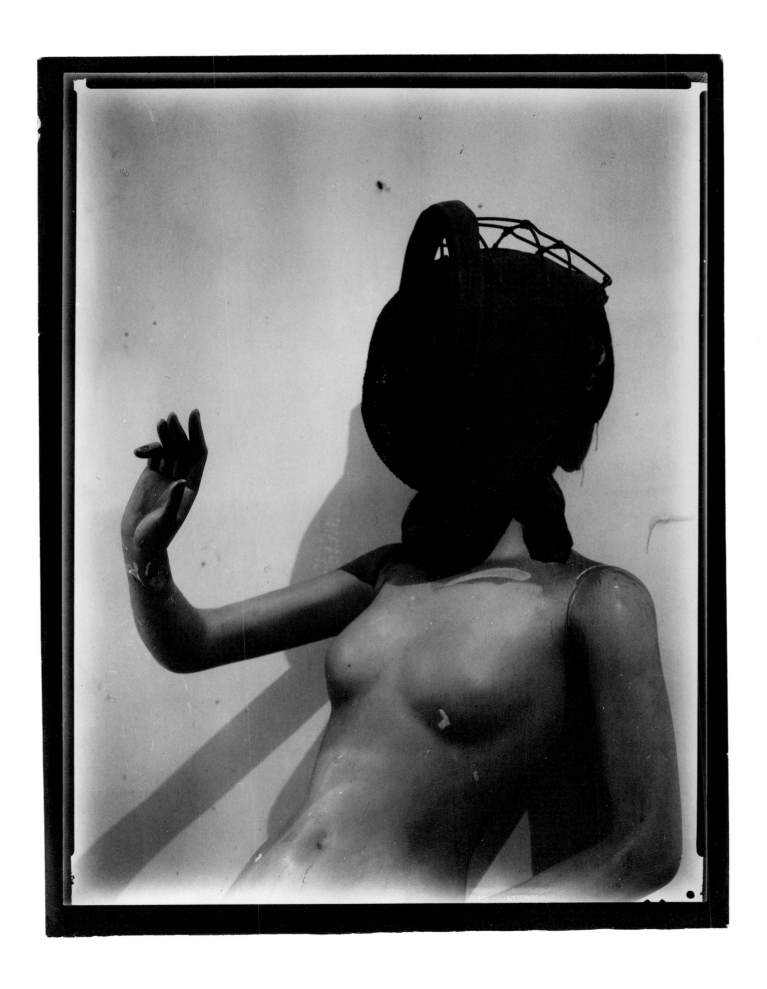

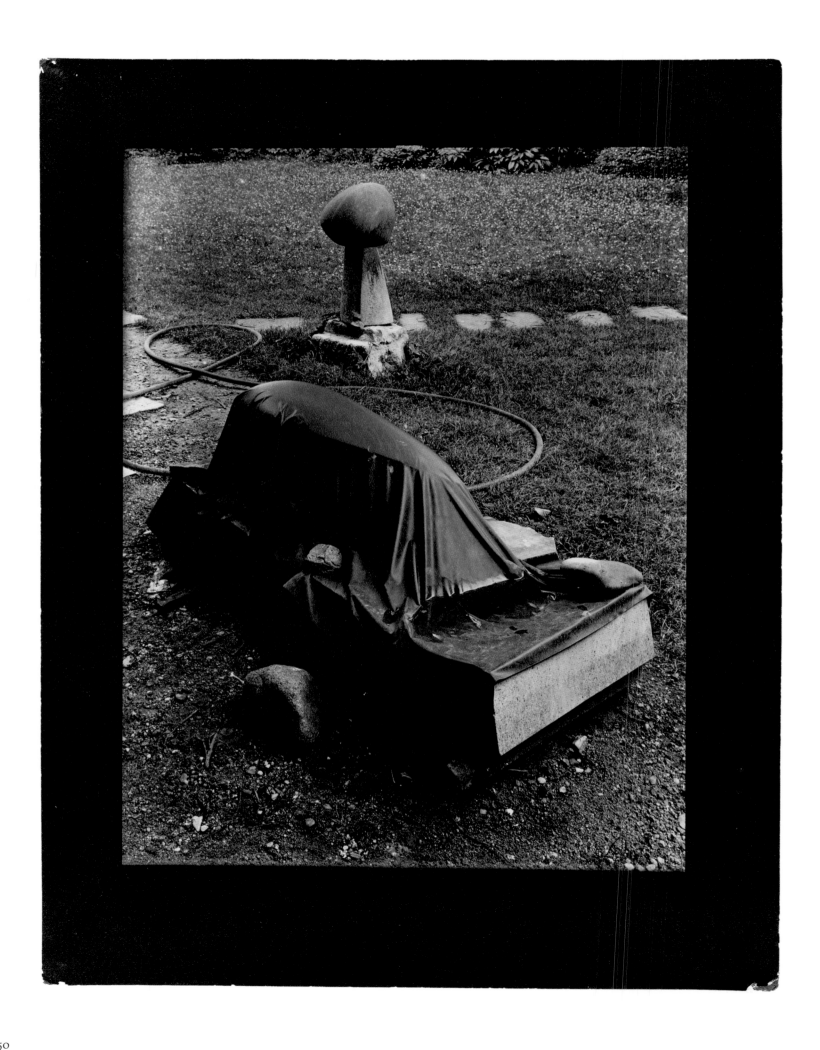

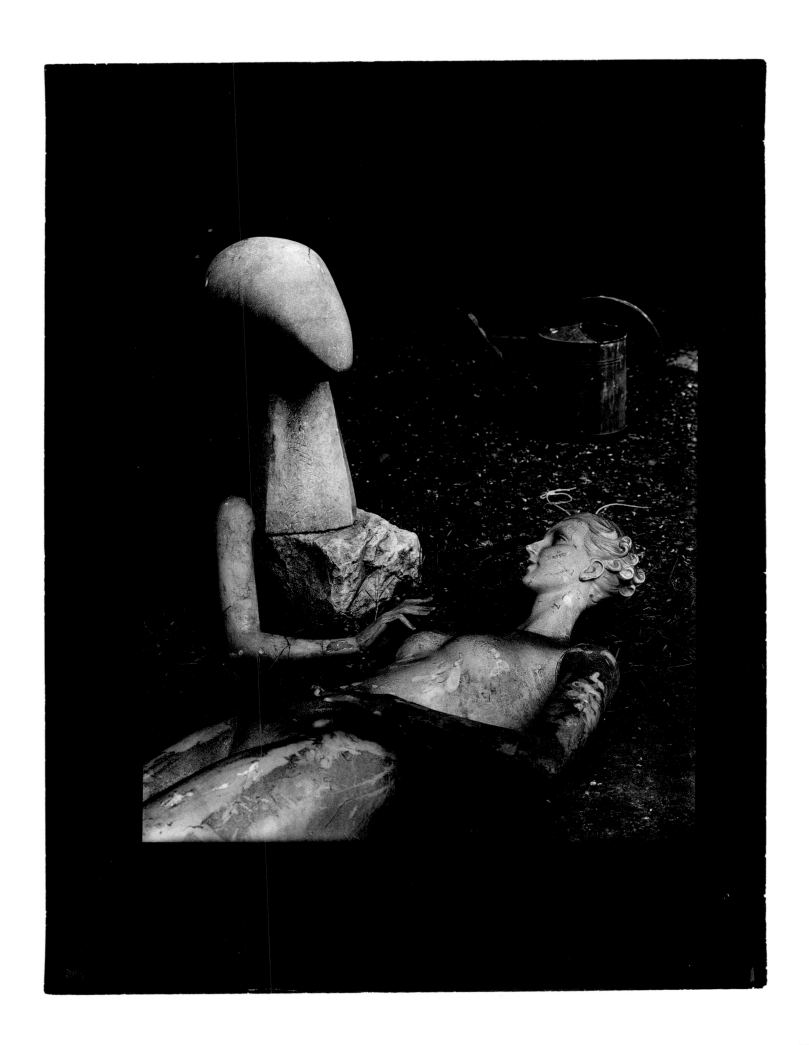

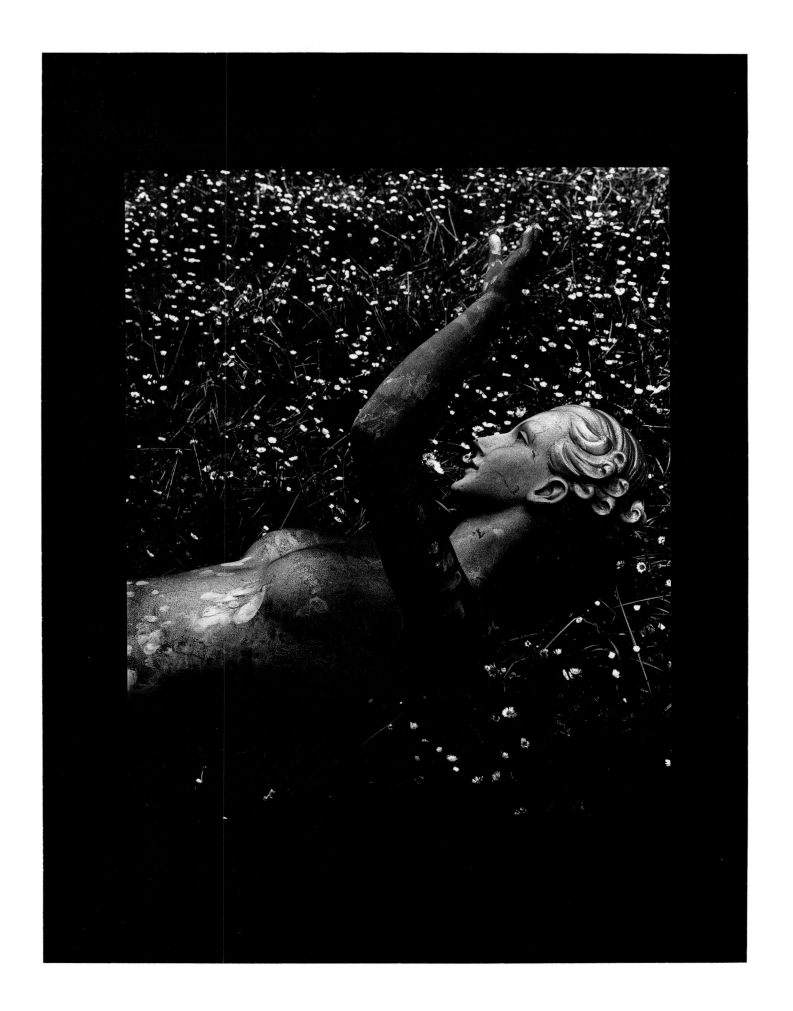

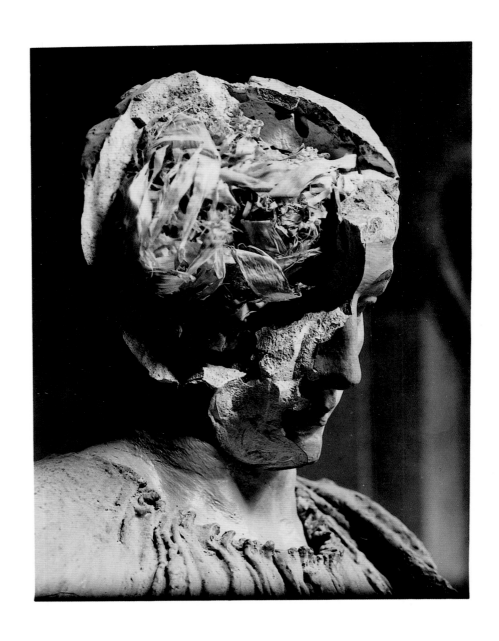

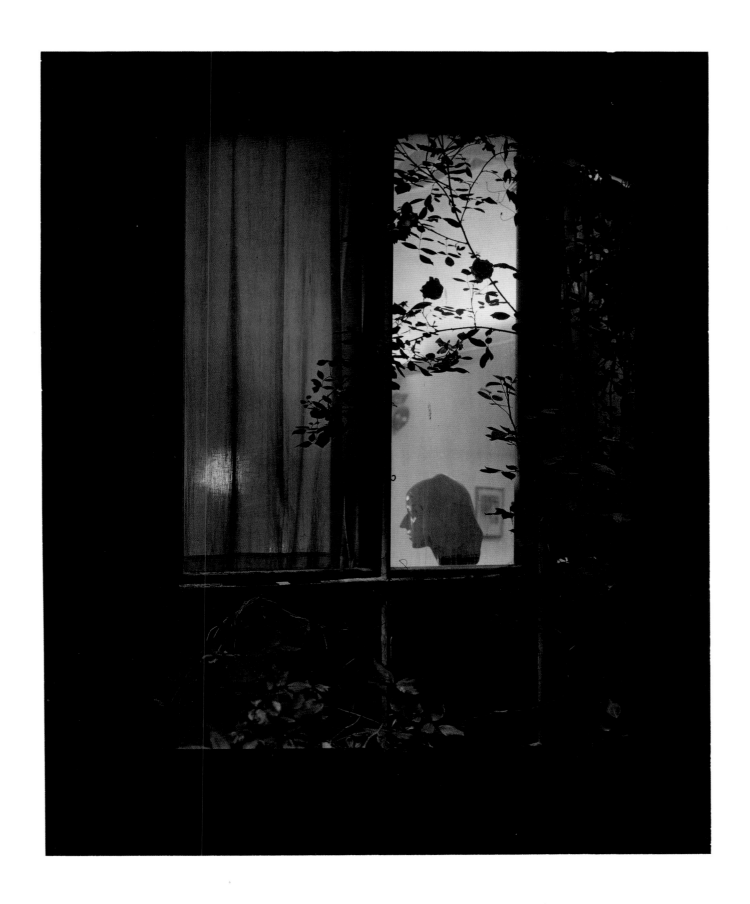

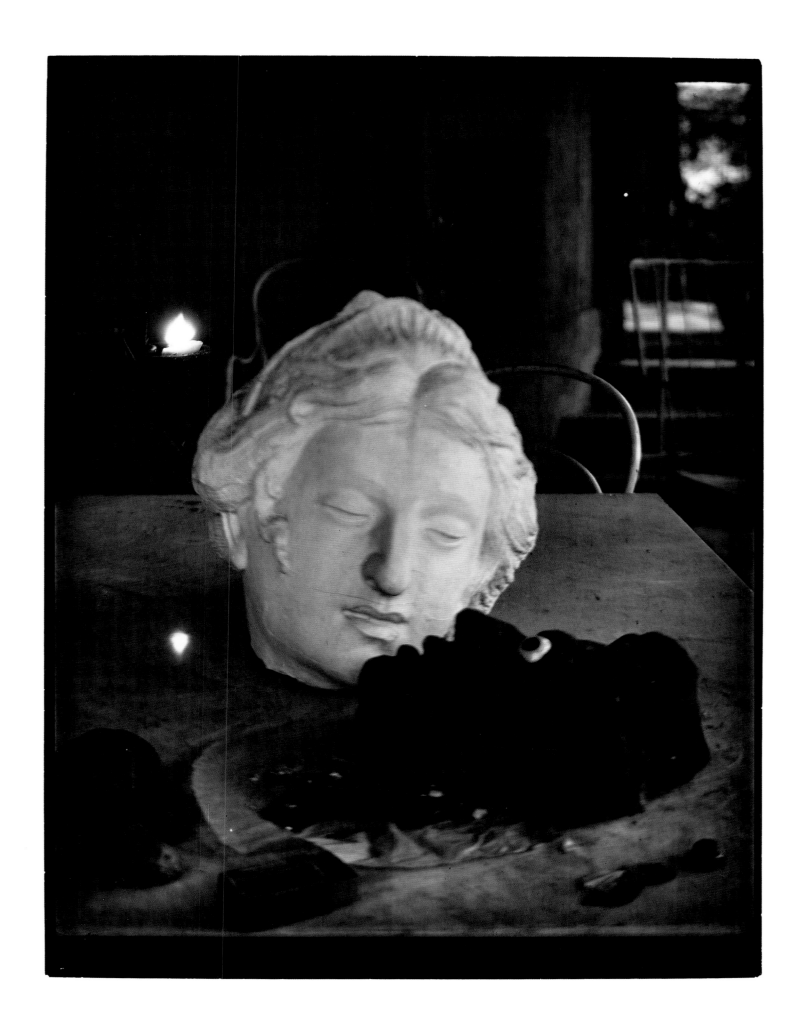

157

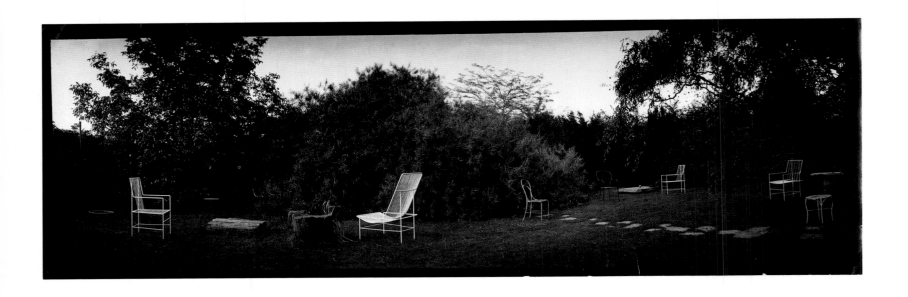

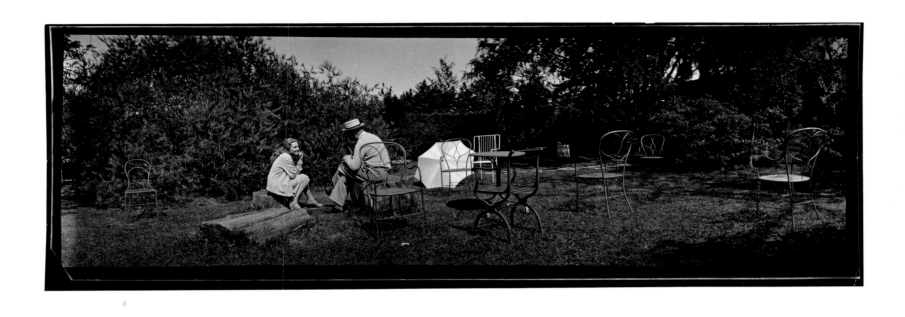

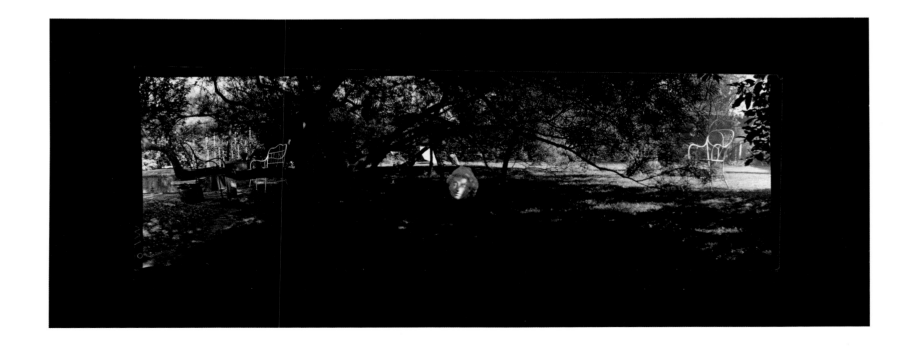

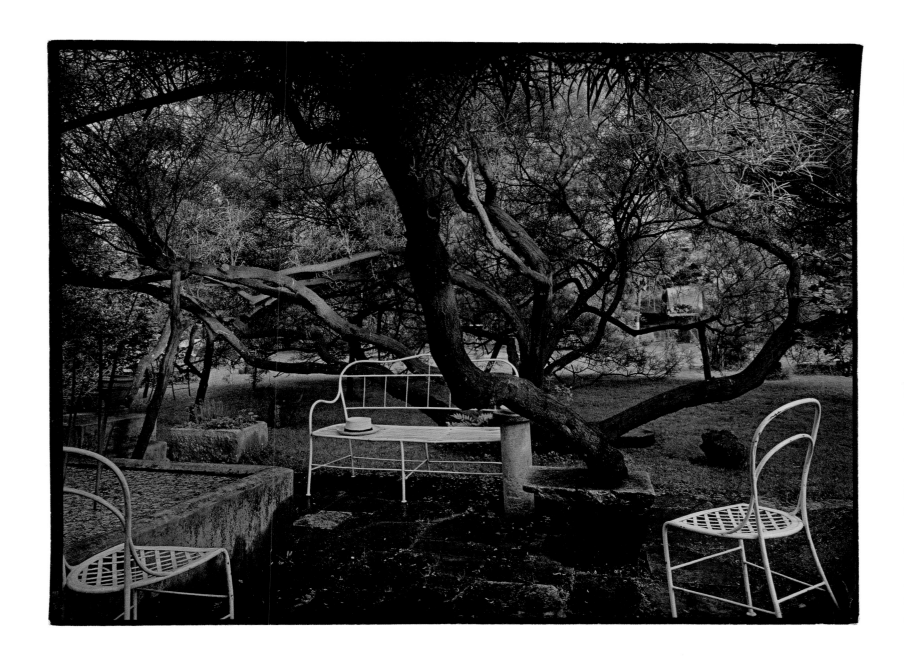

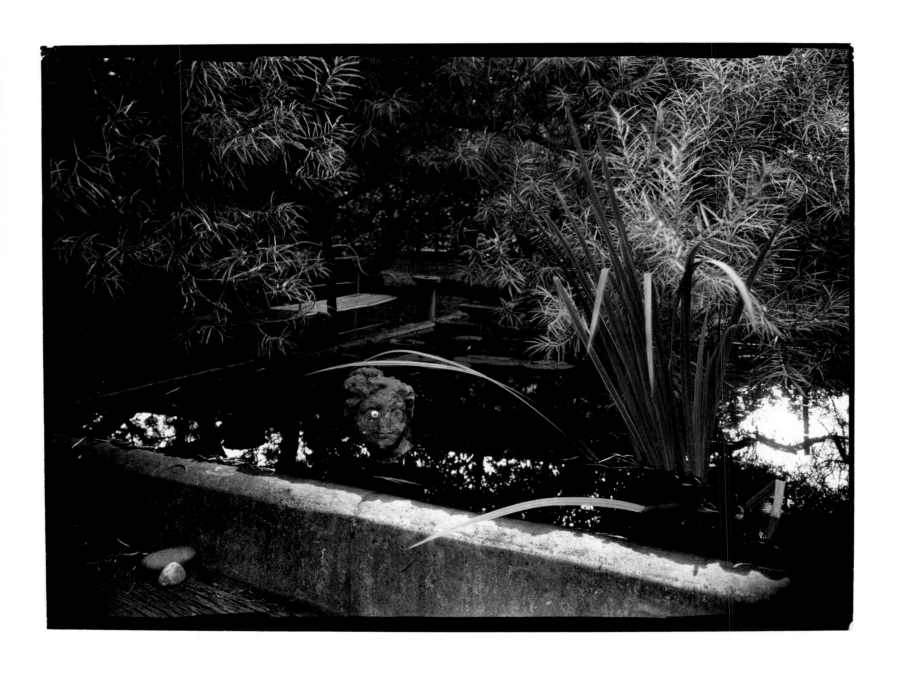

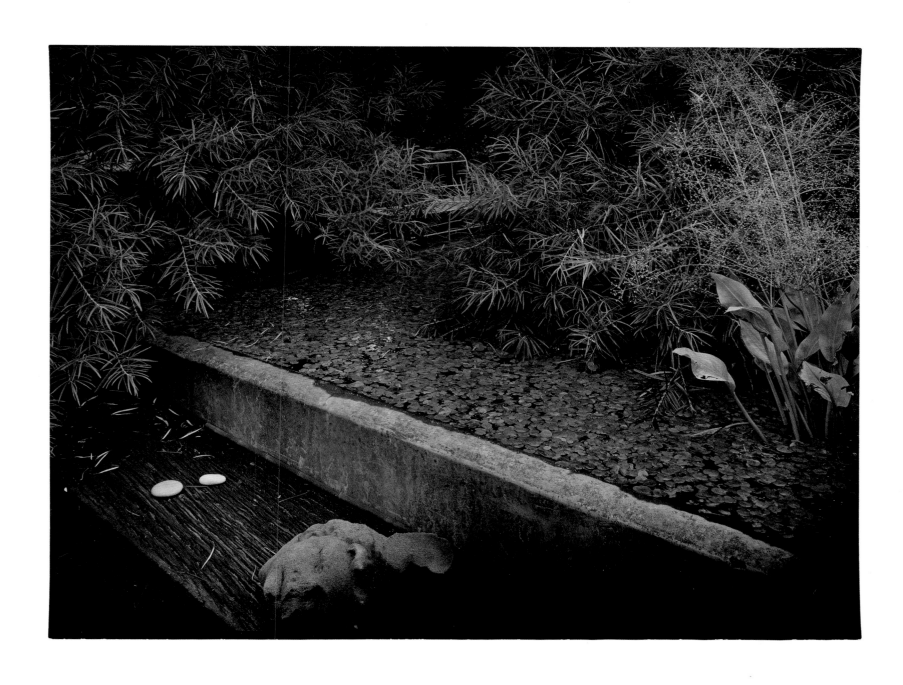

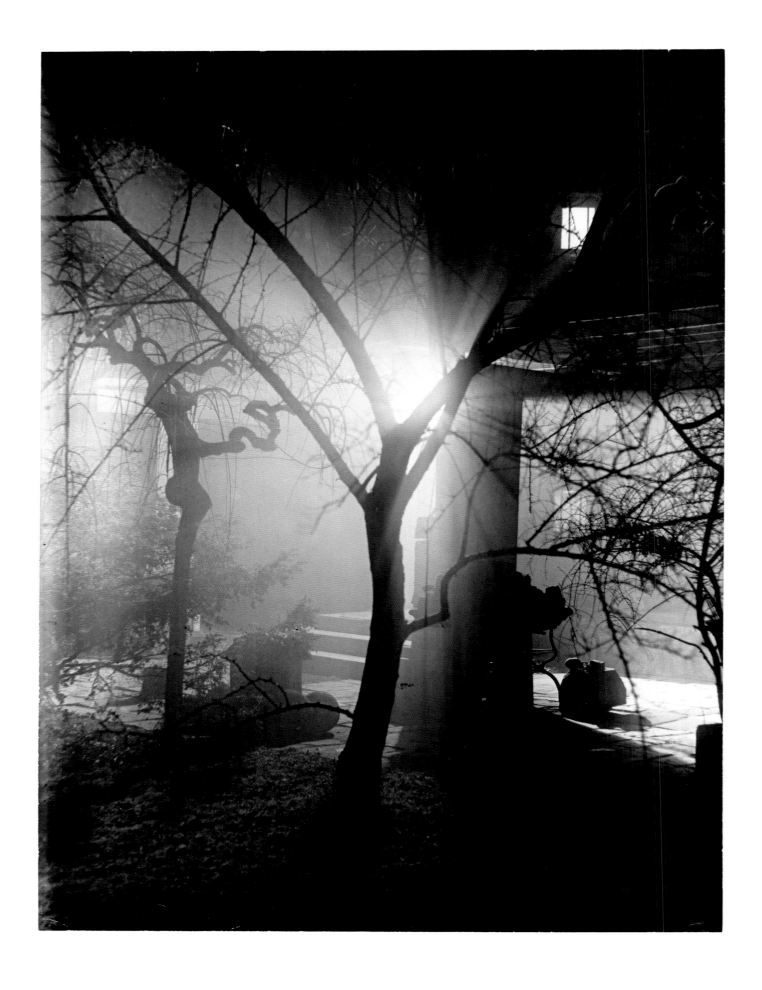

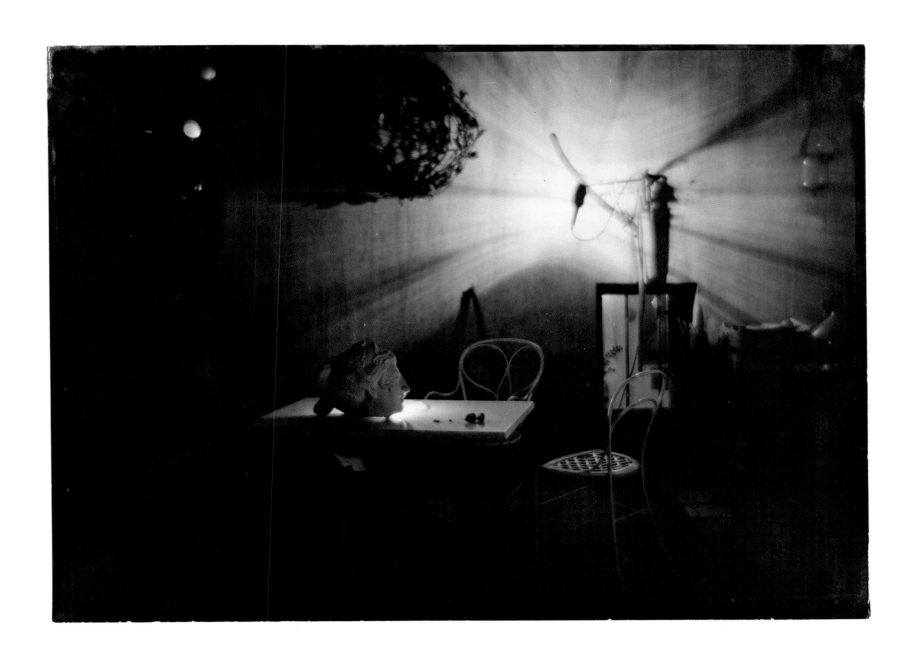

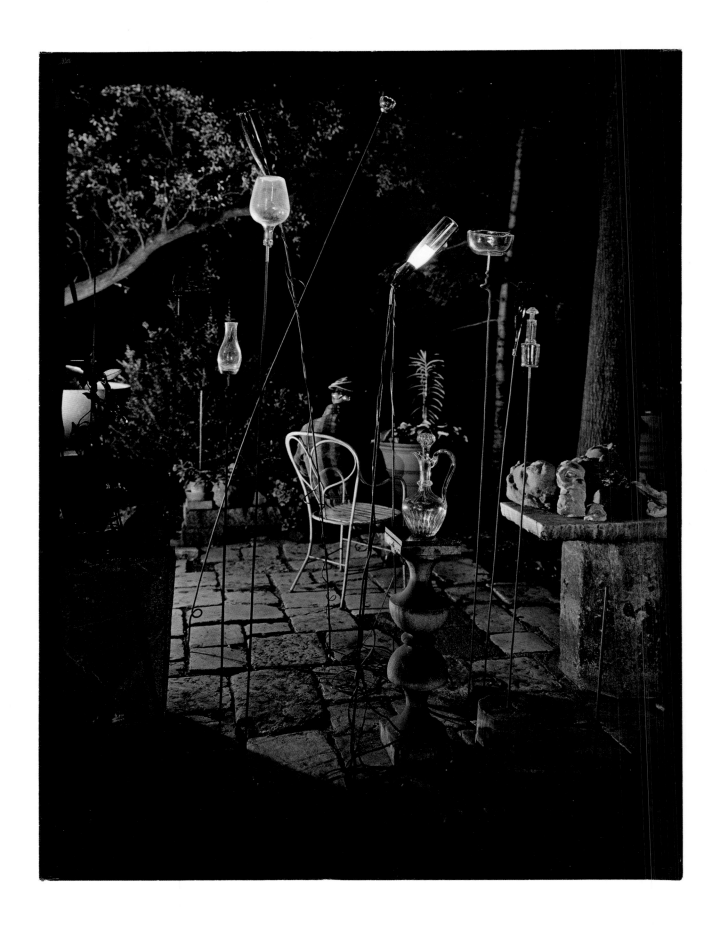

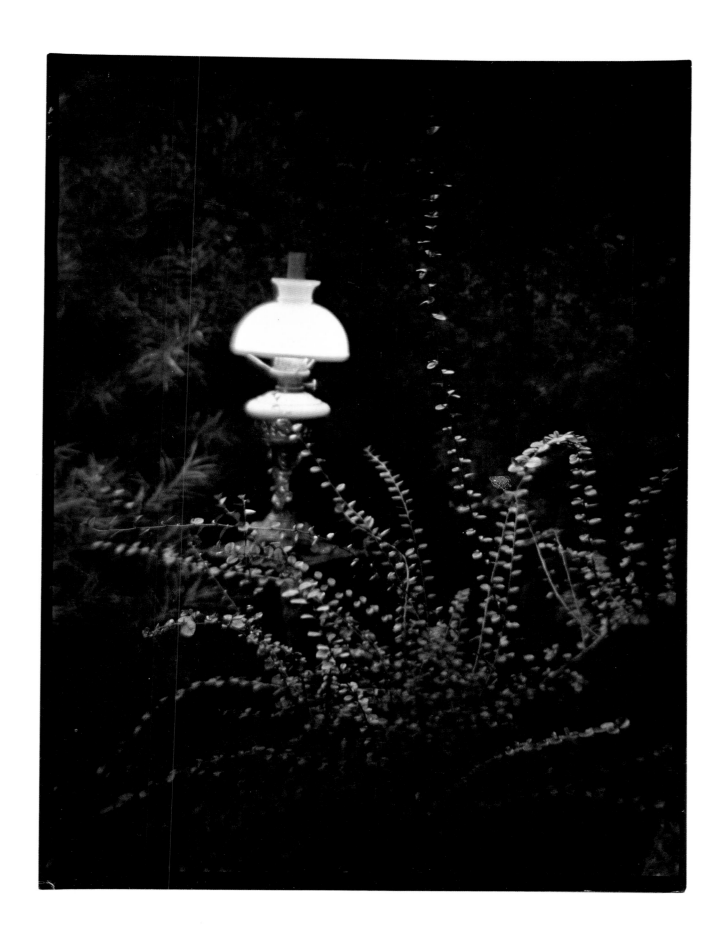

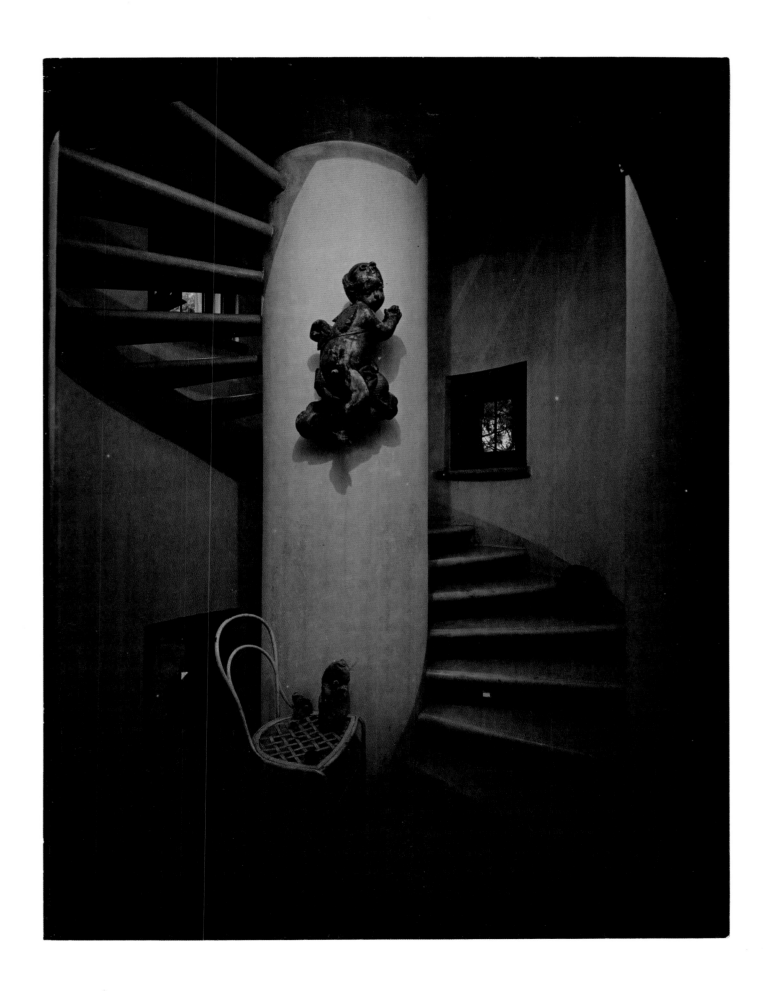

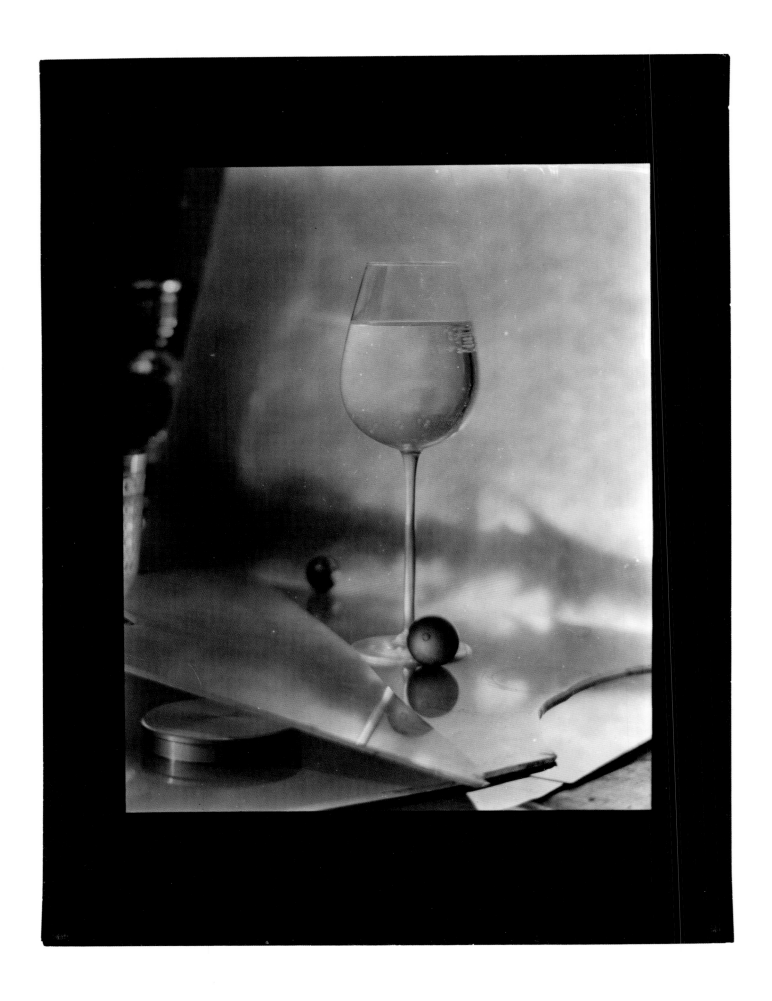

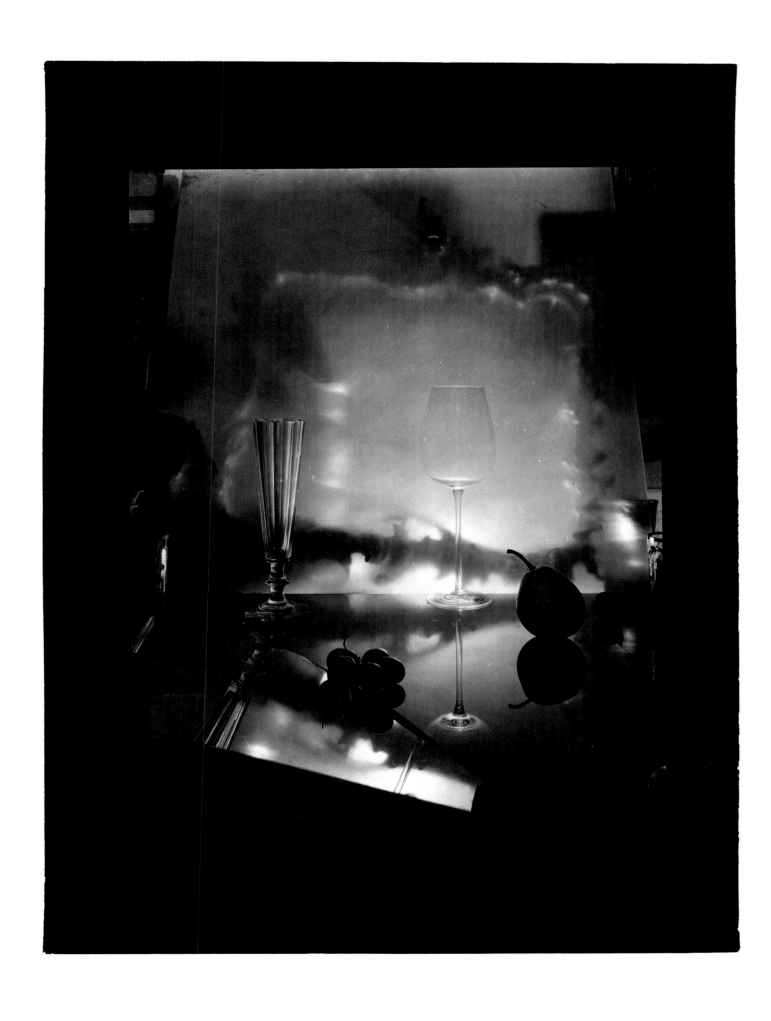

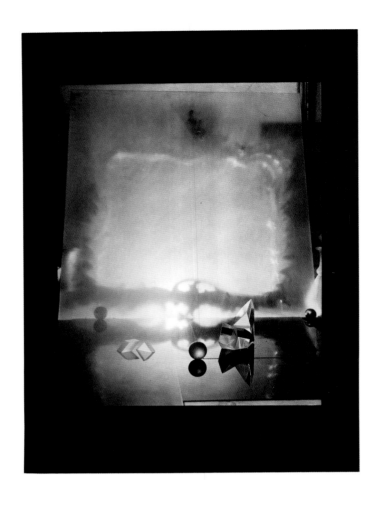
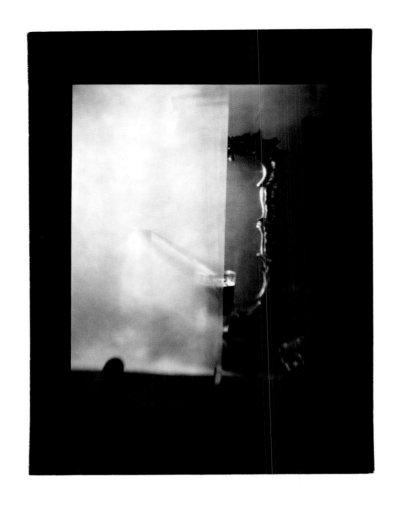
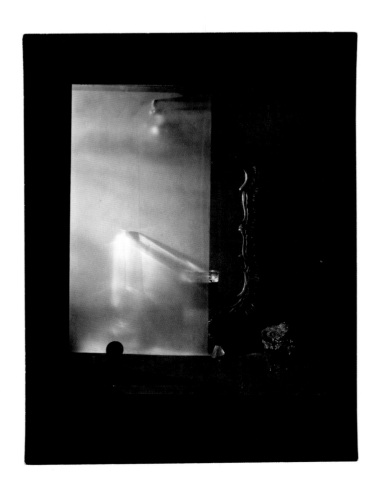
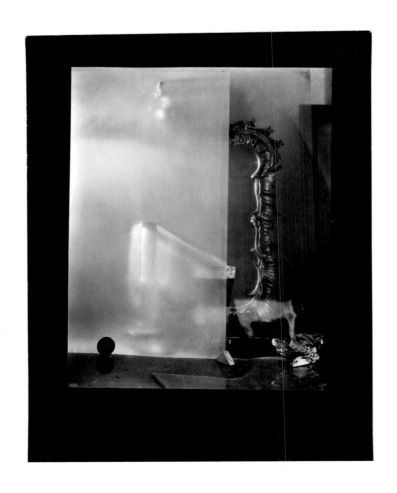

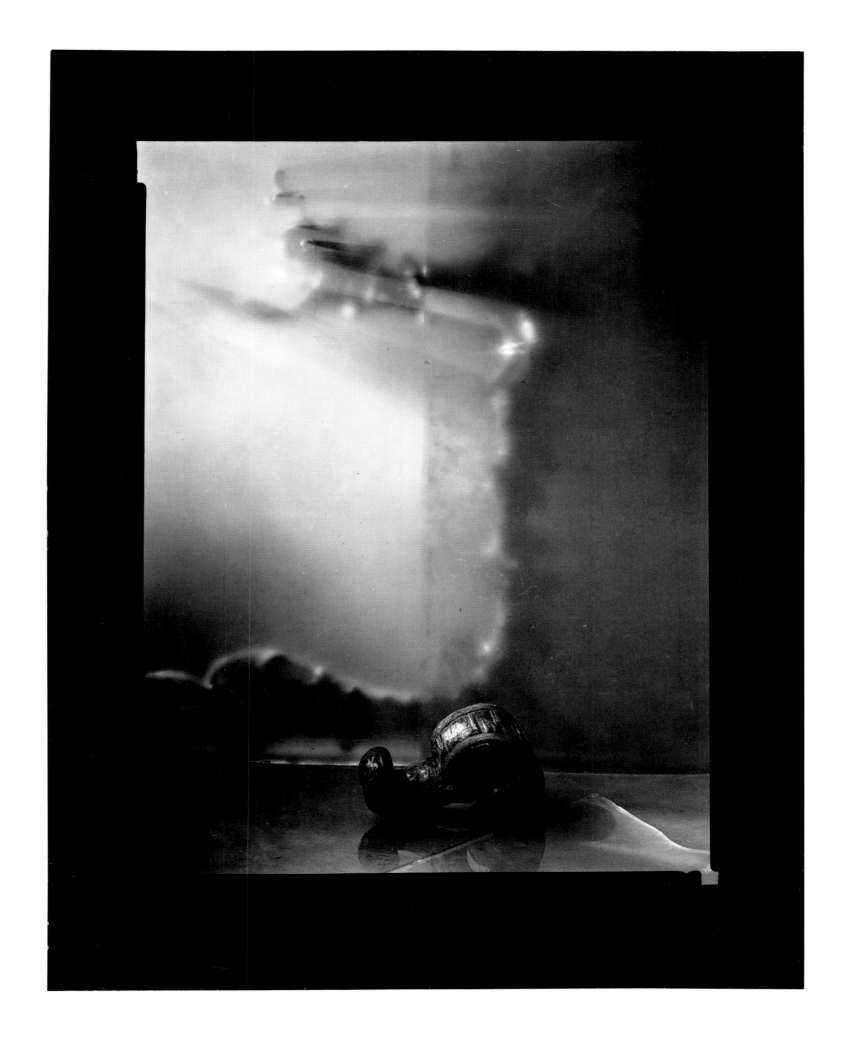

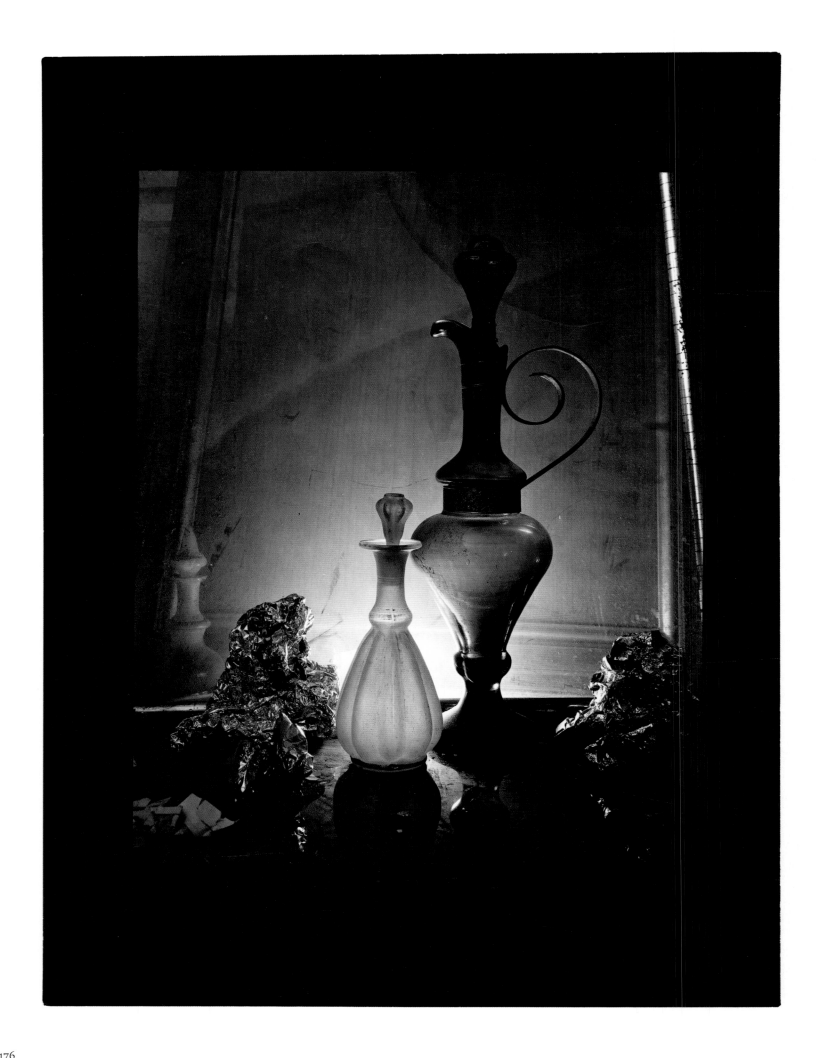

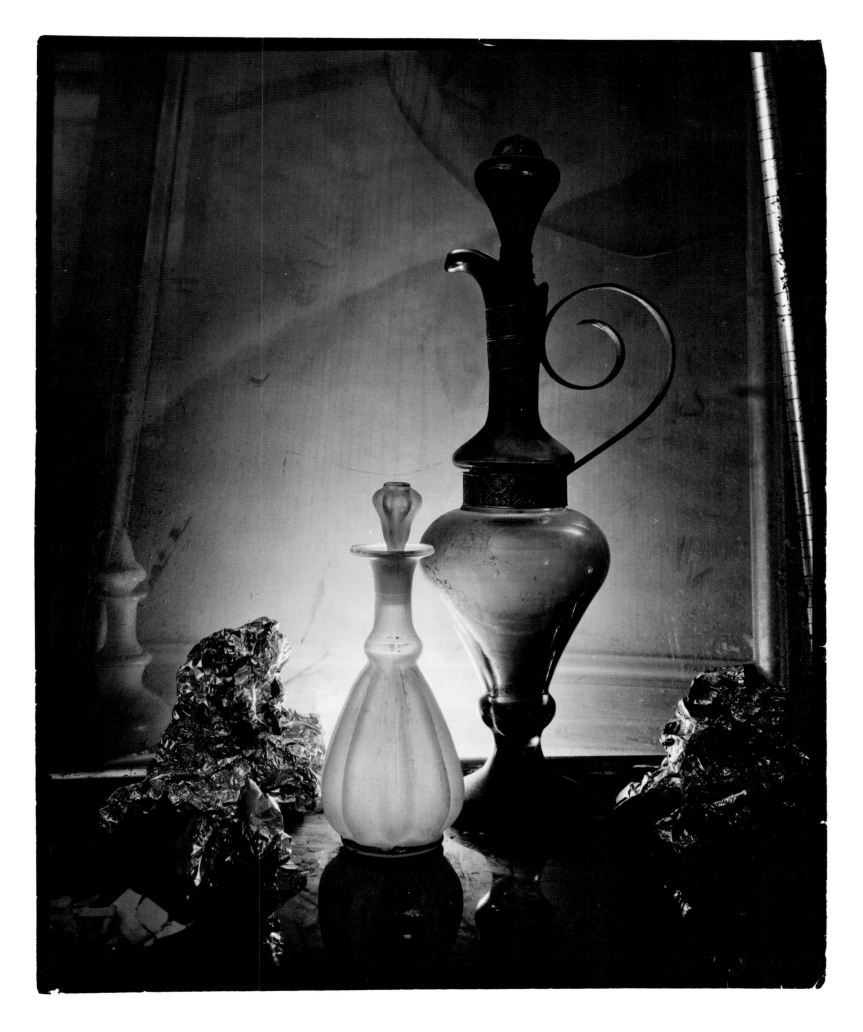

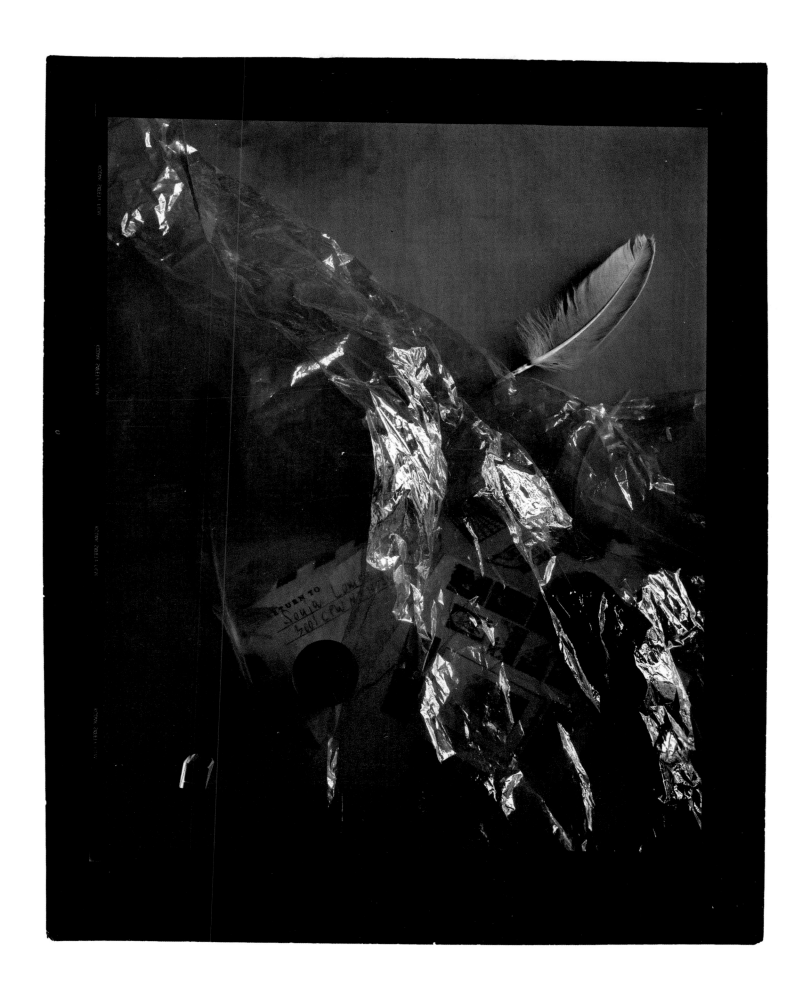

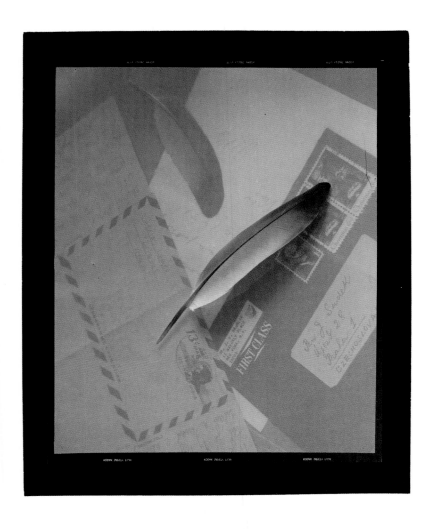
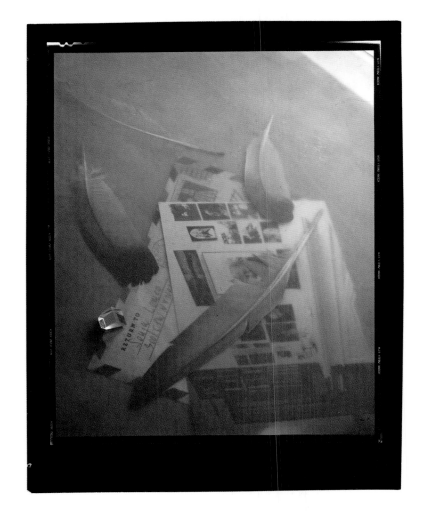

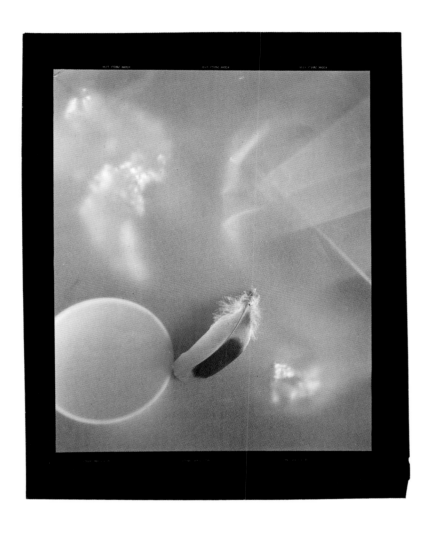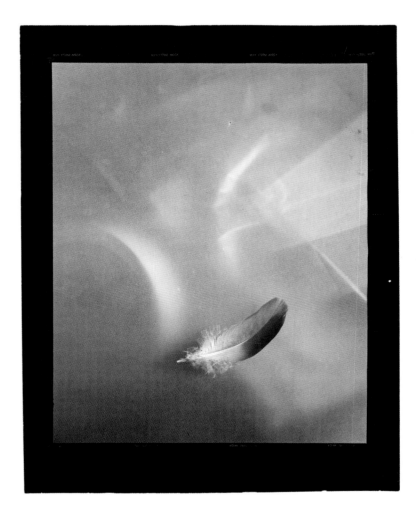

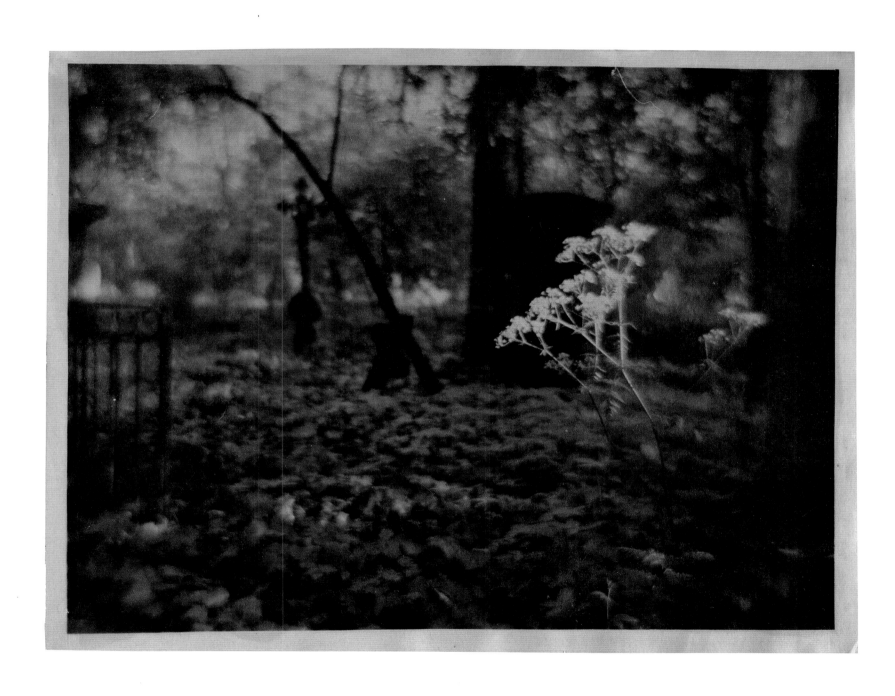

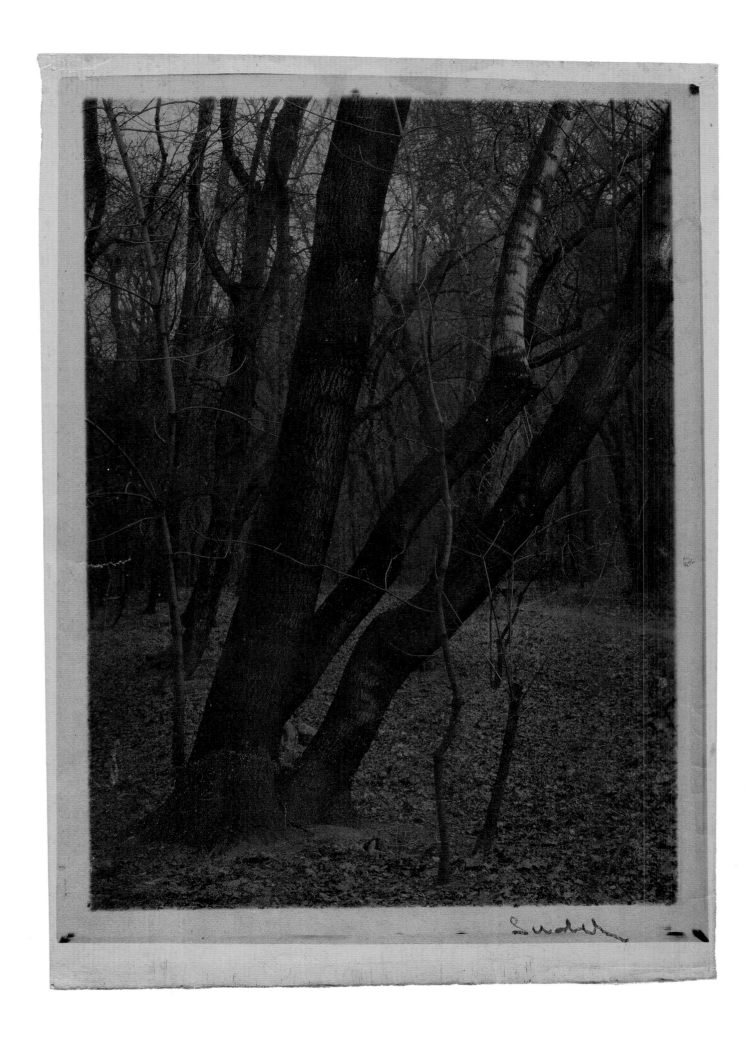

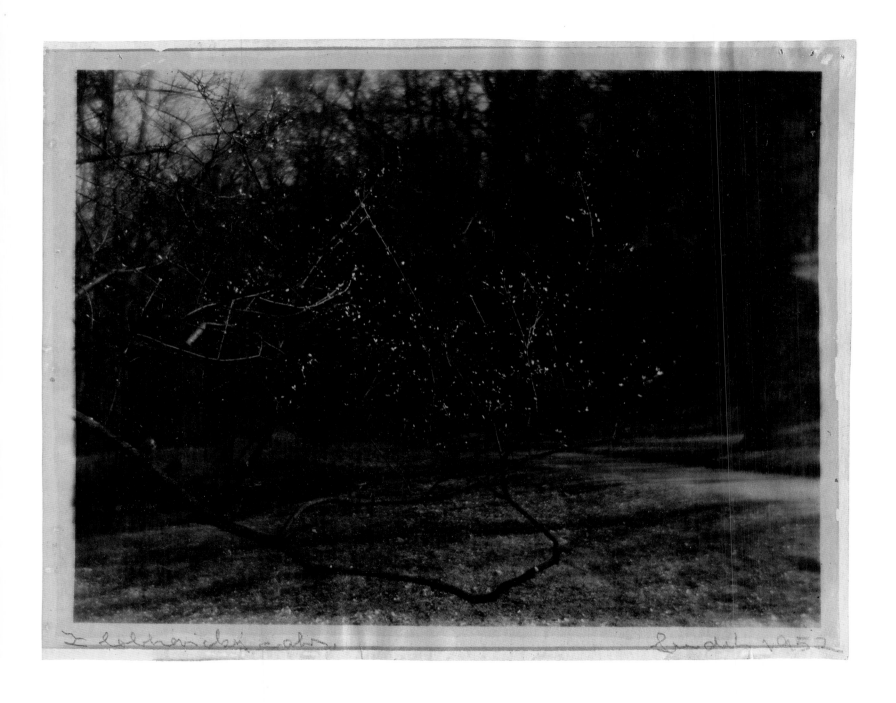

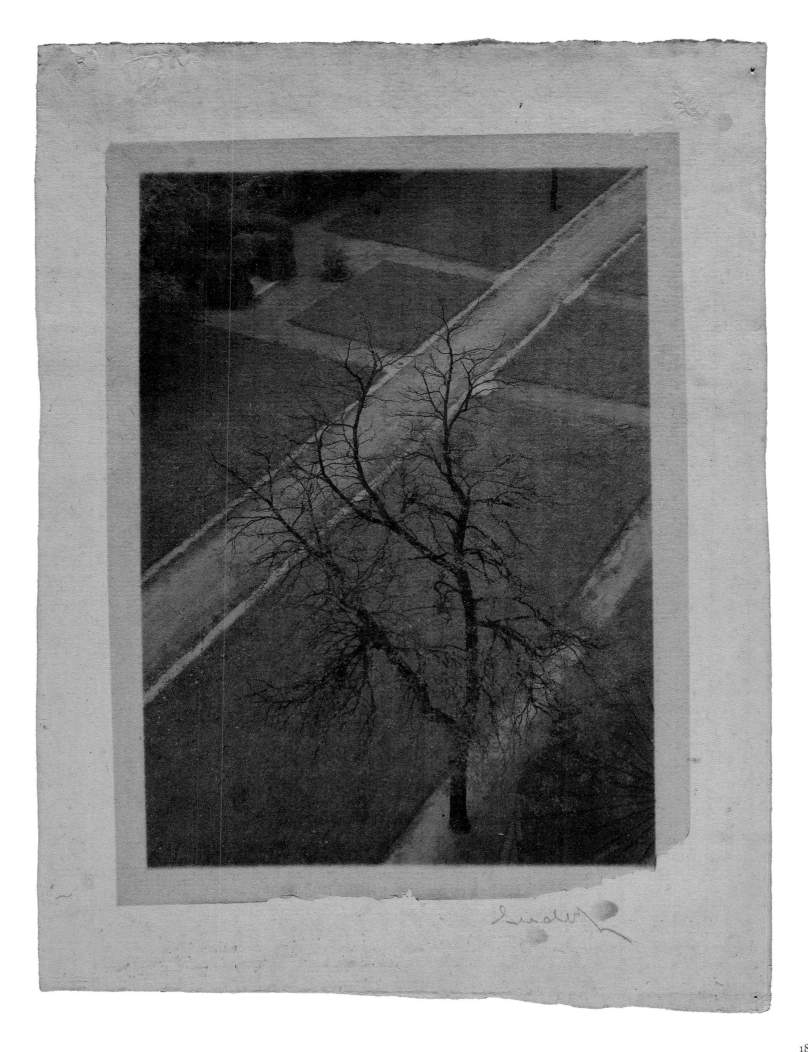

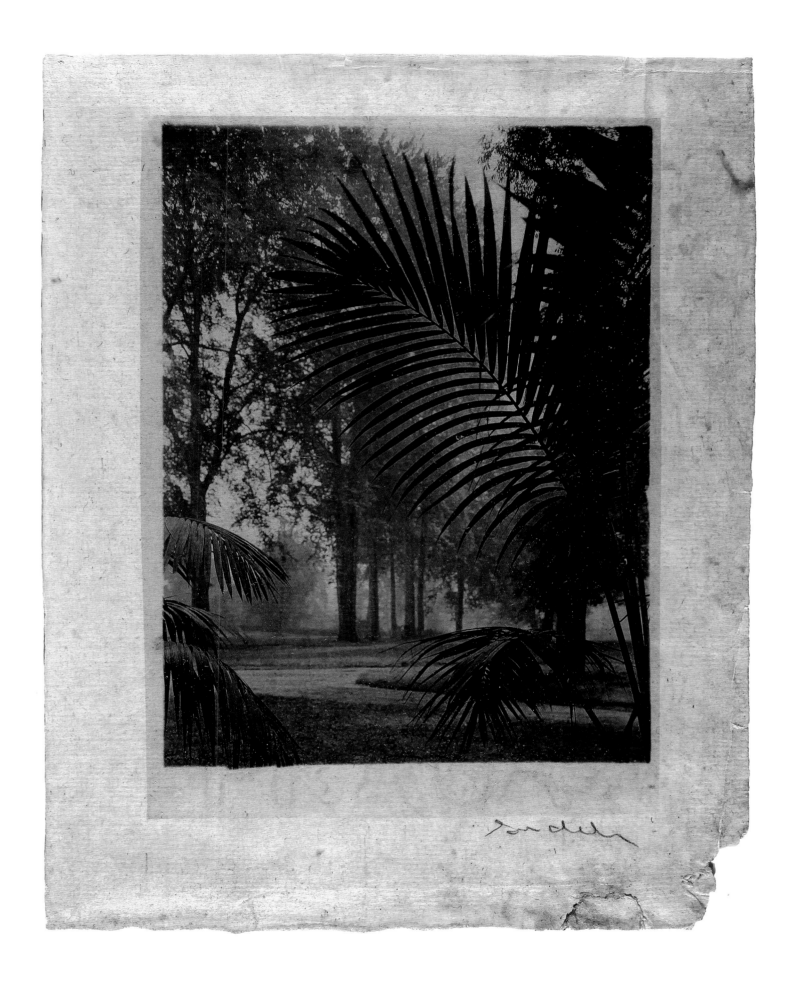

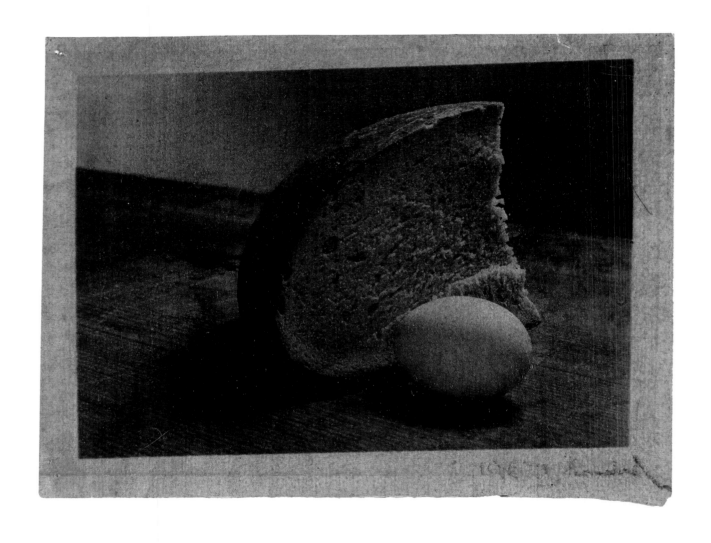

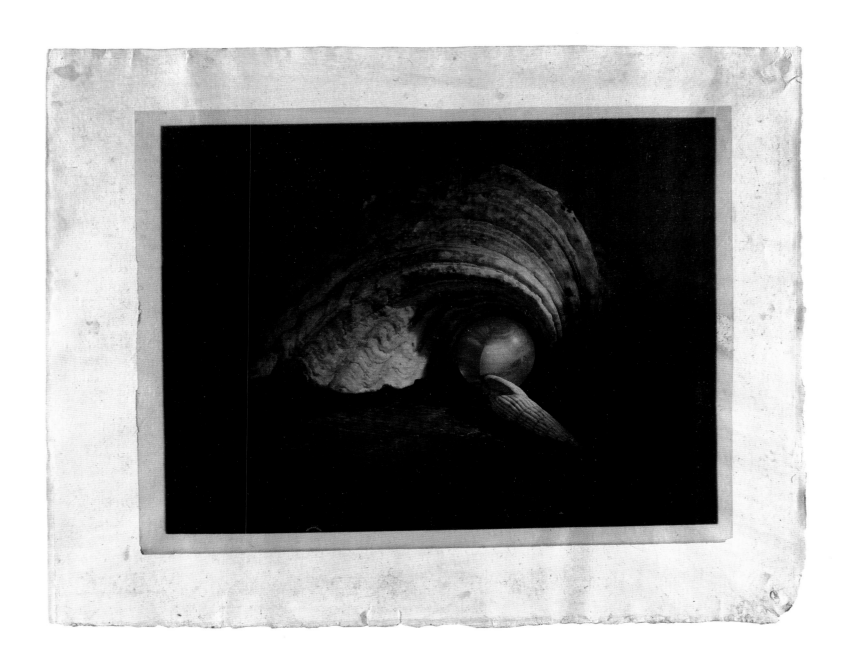

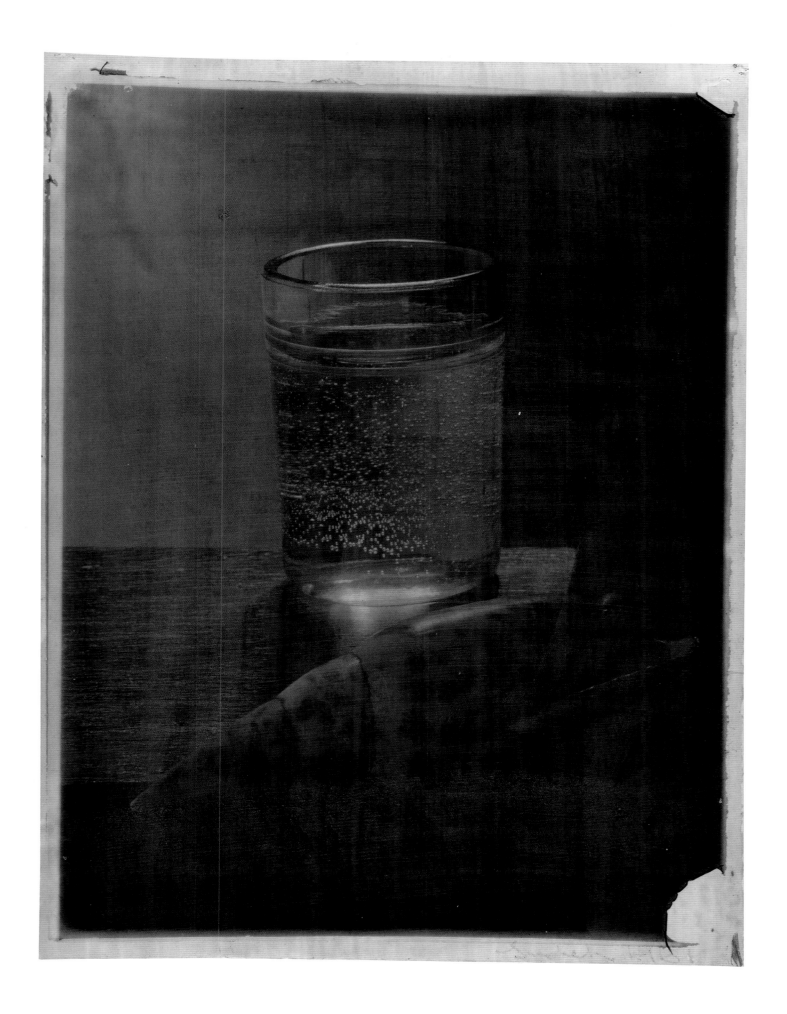

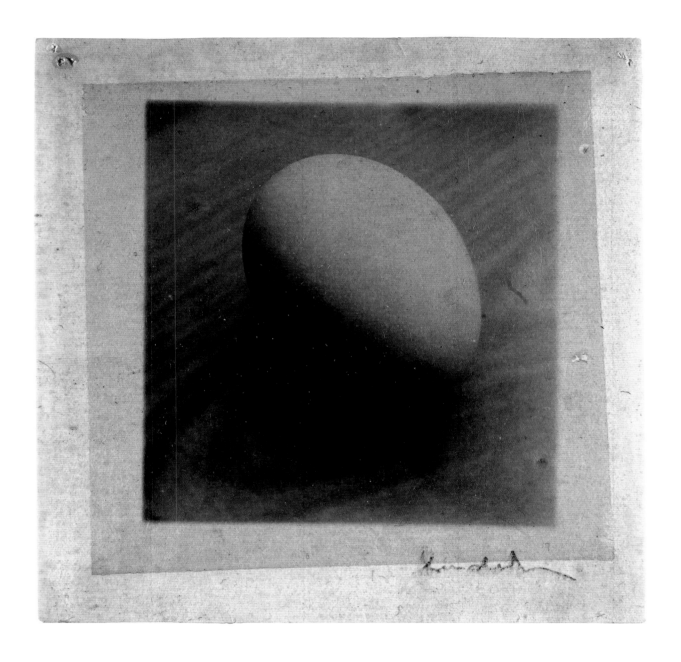

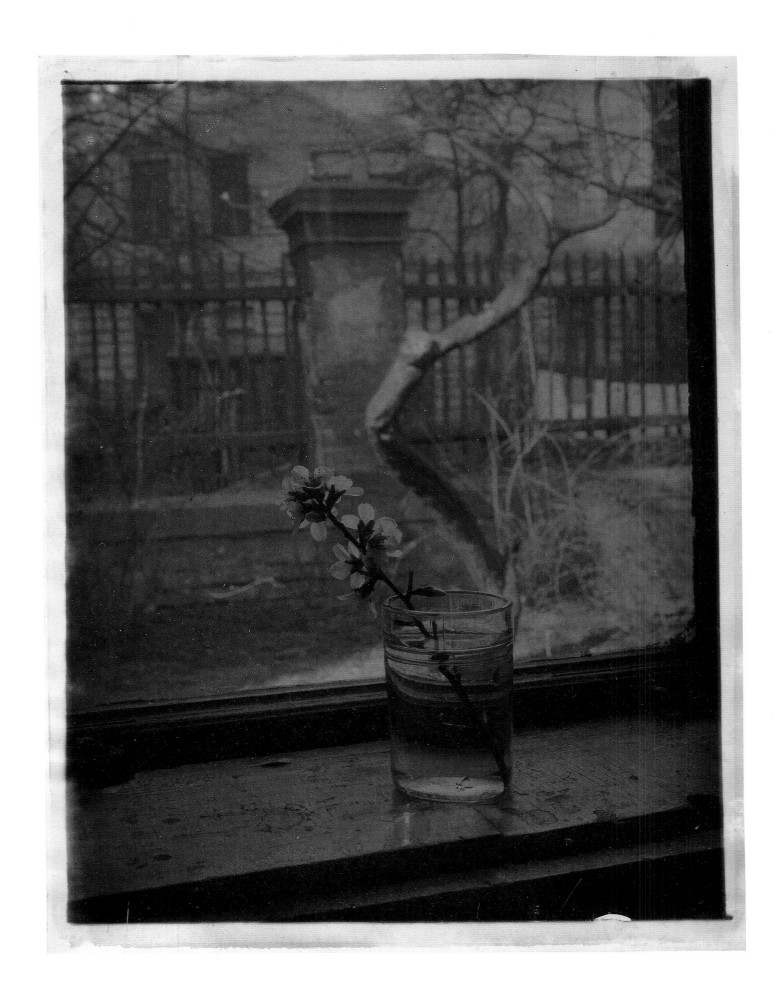

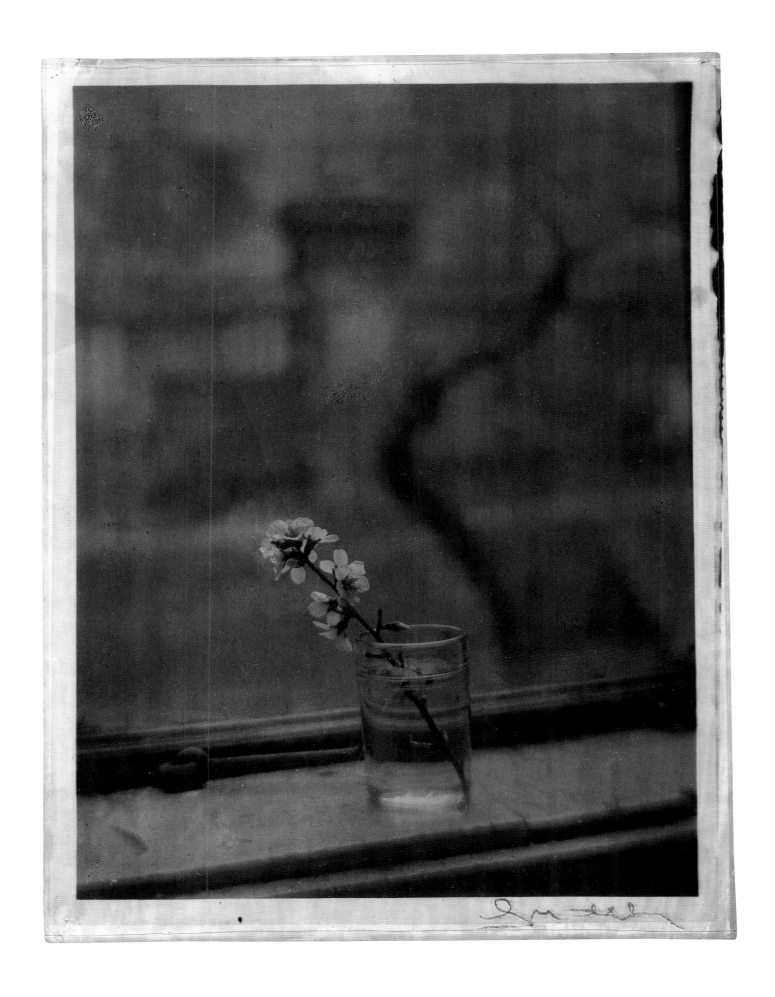

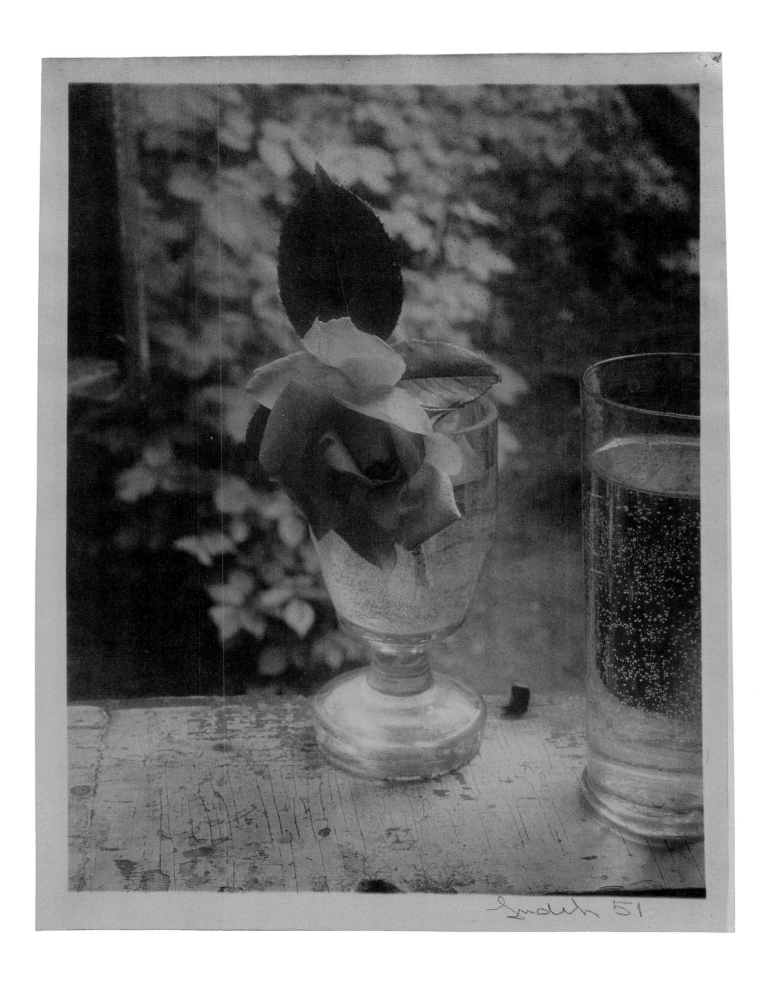

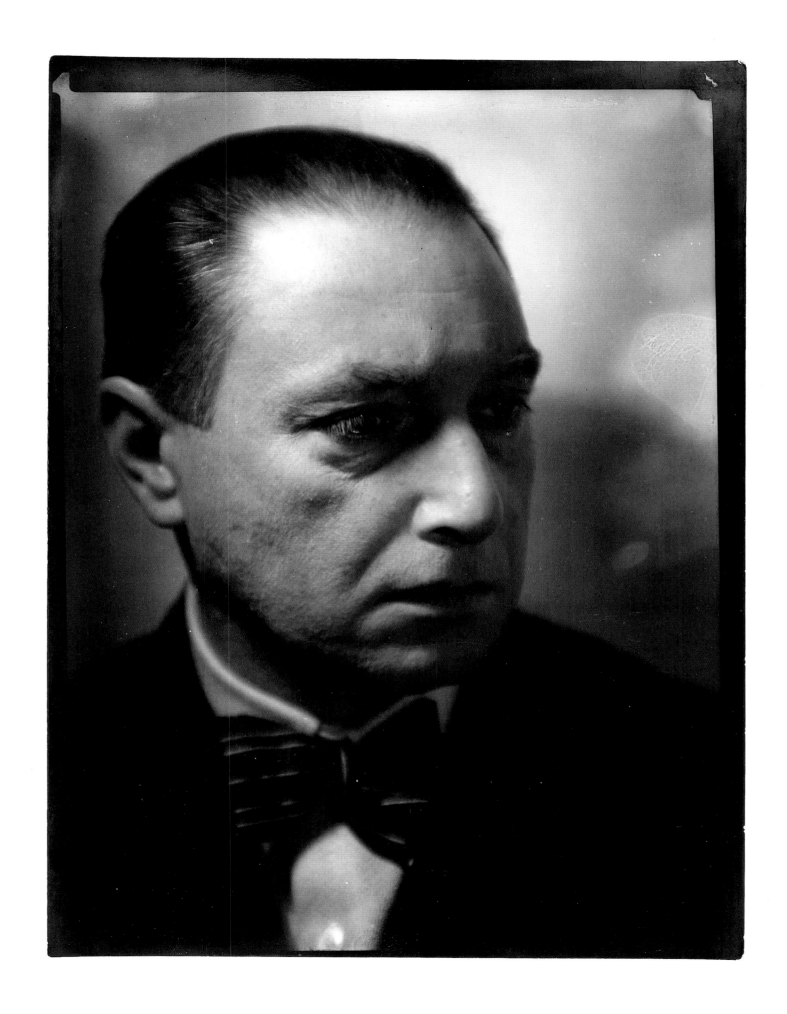

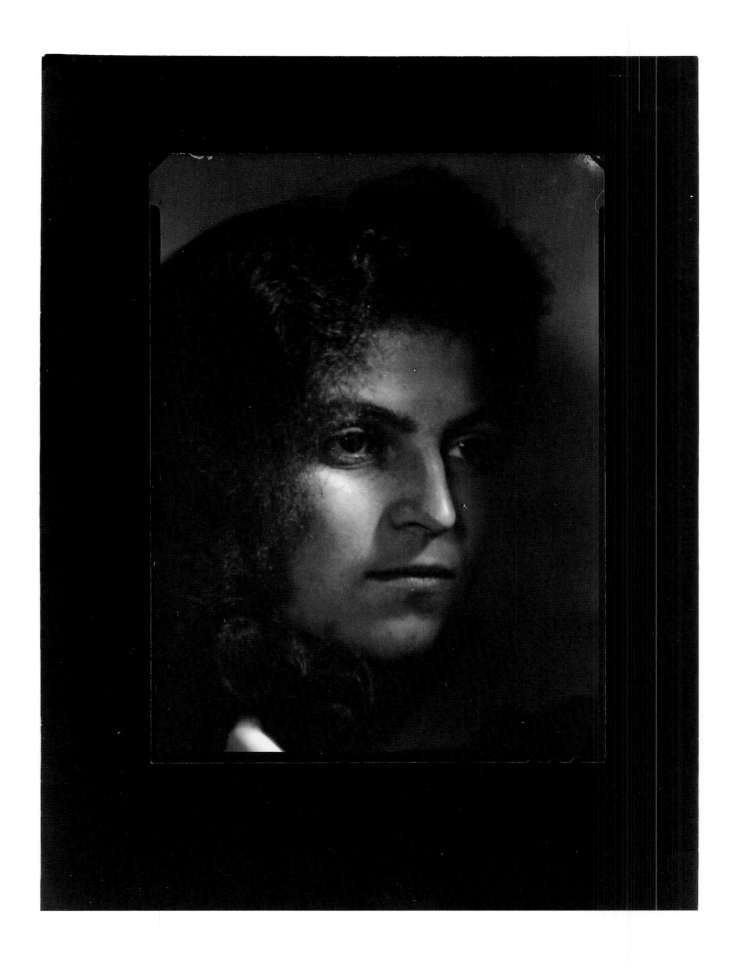

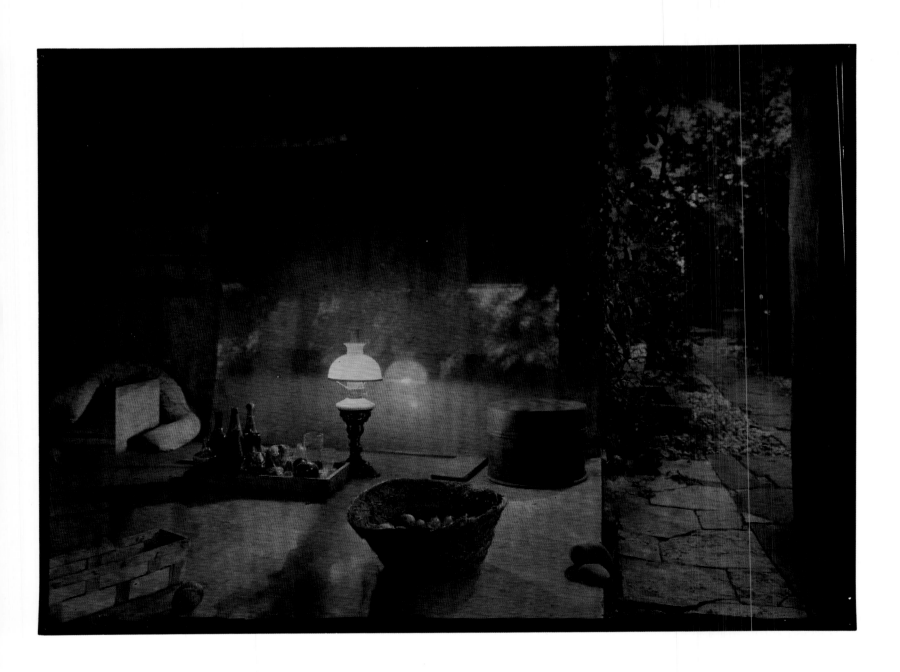

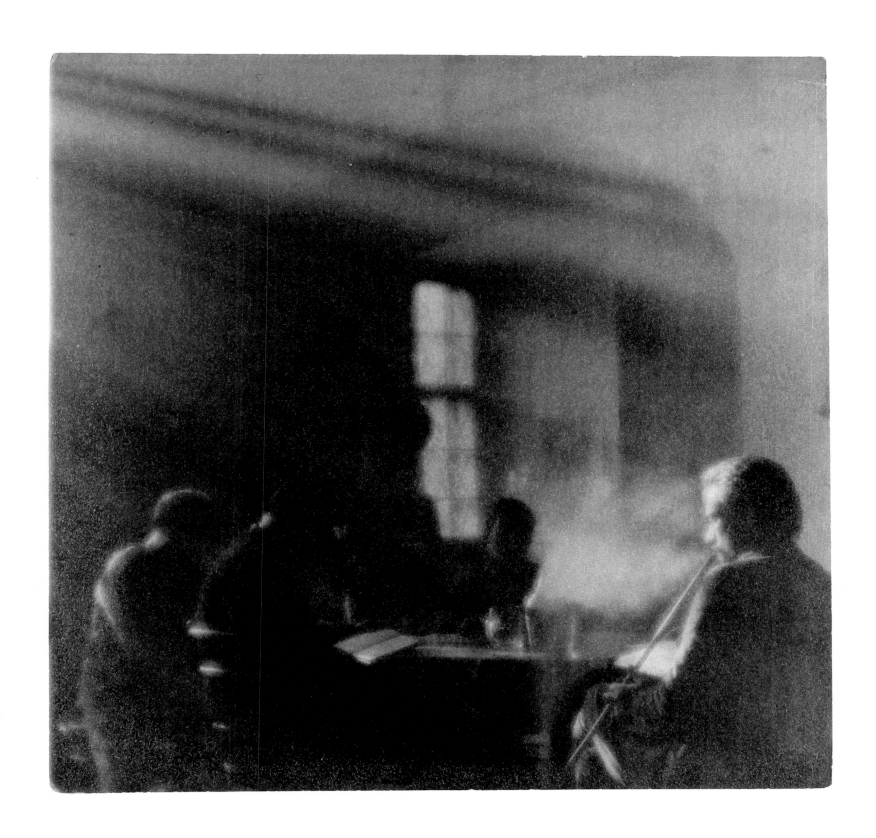

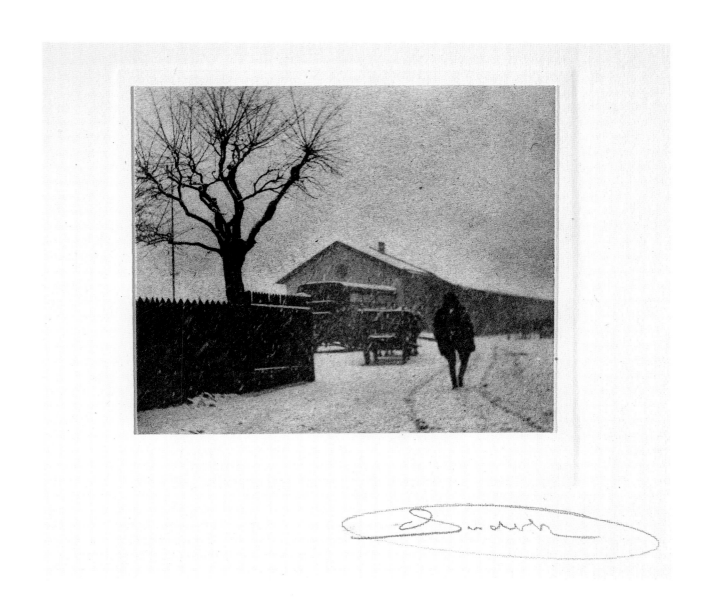

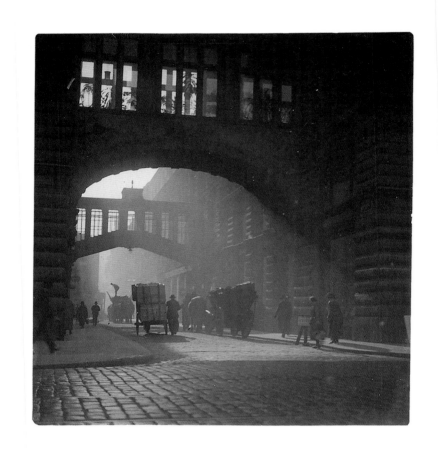

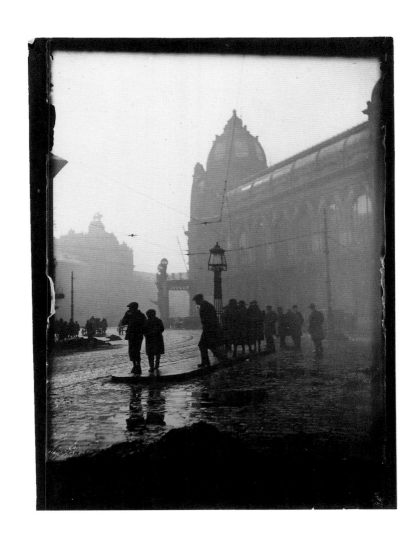

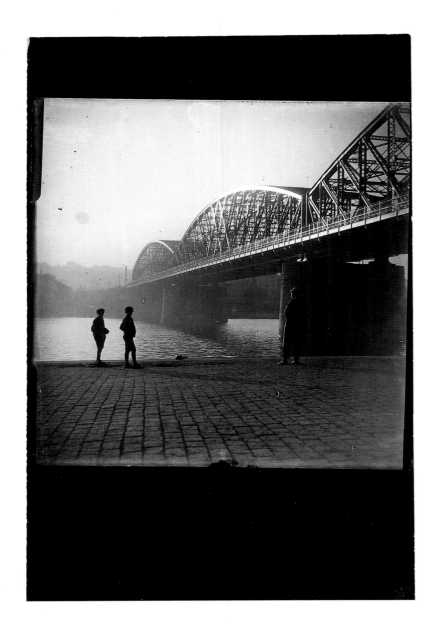
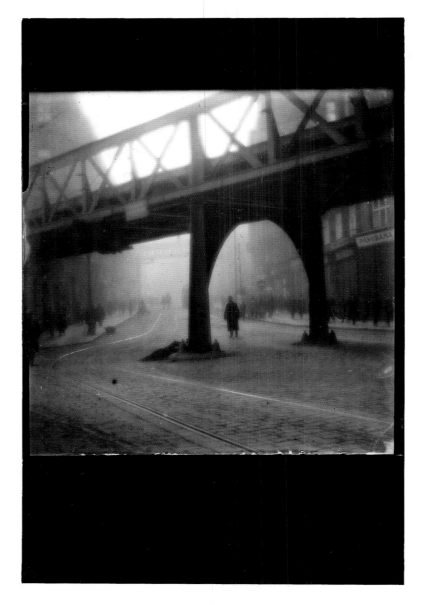

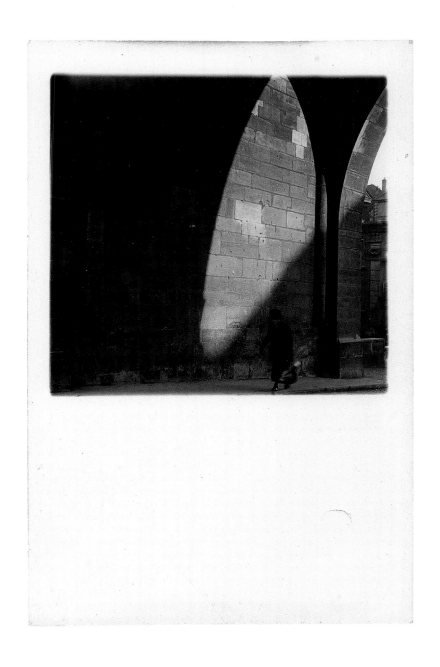

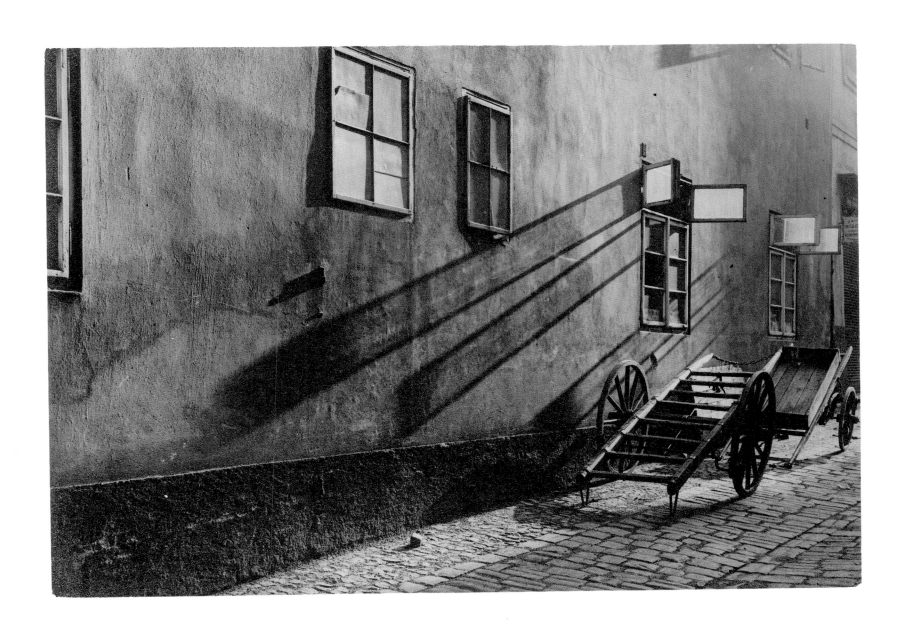

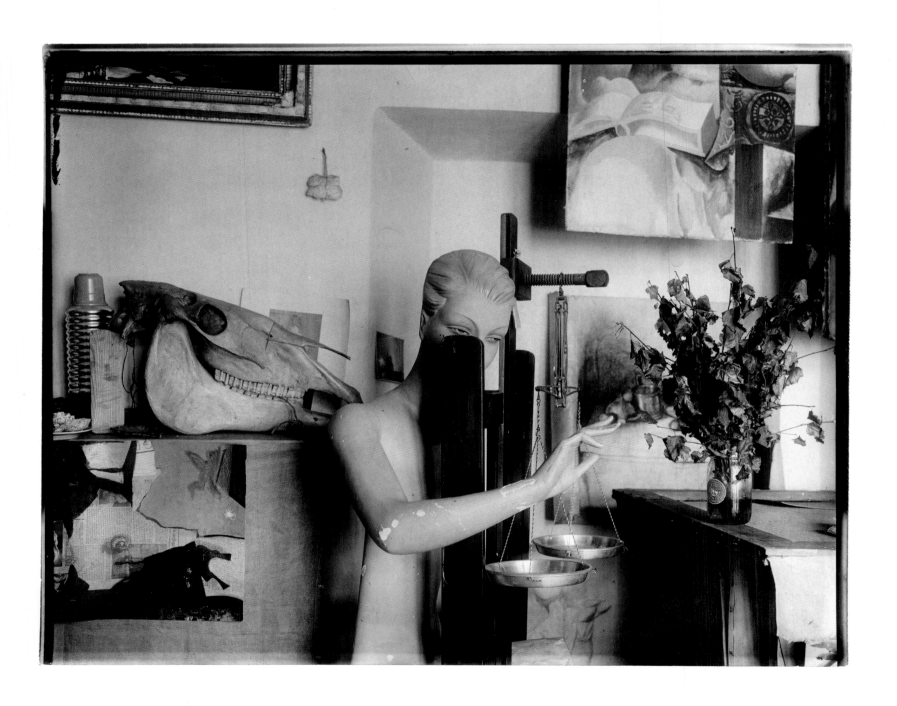

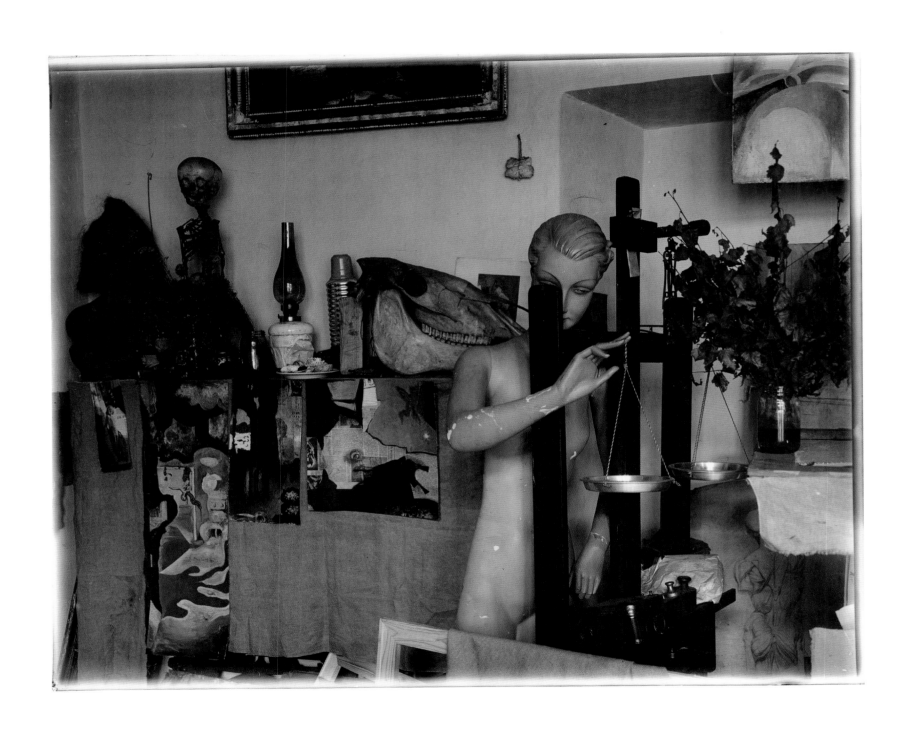

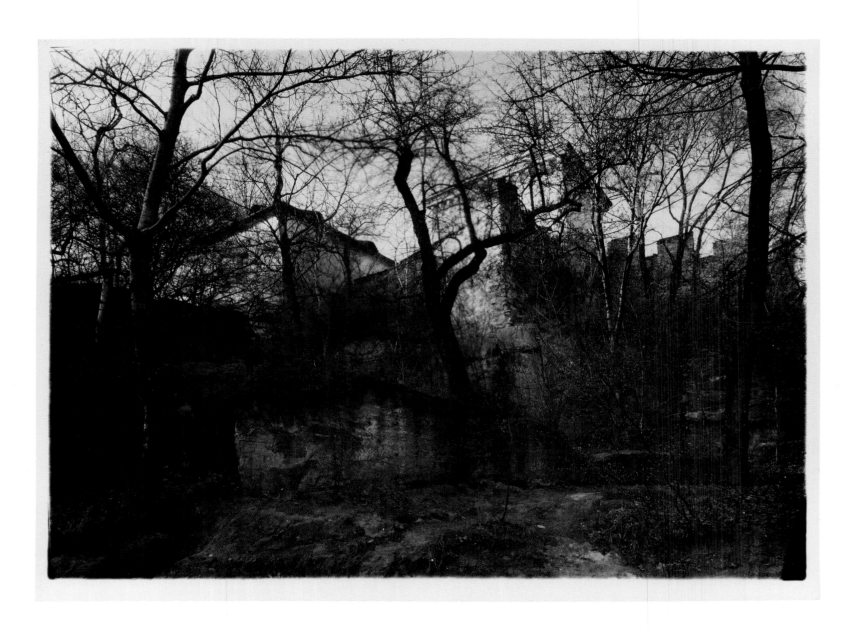

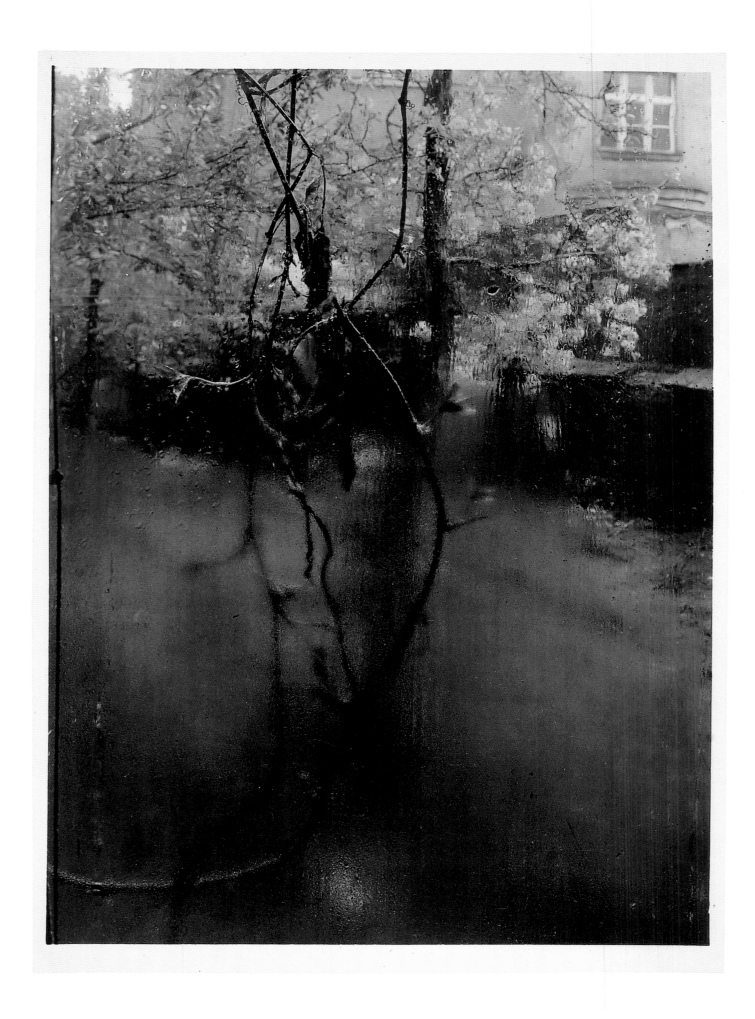

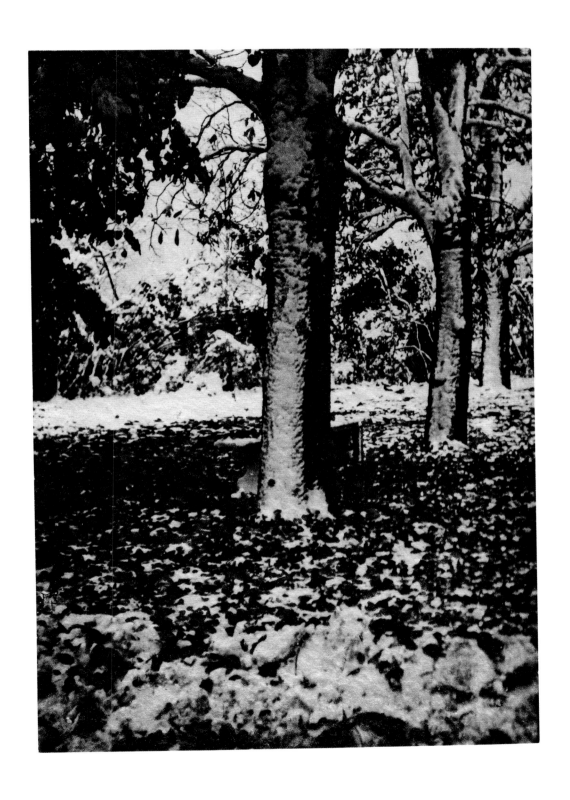

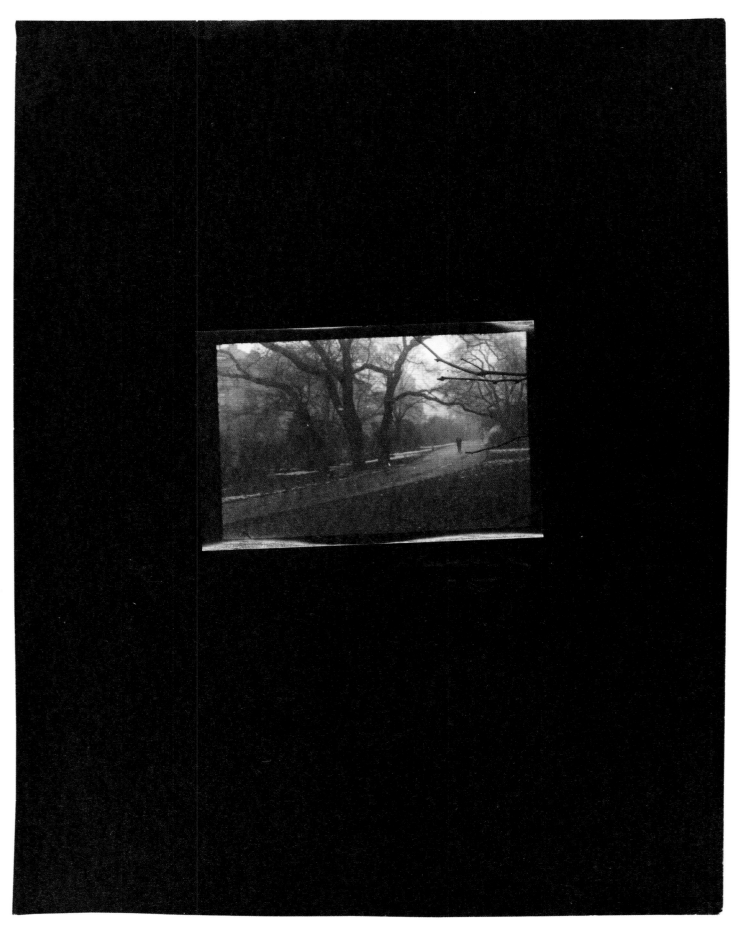

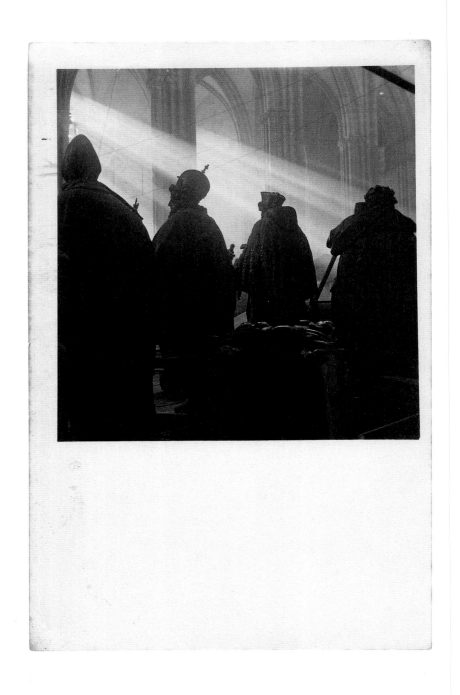

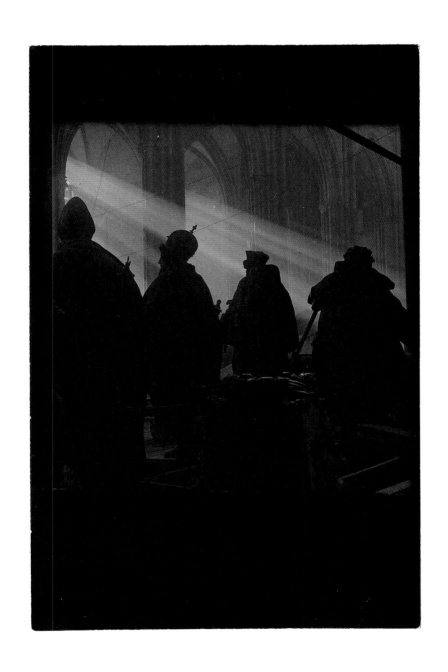

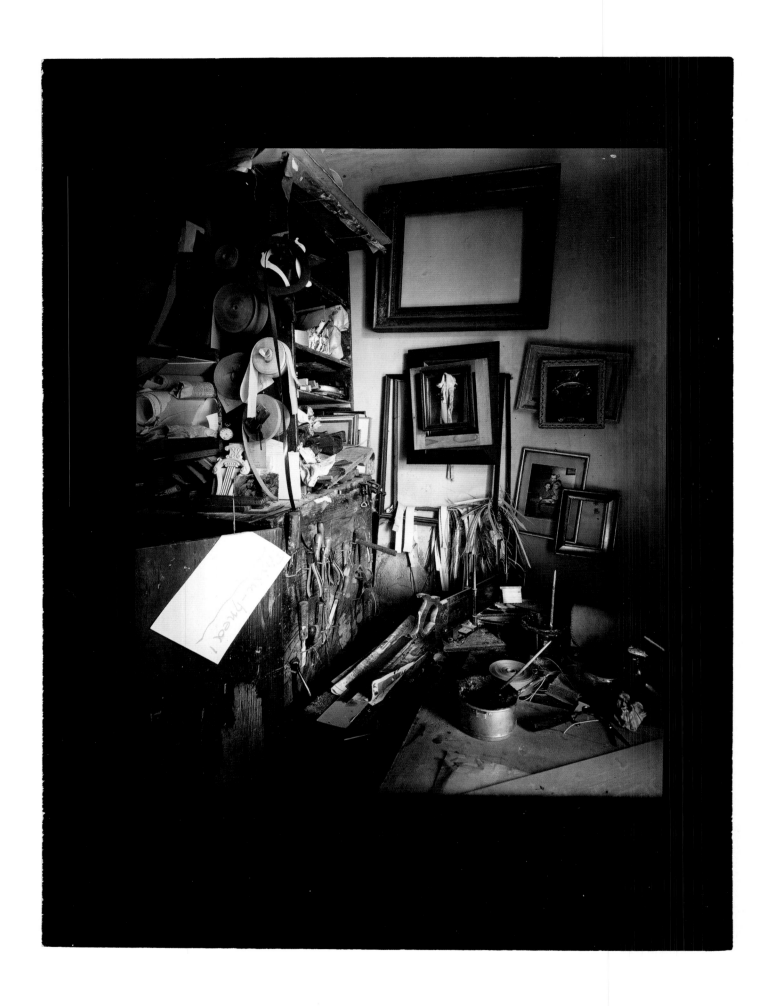

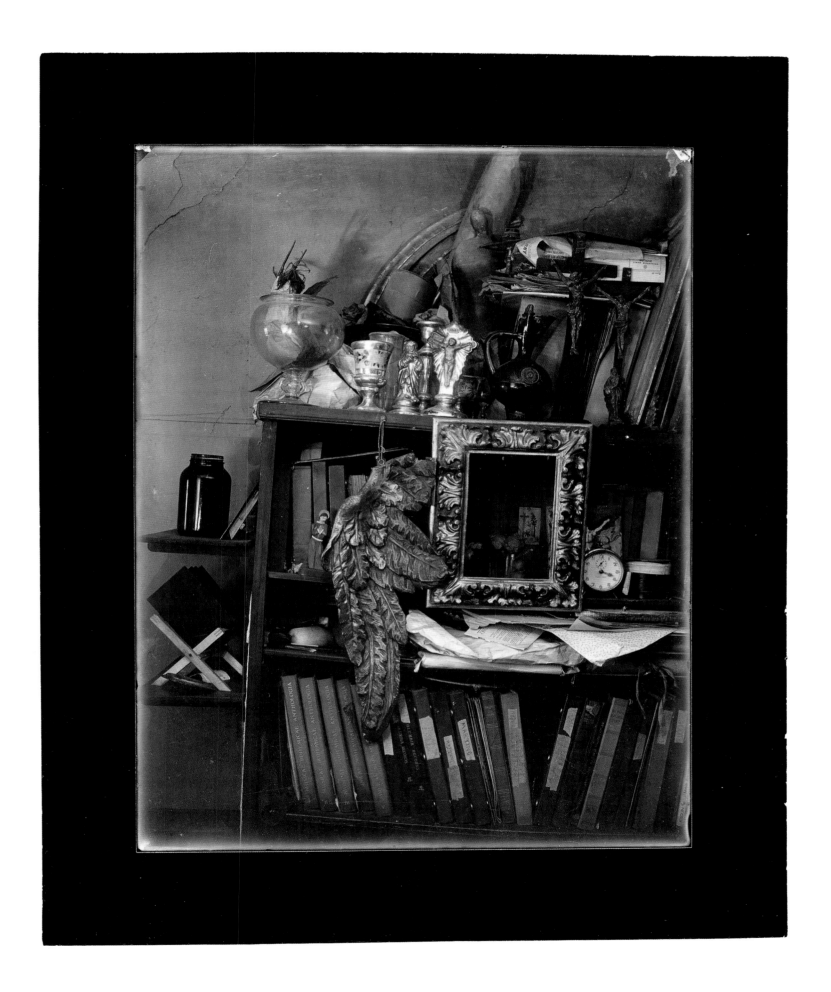

237

Essays

Still Life after Caravaggio, Variation I, 1956

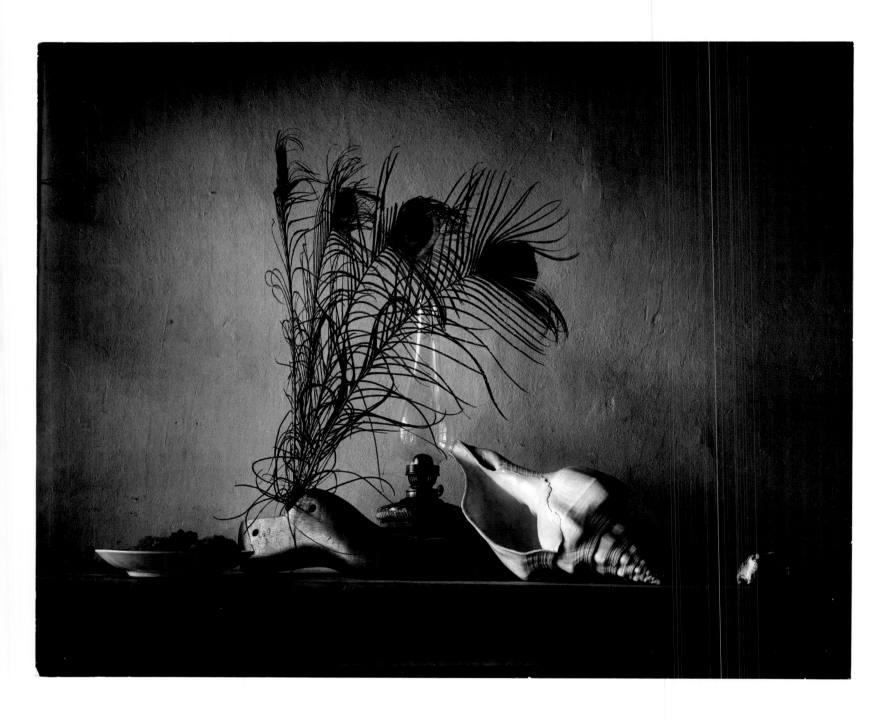

Sudek the Outsider

—

BY ANTONÍN DUFEK

It's a nice craft requiring a certain amount of taste.
—Josef Sudek's response in 1936 to the question: "Is Photography an Art?"[1]

The charm of everything is in its mystery.
—Josef Sudek, 1972[2]

Josef Sudek is most often called a Romantic. An exhibition that presents half a century of his work cannot be satisfied with this label, for the *œuvre* it presents is not uniform. Sudek changed direction as a photographer several times. The road to international recognition opened up to him only a few years before his death, particularly his exhibitions in the United States, where he had been sending mostly his later works.[3] He began to make these photographs in his late forties, amid the Second World War and German occupation of his native land. His earlier works were more firmly linked to the context of photography in Europe and Czechoslovakia in particular.

Few people know that Sudek began to take photographs even before the First World War. He often made light of the early days of his career: "I started to take photographs in 1913, inspired by pictures with a lot of sheep, which some company used to advertise its products. I got a 4.5 × 6 cm camera, and tried to copy them."[4] The amputation of his right arm, the result of being wounded in the First World War, made it impossible for him to work as a bookbinder, for which he had been trained. With only some exaggeration, it could be said that the world of photography has benefited from his misfortune. The first set of works that the young Sudek assembled was called *Prague: Ten Mood Photographs.*[5] The subtitle tells us much about his practice, at the time, in the tradition of the Art Nouveau Symbolist and Decadent landscape. The nocturnal photographs from this set were probably inspired by Vladimír J. Bufka (1887–1916), who was famous in Prague for such works,[6] but perhaps also by the nocturnes of Edward Steichen.

During the interwar period, Sudek gained experience and inspiration at the Czech Club of Amateur Photographers in Prague (*Český klub fotografů amatérů v Praze*) and in subsequent organizations (the Fotoklub Praha from 1922 onward and the Czech Photographic Society [*Česká fotografická společnost*] starting in 1924), as well as in the State School of Graphic Art (*Státní odborná škola grafická*, 1922–24), where one of the teachers, Karel Novák,[7] acquainted him with German and Austrian fine art photography. "In order to make a living somehow, I continued to give photography a try. Then, when I got accepted to the State School of Graphic Art, it was a whole new world. Professor Karel Novák was a gentleman. Intelligent. That was immediately clear, because he tolerated my swearing, which I had picked up during the war. Another thing I liked about him was that he used to show a collection of photographs and didn't say anything about them. It's lovely when nothing's said about photographs."[8] This became a bit clearer in an interview conducted later by the art historian Jaroslav Anděl: "The poor guy [Novák]. Again, it was my opinion against his. Two opposites. He couldn't make me budge, and he finally gave up.... Novák was still teaching there during the Second World War. He had a collection of original photographs from the period, all Viennese Art Nouveau, gum prints this big; pigment prints. He died suddenly and the collection gave its last groan."[9] At school, Sudek expanded his repertoire: he photographed architecture and

made still lifes and portraits in artificial light, akin to the photographs of Hollywood stars from that period. In 1927, once he had mastered the photographer's craft and received his journeyman papers, he bought a studio.

An important impulse for Czech photography was provided by Drahomír Josef Růžička's visit to Prague in 1921. The photographic work of this New York physician and member of the Pictorial Photographers of America,[10] together with the prints of his American colleagues and the periodicals in which they were published (including *Camera Work*), introduced Czech photographers to a form of Purism, which rejected any manipulation of the negative and the print and allowed only a blurring of the image, for example, by means of a soft-focus lens. Růžička, a pupil of Clarence H. White, brought to Czechoslovakia an offshoot of American Pictorialism, which had reached its peak in the United States the previous decade. Almost the whole post-war generation of Czech photographers adopted this variant of art photography, whereas in the neighbouring countries only a few photographers used this style. With a sense of relief, Sudek could give up a difficult aspect of making a bromoil print, which required tapping the print with a brush (a much tougher task with only one hand), without his older colleagues accusing him of trying to avoid the hard work that "real" photography entailed. He did not return to any other alternative (non-silver) photographic processes until he resumed making unmanipulated carbon prints in the 1950s. (He later destroyed most of them, an act he greatly regretted.) At the age of 25, after winning First Prize in his club exhibition for an Art Nouveau (Pictorialist) bromoil landscape, he made some of his best works, concentrating on the depiction of light, particularly contrasts of light and shadow, instead of "reproducing" the objects in front of his lens.

Years later, when he talked about the beginnings of his career, he made no distinction between schools or styles, but he did recall the influence of great photographers: "You always have to go to someone else's trees for plums – at first. I used to do it as well: Stieglitz and Bufka, Steichen, Růžička, and others."[11] Sudek probably saw himself and his handling of the medium in relation not to styles or movements but to leading photographers. This approach is in line with his attitude to theory: "Theory? Well, a bit. All those theories have one big disadvantage. If you eat too many of them, you feel sick."[12] Sudek wrote nothing about photography, and though we might learn something about the way he took photographs from published interviews and commentaries with him, we are given no instructions, no generalizations, no program, no learning, no principles.

Sudek displayed his mastery of the medium in his second portfolio, which is devoted to the completion of the most important work of sacred architecture in the Bohemian Lands – namely, Saint Vitus Cathedral in Prague.[13] Apart from the requisite descriptive depictions, the portfolio contains a set of prints depicting rays of light inside the cathedral, but also, for example, a detailed shot of a column from 1927, which resonates with the style of New Objectivity. It is one of the first photographs of its kind. Sudek's knowledge of most progressive trends was mediated through his friend Jaromír Funke, one of the first avant-garde photographers and a leader of the Czech Photographic Society (*Česká fotografická společnost*). In 1929, the Society hosted two of the most interesting amateur clubs in North America – the Toronto Camera Club and the Seattle Camera Club – establishing a connection to the Toronto arts scene, in particular the work of Bruce Metcalfe (whose reproduction of *Collars* in the catalogue could be compared to Sudek's advertising work). Less than ten years after the First World War, Sudek had mastered the craft of photography,

including two of its styles. The first was the "original" art photograph which stems from the traditions of painting and printmaking and uses manipulated and unmanipulated prints. He then focused on a conception of the photographic image as the "harvest of light and shadow," conveying a perception of the world instead of a description of it.

However, in the next decade, the third period of his work, Sudek devoted himself to detailed descriptions of products and other objects. Unlike the approach that was commonplace among his past and present colleagues, Sudek did not base his business on portraiture. Instead he concentrated on reproductions of artworks and advertising photographs, which was then an innovation.[14] He began to send fewer works to photography exhibitions and photographed mostly for periodicals and other publications, in high-quality photogravure. His most important collaboration was his involvement with *Družstevní práce* (Co-operative Work), where the foremost Czech designer (and his exact contemporary) Ladislav Sutnar (1897–1976) also worked. Sudek published advertisements in periodicals of the co-operative, along with other commissioned photographs of books, art glass, china, tubular metal furniture, and fabrics, as well as some published photographs which he had made strictly for himself but were considered suitable as illustrations. A calendar with his photographs was also published by *Družstevní práce,* as were a series of Christmas cards. Sudek had his first solo exhibition in the co-operative's exhibition hall in 1932, which was perhaps the first public solo photographic exhibition in Prague.

All of a sudden, Sudek had become one of the best-known and best-paid photographers in the country. The new, bewitchingly sharp-focus depiction of objects, usually photographed from above ("table top photography") in diffused light, became typical of his style. The compositions were consistently two-dimensional in effect and the creative aspect of the photographer's work consisted mainly in arranging the products that were to be promoted. Commercial photography in particular could with ease usually employ one of the main principles of the "new photography" – namely, the linking together of the precise reproduction of products with an abstract arrangement, usually geometric; Sudek's arrangements most often use diagonal compositions. They are some of the most dynamic examples of European advertising photographs of that period. "I was influenced by Sutnar, but also, like all of us at the time, by the 'dynamic diagonal', which we knew and liked from Soviet photographs and films."[15]

In some cases, particularly as the opportunity arose when photographing glass, Sudek intentionally turned abstract order into chaos. It was probably his way of regaining a bit of freedom. He enlarged the exceptionally beautiful photographs of glass and tubular metal furniture as exhibition prints. In his other non-commercial photographs from the 1930s, the concrete and the abstract are usually separated. Examples of this are, on the one hand, close-up photographs of nature in which photography has discovered the world in a new way, and, on the other, bird's-eye-view landscapes of plots of farmland reminiscent of aerial photographs. Sudek presented his non-commercial photography from the 1930s in his first book (1956), but rarely returned to it after that time.

In 1936 the Czech illustrated weekly *Světozor* (*Viewing the World*) asked a whole range of Czech artists, writers and scholars: "Is Photography an Art?" Sudek answered: "It isn't. It's a nice craft requiring a certain amount of taste. It can't be art, because it depends entirely on things that already existed before it and apart from it, that is, the world around us."[16] This answer, which was a blow to

FIG. 1 Edward Weston, American (1886–1958)
Fog and Cypress, 1938
Gelatin silver print
Art Gallery of Ontario, gift of Sandra Ball
and Marcia Reid, 1987

FIG. 2 *Untitled,* 1950–1954
Invitation card image for the exhibition,
Josef Sudek: Souborná výstava fotografického díla,
Brno, Moravská galerie, 1976
(*Josef Sudek: Collected Photographic Works,*
Brno, Moravian Gallery, 1976)

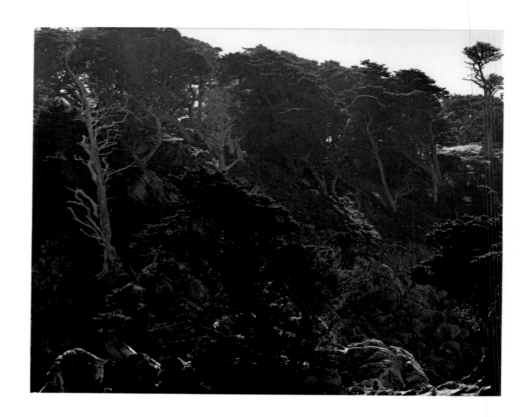

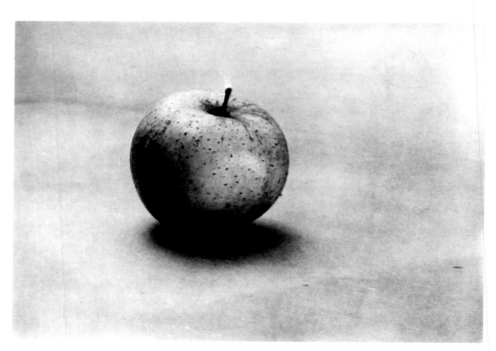

leading theorists, probably reveals how Sudek really felt. At the time he was among the elite of European photographers employing New Objectivity, and one of the first to embrace the New Photography. In the mid-1930s, however, he was but one of many making photographs in this same way. The New Photography provided few opportunities for individual vision. It was chiefly the application of generally accessible and quite rigorous methods to photography. On the other hand, a natural and pleasant consequence of working on commission was that it enabled Sudek to be in contact with Prague's intellectual elite. In contrast, however, to cold Functionalism and New Objectivity, Sudek absorbed entirely different impulses, particularly Surrealism (and Czech art remains one of its centres to this day). He also became acquainted with snippets of the work of Eugène Atget, with whom Sudek is most often compared. During the Second World War and afterwards, Sudek entered the last period of his work, a new photographic vision.

The common denominator of the famous final phase of Sudek's career is the contact print. He himself claimed that he was inspired to make them by some sort of awakening: "When I was young, I worked with small cameras. The Topič publishing house had a collection of nineteenth-century paintings. [The painter Emil] Filla knew it and gave me the collection to photograph for the [art monthly] *Volné směry* [*Free Trends*]. Once, while shooting a photo [which could typically take him several minutes], I saw a vertical-format picture on the wall – a watercolour or something. I moved in closer and saw a contact print, from 1900, of a Romanesque statue from Chartres. And that gave me the impulse to use larger formats. (That photo hit me like a cannonball.)"[17] After that time, he rarely ever made enlargements again. His wooden cameras, usually from the nineteenth century, took negatives of up to 30 × 40 cm, but such cameras were particularly difficult for Sudek to operate with only one arm. He often needed an assistant, and could more easily have worked, for example, with a Leica. Once a "craftsman" respected by everyone, he had now become an outsider, and not only because his method was the contact print. Though Sudek reverted back to a nineteenth-century technique, the subject matter he chose to apply to it was new in the history of photography and fine art. That subject was the windows of his studio.[18] Not a view from the window, or a "pre-picture of a picture," but a surface of glass covered with dew, raindrops, ice and so on, and of course the shadows of reality beyond the window. Sometimes these photographs bring to mind the Art Informel of the post-war period.

In the existential climate that prevailed during the years of the Second World War and the German occupation, Sudek, a veteran of the First World War, was probably more motivated to search for his true self. His work became deeply personal and was usually recognizable at first sight.[19] Sudek's work diverged radically from mainstream European photography – in which the reduction of half-tones was gradually growing stronger, almost to the point of being a graphic artist's interpretation of reality – adhering more closely to the large-format realism of Americans (FIG. 1) like Strand, Weston, Cunningham, Adams and Evans. "There's nothing in photography to be embarrassed about," he said. "That's also why, for example, one needn't flirt with graphic art."[20] In his version, reality is still drawn in detail as it used to be, but a large part of it is now defined by light. The contact prints come "alive" by way of the light values. Sudek managed to achieve a synthesis of two previous phases of his work, concentrating on the depiction of light and the surface of things. Indeed, he also returned to the evening "moods" of his earliest photographs. It was perhaps this continuity with himself which gave Sudek the certainty and courage he needed to break

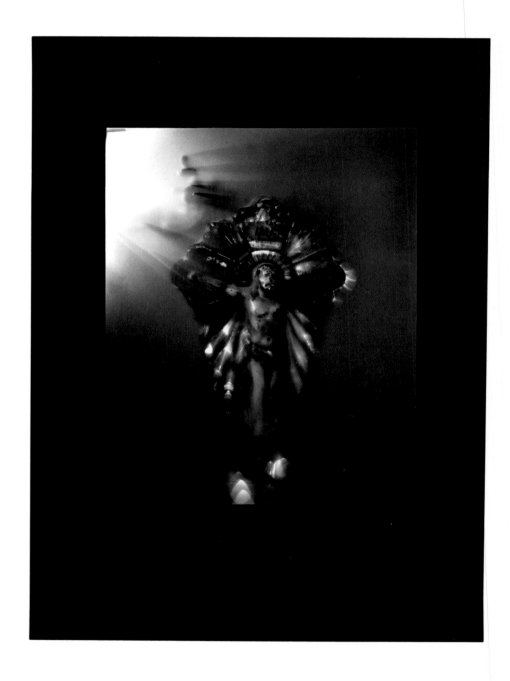

away from the photographic canon on multiple levels including technique, craftsmanship, subject matter and style. But the decision had been made by a man, marked by the slaughter of the First World War, who would no longer allow himself to be manipulated. In his work, as in the rest of his life, he refused to be guided by convention. A distinct example of this new approach is apparent in his variations on works by artists he had gradually discovered for himself, including Pieter Claesz, Caravaggio, Jean-Baptiste-Siméon Chardin, Wenceslas Hollar, Josef Navrátil and Giorgio Morandi. What has now become common in postmodernism seemed at the time to be an incomprehensible denial of one's originality. Among the other sources of Sudek's inspiration were literature (particularly Jakub Arbes and Edgar Allan Poe) and music, which for him was present everywhere. (As he was shooting photographs, he would typically say: "The music's playing.")

Even Sudek's later work, from the Second World War onwards, is not uniform. From the late 1930s, Sudek was particularly occupied with photographing Prague Castle, including its gardens, and other historical sites of Prague. Beginning in mid-1945, after the war had ended, these subjects began to appear in books, the most famous of which is *Praha panoramatická* (*Prague Panoramic*) (1959), including many astonishing photographs of the outskirts. Like the other panoramic set from the coal-mining area of northwest Bohemia,[21] we might see this photography today through the lens of the "new topographics." Other important sets made outside Prague include north Moravia, the native region of Leoš Janáček,[22] and the nearby ancient Mionší Forest.[23]

Another group consists of photographs from Prague, depicting parks, gardens and secluded little spots in the city. Sudek usually took these photographs in late winter, spring and autumn, most often near his studio on Újezd Street and later near his flat in Úvoz, in the garden around the studio, and in the "magic garden" of Otto Rothmayer, then chief architect of Prague Castle. It was at Rothmayer's home that Sudek stored his largest camera, 30 × 40 cm, and it was here, using objects owned by both the architect and himself, that he made another distinctive group of works: mysterious, dreamy, staged photographs, partly inspired by Surrealism and often photographed at dusk or in nocturnal lighting.

In his still lifes, Sudek began concentrating on achieving the greatest simplicity possible. He most often depicted a single thing (a piece of fruit, an egg, bread, a glass, a seashell, a rose), though on rare occasions he combined several objects. He wanted their simplicity to be clear and for them to seem "alive." "With Filla I used to talk about the Dutch still lifes of van de Velde.[24] His work has imaginary space. He made about forty paintings. One small reproduction shows one little apple. I told myself that I could do it like that too. One thing in space. It was stupid. The thing that I put there didn't fit. It had nothing to do with the space. I put aside still lifes. Some time later I returned to them.... I then experimented with the still life to explore the effect of light (FIG. 2). The still life was my laboratory."[25] The title of one of these works, *Simple Still Life*,[26] applies to all of them. Sudek included the later still lifes, from 1960–73, in his series *Labyrinths, Glass Labyrinths, Easter Memories* (with a rococo frame) and *Air Mail Memories*. These works form a counterpart to Sudek's commercial work; instead of a world that is organized into patterns, they depict it as a labyrinth. Illegibility, which requires close observation and deep contemplation, takes the place of the straightforwardness of his advertising photographs. Years after the fact, Sudek found a way – in a whole range of still lifes, not only in *Glass Labyrinths* – to react to Cubism, which he knew so intimately from his friend Emil Filla. By contrast, *Easter Memories* (one of the last works), a depiction of mystical light, tends

to draw upon the Baroque conception of the picture and the photographer's early work. It is the light linking heaven and earth into a single universe. Though its inspiration cannot be depicted, music was Sudek's other life, and the world of meaning in his works is, with few exceptions, closer to music than to literature.

Sudek's unique late work does not exist entirely in a vacuum. Asked in 1956 if there was a foreign photographer who influenced him, he replied: "The American Edmond [*sic*] Weston, who is my age, about sixty. I value his new view of reality. He doesn't yearn to be a painter. He sees things photographically. He has a photographer's eye."[27] One has to recall that *My Camera on Point Lobos* was published in 1950. This book by Edward Weston puts a new emphasis on light, much like Sudek's work, except that an ill Weston could no longer make new work. In addition to clinging to the possibilities of the medium, the two photographers shared a persistent examination of things as they really are. Sudek's interviews also fit neatly with the context of the great body of Weston's writings: "As for the striking quality of the pictures, the striking ones are those that are different from what's supposed to be seen, and that's why they seem to be interesting; but they aren't truthful."[28]

Throughout his life, Sudek would "come across" (as he put it) several dimensions of perception and the depiction of reality. Systematic documentary photographers like Robert Adams and artists like Jan Svoboda, James Welling, Claudio Parmiggiani, and Olivier Richon could count themselves among his successors. Several times in his career Sudek was asked the question that appears in the first epigraph of this article, whether photography is an art. In 1972, four years before his death, he said: "When I began photography, it was an art for me. In mid-life I started abandoning that view and today I couldn't care less about it."[29] Clearly, Sudek did not want to call himself an artist. Fortunately, a claim he later made neatly sums up the road he travelled: "One thinks that all sorts of things are useless, but that's not true. Those too are things one has to go through. That's how we learn. And in art, if one knew what one would be doing ten years ahead, life wouldn't be worth living. Up to the age of 35, you can do whatever you like, experiment, fool around. But after that, you have to know what you want. From the age of 40 to 50 you really have to work hard, you have to make something. And from the age of 50 to 60, every day is special. That work can no longer be erased. What you do from that period on has to be your credo."[30]

1. "Je fotografie umění," *Světozor*, 16 July 1936, p. 486.

2. Miroslav Venera, "S Josefem Sudkem o dobré práci," *Věda a život*, 1972, no. 2, p. 107.

3. "Josef Sudek," New York: The Neikrug Gallery, 1972; "Josef Sudek," New York: The Light Gallery, 1974; "Josef Sudek: A Retrospective Exhibition," Rochester: International Museum of Photography, George Eastman House, 1974; "Josef Sudek," Milan: Galleria Il Diaframma, 1974; "Josef Sudek," Washington, D.C.: The Corcoran Gallery of Art, 1974–75.

4. V. J. Kovářík, "Ateliér ve stínu činžáků" (interview), *Květy*, 14 September 1968, pp. 42–44. The Photography Collection of the Moravian Gallery, Brno, includes a carbon print of a photograph of sheep, dated by Sudek between 1918 and 1922. See Antonín Dufek, *Josef Sudek neznámý – Salonní fotografie 1918–1945 / The Unknown Josef Sudek – Vintage Prints 1918–1942* (exh. cat.), Brno: Moravská galerie, 2006, cat. no. 2.

5. Josef Sudek, *Praha: 10 náladových fotografií*. Prague: Ústřední státní ústav grafický, c. 1922–24. This album of photographs is in the collections of the Museum of Decorative Arts, Prague.

6. Antonín Dufek, Vladimír J. Bufka, with an English trans. by Derek and Marzia Paton, Prague: Torst, 2010.

7. Monika Faber and Josef Kroutvor, *Photographie der Moderne in Prag 1900–1925,* Zurich and Düsseldorf: Schaffhausen and Frankfurt am Main, Edition Stemmle, 1991.

8. Rudolf Křesťan, "Josef Sudek: Muž s černou bedýnkou" (interview), *Mladý svět,* 1976, no. 18.

9. Josef Sudek, *Josef Sudek o sobě.* Interviews conducted in 1976, recorded and edited by Jaroslav Anděl. Prague: Torst, 2001, p. 32.

10. Christian A. Peterson and Daniela Mrázková, *The Modern Pictorialism of D. J. Ruzicka / Moderní piktorialismus D. J. Růžičky.* Minneapolis and Prague: Minneapolis Institute of Arts and Galerie hlavního města Prahy, 1990.

11. Miroslav Venera, "S Josefem Sudkem o dobré práci," p. 103. The list of names changes: "Of the earlier, I like Steichen, Stieglitz, Weston and Růžička. They are the ones whose trees I used to go to for my plums. A great influence on me was silent film. Chaplin. And Griffith – in his work I discovered the first close-up." Alexej Kusák, "Malé fotografické panoráma," *Kultura,* 1959, no. 5, p. 1.

12. Miroslav Venera, "S Josefem Sudkem o dobré práci," p. 107.

13. Josef Sudek, *Svatý Vít,* with an introduction by Jaroslav Durych and a French translation of it by R. Ruelle, Prague: Družstevní práce, 1928. This portfolio of fifteen original photographs from 1924–28 was published to mark the tenth anniversary of the establishment of the Czechoslovak state, at which point construction work on the cathedral was finished. See also Josef Sudek, *Saint Vitus's Cathedral,* with the original introduction by Durych, and articles by Josef Moucha, Klara Benešovská, and Jan Chlíbec, trans. Derek and Marzia Paton, Prague: Torst, 2010.

14. Vojtěch Lahoda, *Josef Sudek: Commercial Photography for Družstevní práce,* Jyväskylä: Alvar Aalto Museum, 2003; Lucie Vlčková (ed.), *Družstevní práce: Sutnar – Sudek,* Arbor vitae, 2006; Vojtěch Lahoda, "The Advertising Photography of Josef Sudek," in Josef Sudek, *The Advertising Photographs,* trans. Derek and Marzia Paton, Prague: Torst, 2008.

15. Anna Fárová, "Rozhovor s Josefem Sudkem," in Anna Fárová, *Dvě tváře,* ed. and with an interview conducted by Viktor Stoilov, Prague: Torst, 2009, p. 441; originally published in *Camera* (Lucerne) 55 (1976), no. 144. (Published in three language editions: French, English and German.)

16. "Je fotografie umění," p. 486.

17. Miroslav Venera, "S Josefem Sudkem o dobré práci," p. 107.

18. Sudek did not talk much about why he began to make photographs of the window: "It started in the Protectorate. One autumn in the Protectorate I began to see the windows. I made them for a long time, you know, so many years." Ibid., p. 104.

19. Jaroslav Anděl, "Obrazová kvalita ve fotografiích Josefa Sudka," *Fotografie* XVII (1973), no. 2, pp. 18–19.

20. Zdeněk Šaur, "Wir stellen vor Josef Sudek," *Fotografie* (Halle), 1961, vol. 11, p. 434.

21. Josef Sudek, *Smutná krajina / Sad Landscape / Traurige Landschaft,* with articles by Antonín Dufek, Bohdan Kopecký and Dalibor Kozel, Litoměřice: GVU, 1999, 2nd ed., Prague: Kant, 2004.

22. Josef Sudek, *Janáček – Hukvaldy.* In Czech, German and English, Prague: Supraphon, 1971.

23. Ibid; Josef Sudek, *Mionší Forest,* with essays by Antonín Dufek, Petr Helbich, Tomáš Vrška and a Life in Dates by Anna Fárová and Josef Moucha. Trans. Derek and Marzia Paton, Prague: Torst, 2009.

24. Jan van de Velde (Haarlem, 1619 or 1620 – Amsterdam after 1660).

25. Josef Sudek, *Slovník místo pamětí,* ed. and intro. by Jan Řezáč, Prague: Artfoto, 1994, p. 21.

26. Antonín Dufek, *Josef Sudek: Souborná výstava fotografického díla* (exh. cat.), Brno: Moravská galerie, 1976, cat. no. 85 (Tab. not numbered).

27. Oldřich Adamec, "Na slovíčko s fotografem," *Večerní Praha,* 10 December 1956. As early as 1936, in a review of an international exhibition in Prague, one could read: Funke's and Sudek's pictures … have a purity and perfection of craftsmanship that one can find only in the American photographer Weston." See P. A. [Pavel Altschul], Přehlídka nové fotografie: K mezinárodní výstavě fotografie v Mánesu," *Světozor,* 16 July 1936, pp. 156–57.

28. Zdeněk Šaur, "Vzpomínka na chvíle se Sudkem," in Jaroslav Anděl, ed., "Pocta Josefu Sudkovi" (manuscript), Prague, 1976; Brno: Photography Collection Archive, Moravian Gallery.

29. Miroslav Venera, "S Josefem Sudkem o dobré práci," p. 103.

30. Karel Vysušil recalling Sudek's words, recorded by Petr Hron in 1980–81. Jan Mlčoch and Jan Řezáč, eds., *Růže pro Josefa Sudka,* exh. cat., Prague: Uměleckoprůmyslové museum Praze and Správa Pražského hradu, 1996, pp. 197–98.

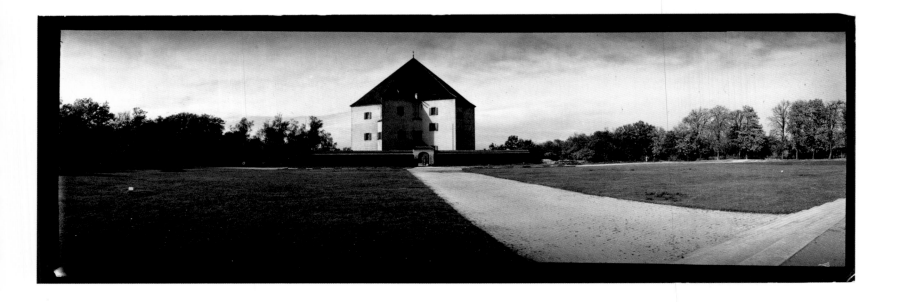

Josef Sudek and the Panorama

—

BY GEOFFREY JAMES

With her usual mixture of acerbity and honesty, Louise Bourgeois once remarked that artists are not interested in each other's ideas, but rather their techniques. This is almost certainly a half-truth, but in the case of photographers, it has particular resonance. Photography is the child of technology, and photographers are entirely dependent upon industrially made materials and machines. The camera, as Paul Strand once observed, is indifferent to the feelings of its operator. The question of how photographers impose their own subjectivity onto a medium that leaves no autographic trace is one that cannot be answered easily, but what is certain is that technical questions have significant aesthetic ramifications. Gear matters.

Sudek originally subscribed to the tenets of Pictorialism, an essentially amateur movement with its late-Victorian aesthetic of broadly massed subjects, gauzy light and Arcadian subject matter that was strangely at odds with the convulsive social and technological changes of the early twentieth century. With its artisanal printing techniques, Pictorialism did its best to hide the industrial origins of the medium. As a professional, Sudek was obliged to have a wider range than that, and as a well-connected member of the cosmopolitan artistic milieu that looked primarily to Paris, he was well aware of what was going on in the vanguard of the visual arts. He was clearly interested in Surrealism and Cubism, and his commercial work of the 1930s evidenced a familiarity with the aesthetics of the New Objectivity, with its emphasis on realism, precision and strong diagonal compositions.

Yet it wasn't until he decided in 1940 to make no more enlargements and to commit himself to the contact print that Sudek began creating the long-arching, personal cycles of images that have come to define his style. The decision was apparently made after he came across a 30 × 40 cm, turn-of-the-century contact print of a sculpture in Chartres Cathedral. The move may also have been imposed by circumstances – by this time, the Nazis had occupied Prague, commissions had dried up, and it was no longer safe to walk the streets with a camera. So he worked for himself, with view cameras of all sizes, often depicting interiors infused with his own subjectivity. The contact print – with its capacity to present the world in grain-less tones of subtle gradation – seemed to accord with his own sense of slow, careful craftsmanship, while his subjects seemed to increasingly exist in a private, enclosed world.

The first time I came across Sudek's work was at Expo 67 in Montreal. I purchased a book of photographs at the Czech Pavilion, which he made through the window of his studio between 1940 and 1954. Conditioned to the modernist narrative that dominated the North American history of photography, I found the photographs wonderful, but with a slightly suspicious air of romanticism about them. They spoke of conditions of light – damp, frosty, deliquescent, crepuscular, even nocturnal – in a series of remarkable variations of what could be seen from his modest studio, which was really a shed in a walled garden. Milan Kundera's *The Book of Laughter and Forgetting* poses the question of why Beethoven, at the peak of his career, became so fascinated with composing variations, the "most superficial of musical forms." Kundera's answer is that the variation leads to the endless inner variety that lies hidden in each thing. "Variation form," writes Kundera, "is the form in which concentration is brought to its maximum." The variation, and the style of the variation, become more important than what is varied. In the case of Sudek, the infinitely varied surfaces of the studio windows become the occasion for the creation of mere atmosphere, an expression of the artist's essentially romantic sensibility.

Early Evening in the Seminary Garden, 1950–1955

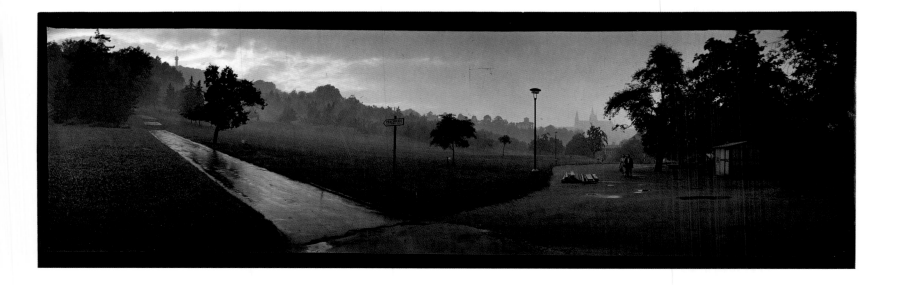

Sudek's discovery and use of the panoramic camera probably mitigated his more romantic tendencies, even if it did not fully stop him from being a self-proclaimed Romantic. As an amateur before World War I, he had heard about the Kodak Panoram (FIG. 1), but he did not get his hands on one until 1949, by which time the camera was obsolete and Kodak was no longer making roll-film for its 10 × 30 cm image. Introduced in 1899, the Panoram is radically different from a conventional camera, the most important differences being that the film is on an arc, and a pivoting lens attached to a slot scans the film. This runs counter to all the notions of Renaissance single-point perspective; the action of the lens most closely resembles the turning of the head. And while the photographic image has nothing to do with the way we perceive, I have a slightly irrational belief that the panoramic shape better reflects the horopter of human vision, more closely duplicating our peripheral sense of inhabiting space. On rare occasions, painters have managed to create this sense of head-turning perspective, most notably J.M.W. Turner in his *Rome from the Vatican (or Raffaelle Accompanied by La Fornarina, Preparing his Pictures for the Decoration of the Loggia)*, first exhibited in 1820, in which the curving balcony would be similarly rendered by a scanning lens. (This "distortion" can be replicated by anyone rapidly swinging their head from side to side and observing the curving of the walls around them.)

Like most photographers who approach the panoramic camera, Sudek's initial reflex was that it would be ideal for grand panoramic landscapes – in his case the Beskid Mountains, which he had visited with his friend, the painter Emil Filla, who happened to work in a long horizontal format influenced by Japanese scroll painting. "When I was in the mountains, I really wished I had one of them," Sudek said. "When you use a camera like that, your whole sense of space changes and the perspectives are different. The results always surprised me. The thing that was most important then turned out not to be so important after all. It was only later that I learned the right way to use it. I had to train myself to see how the camera saw."

Before he could do that, Sudek had to get the camera to work. It took him a long time to solve the problem of film. Since roll-film was no longer made, he had to cut strips from large sheets of German film, usually outdated. At first he was confined to a single shot, loaded in the darkroom and unloaded upon his return, a testament to both his tenacity and patience. Then his friend, architect Otto Rothmayer, the talented student of the great Croatian architect Jože Plečnik, came up with the idea of a changing bag, so that film could be loaded on the road, although it is hard to imagine how a one-armed photographer, however dexterous, could manage such a complicated operation alone (it seems Sudek often worked with an assistant).

The camera had other idiosyncrasies: only two shutter speeds and a viewfinding system that was approximate at best. An inscribed V on the top of the camera gave a fairly good idea of where the scan would end – and this is apparent in the precision with which Sudek worked in complex architectural spaces – but the horizontal limits of the image, especially towards the top, were much harder to judge. Another interesting problem – although it was certainly not a problem for Sudek – was that there was no real precedent for using the camera. The Spanish-Venetian fashion designer Mariano Fortuny used a Panoram to take photographs of the Venetian lagoon, and the French Pictorialist Constant Puyo made stylish landscapes with it, but otherwise the camera was ostensibly for well-heeled tourists. Teddy Roosevelt was the most famous owner of a Panoram, and probably not an atypical one.

FIG. 1 Eastman Kodak Camera, *Panoram* Model B, c. 1900

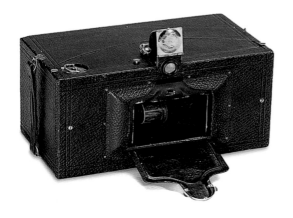

Although Sudek did some work in the Beskid Mountains – he started photographing there and would later return to the natural landscape – he must have come to the conclusion that the camera in fact worked well, perhaps even better, in the urban environment, particularly in spaces with multiple entry and exit points. In 1956 he began the huge project of systematically photographing his beloved Prague. Photographic historians have described the Panoram as a bulky and cumbersome camera. In fact, although it is roughly the size of a shoebox and tricky to load, it is lighter than many of today's DSLRs and is very much an ambulatory machine, especially since the sheets of film would have been stored in a light-proof box rather than heavy, bulky wooden film holders.

Sudek worked on the Prague project for three years. The Panoram seems to have propelled him from his interior world since, among other things, it was incapable of the long exposures which were necessary for so many of his interiors and low-light subjects. The book that resulted, *Praha panoramatická (Prague Panoramic)*, designed by his friend Rothmayer, had an astonishing print run of 15,000 copies and remains his masterpiece, containing no fewer than 284 of what he called his "sausage-long" views of the city. Not even the Czech curator Anna Fárová, who devoted many years of her life to organizing and reflecting upon Sudek's work, has been able to discern anything resembling a schema to the sequencing of the Prague book. It begins, conventionally enough, with views across the Vltava River and the city silhouetted against the sky. The second and third plates of the book are from the same viewpoint, but one is taken in winter and one in summer. It soon becomes apparent that the Prague panoramas, for all their formal rigour, are as much about light and atmospheric conditions as topography and architecture.

While Atget chose to photograph Paris in the lambent light of early morning, Sudek seemed to thrive at dusk, under darkening skies or in the foulest weather, although he may not have had much choice, given Prague's climate. His Prague, mostly unpeopled and, thanks to socialism, remarkably free of traffic, starts to become an imaginary place, the creation of a photographer not entirely tethered to prosaic fact. Around plate 120, Sudek moves to the edge of town, a modern world of quarries and anonymous apartment buildings, smokestacks and gasometers, tramlines and power pylons. There are occasionally people in his photographs, although they mostly fill the anonymous role of Figure in Landscape. He returns to the heart of the city, and is then back in the outer zones, at fun fairs and humble street corners that recall the light-industrial edge of an older Paris. The book is full of surprises – a morning photograph of a pond in Royal Hunting Park which recalls Atget's early-morning rambles in the park at St. Cloud. Sudek's photograph of the *Villa at Hvězda,* with its offset approach that gives the picture a spinning energy, could convince us we are looking at the work of 20th-century Italian architect Aldo Rossi rather than the 16th-century palace of the Archduke Ferdinand of Tyrol. The same ability to energize the often static frame of the panoramic format can be seen in the heavily atmospheric *Early Evening in the Seminary Garden* (c. 1950–1955), where a rain-slicked path descends magisterially across the picture.

The greatest surprise of *Praha panoramatická (Prague Panoramic)* occurs at the end when the reader has to turn the book ninety degrees to look at 24 vertical panoramas (FIG. 2). In horizontal mode, the curved panoramic can be treacherous. Walls photographed perpendicularly can assume the shape of a cigar, and anything rectilinear presents a challenge. But in vertical mode, it is extraordinarily difficult to avoid the camera's inherent distortion. Sudek had somehow succeeded

FIG. 2 *Spring in the Fürstenberg Garden,* 1950–1955
from Josef Sudek's *Prague Panoramic,* 1992 (English ed.)

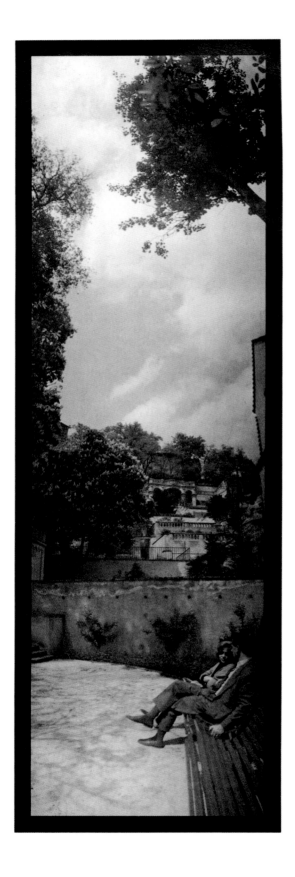

in hiding the machine's defects. These remarkable manipulations of space entirely conceal the fact that the film plane is curved. He seems to have solved a different visual problem in every photograph – a piece of virtuosic legerdemain that recalls the French novelist Georges Perec's feat in *La Disparition* of writing a book without the most common letter in the alphabet.

The author would like to thank Sandra Phillips of the San Francisco Museum of Modern Art for her generous gift of Sudek's book, *Praha panoramatická* (*Prague Panoramic*).

—

I have never been to Prague. It remains for me an imaginary city, an amalgam of the early novels of Kundera and Josef Skvorecky, with a few passages from W. G. Sebald's brilliant *Austerlitz* and, of course, Sudek's enchanted perambulations with the Panoram. When I eventually get there, I suspect I will find sex shops and McDonald's, as well as hordes of my former countrymen not always on their best behaviour. I know I will not find Sudek's Prague, which is as much a fiction as the writing – the aggregate of a peculiar machine and a particular, melancholy-sweet sensibility.

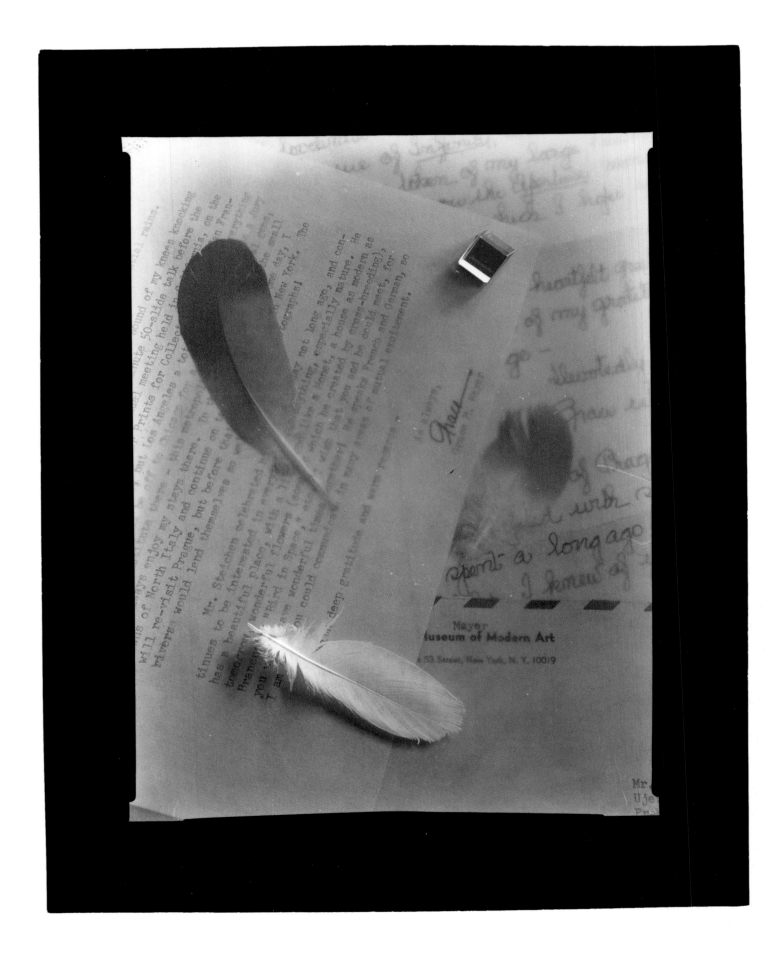

Josef Sudek: Grace Notes

—

BY RICHARD RHODES

There is a photograph of Josef Sudek with his young assistant, Sonja Bullaty, in Prague in 1945 or 1946. It shows him standing on what looks like a rooftop with a massive view camera angled up towards something higher. They are waiting on the light and Sudek has a characteristic scrunch on his face, the left eye squinting almost closed to flatten the view for his right eye. The scrunch is what gives him the sloping brow that you see in many photographs. As the years pass, this sloping brow becomes a fixed feature, whether he is shown with a camera or not. It is as if he is always photographing, always waiting on the light. If there is no camera with him now, he'll have it next time. The bronze portrait head on his tombstone carries the same sloping brow into the afterlife.

Who was this man? We know that Sudek's father died when he was a small boy and that he grew up with his mother and sister in a town 50 kilometres east of Prague. He didn't do well at school and apprenticed as a bookbinder when Czech Republic was still part of the Austro-Hungarian Empire. In World War I, on the Italian front, he lost his arm to a short-falling artillery explosion. The handicap ended his bookbinding career but did not get in the way of photography. In some photographs, the missing arm can make him look awkward, sometimes even forlorn. Yet in others, Sudek has an ironical, amused expression on his face. Friends remember him fondly and he lived most of his adult life with his sister. He loved music and made a living with his photographs. They brought him prizes and earned him a reputation as The Poet of Prague.

The nickname originated in reviews of his early photographs of St. Vitus's Cathedral, one of the Gothic highlights of Prague. Started in the 14th century, the church holds the tombs of Bohemian kings and Holy Roman Emperors. It was still being worked on in the 1920s when Sudek photographed it. He shows it as a vaulted-ceiling construction site. Ancient statuary and high, pointed windows and arches take their place within a surround of timber and dust. Sudek would kick up the dirt and turn the light into something palpable, filling every inch of space. The illumination upstages the kings and the architecture with a godliness that matches the photographer's sly, secular, mischievous attention on remodelling and repair.

Light was Sudek's love. Its eternal nature put him at odds with the emerging norms of modernist photography where sharp edges and high contrast spoke for the optical speed of a motorized 20th century. Sudek, by comparison, was a reluctant Modern. His photographs glory in the 19th-century atmospherics of early photography, with its soft light and muted clarity. He composes with brightness and shadow, and delves into their complex overlay. In his photographs he is taken with scrims of interference: trees lattice the view to backgrounds, windows separate outside from inside, shadows make black holes, mists cloud the distance, rain gathers on windows, frost blooms into radiant patterns, reflections bring supplementary spaces into the frame, refractions fragment what is already there. Nothing bears the proud simplicity of the new Modern style. Sudek teases out subtleties for his subjects and creates a roomy inner world of memory and morphing subjective potential.

"Hurry slowly," he liked to say, which sounds like a formula for finding hidden, overlooked spaces. He didn't need a larger world. Prague held endless discoveries of things to see and photograph. So did his studio. Some of Sudek's best work is circumscribed within those walls. Beginning a year after the arrival of the Nazis in Prague in March 1939, he launched his series *The Window of My Studio.* The camera is literally focused on the studio window or its sill. We see day, night, trees, hanging laundry, snow. Often it is raining or cold outside. Still lifes of fruit – sharp-edged, tangible and nourishing – are sometimes shown on the inside to contrast

From the cycle *Glass Labyrinths, 1968–1972*

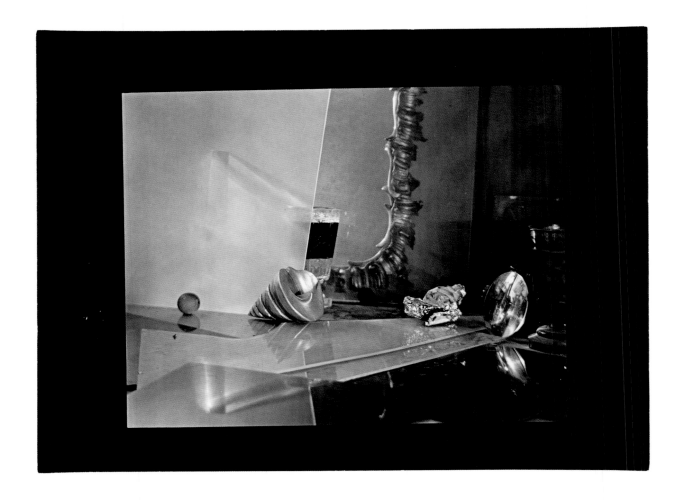

with the mystery world that takes shape on the other side of the pane. Every image is a metaphor for an occupied city, first by Nazis, then by Soviets. Sudek finds beauty in shelter, in a place that he controls, yet never is there not an embedded wish to see more.

The *Labyrinths* series of the 1960s turns, in spatial terms, further inward. The photographs migrate from the studio window towards a studio desk on which Sudek lights varying assortments of treasures: gilded fragments, broken glass, frosted glass, crystal prisms, metal spheres, mirrors, tinfoil and crumpled cellophane. From this modest but magical collection of things, he fashions some of the most remarkable abstract images in photography. The images are studies in light with a transcendent, radiant aura. The self-reflexive, or meta, dimensions of the *Window* series, where the window is a surrogate for both the lens of the camera and the human eye, give way to broader references of history, science, mathematics and the natural world.

The series shows off Sudek's capacity for invention. His *Labyrinths* are endless with suggested space, but they are also tabletop tricks that unravel with a bit of looking. A gilded, baroque mirror makes multiple appearances as a backdrop. Sometimes it is overlaid with a slanting plane of glass, sometimes not. Objects can appear in the same places from photograph to photograph, but look altogether different when he shifts the lighting from above to below, or flips the format to horizontal, or chooses a different exposure or print colour. The stagecraft is traceable, yet each image leaves it behind in a concert of light. You are in a land where shadowy flares, wavering apparitions and startling bright spots count for more.

This effortless intimacy is also part of the *Air Mail Memories* series, which shares the same tabletop genesis as the *Labyrinths* photographs. In them, Sudek honours his friends by shaping collages with their correspondence and stray studio materials. They include pigeon feathers that often seem a material equivalent for the soft, heightened grey light that features so prominently in the series. The light is not dissimilar to the dusty, streaming window light of the St. Vitus's photographs. In one image, a spotted feather rests on a surface of muted, shifting greys. While it likely sits on frosted glass balanced on a bowl with bits of crumpled paper and tinfoil placed below, the effect is otherworldly. In another photograph, the base layer is a collection of pages of English language correspondence, where three feathers and a prism make a closing visual frame around the longhand signature, Grace. The name belongs to Grace Mayer, a curator in the photography department at the Museum of Modern Art in New York, but for the viewer of the image, Grace suffices. It names what Sudek brought to photography over a lifetime – the grace of a moving and playful sensitivity, the grace of intelligent observation conducted with an eye for the uncanny.

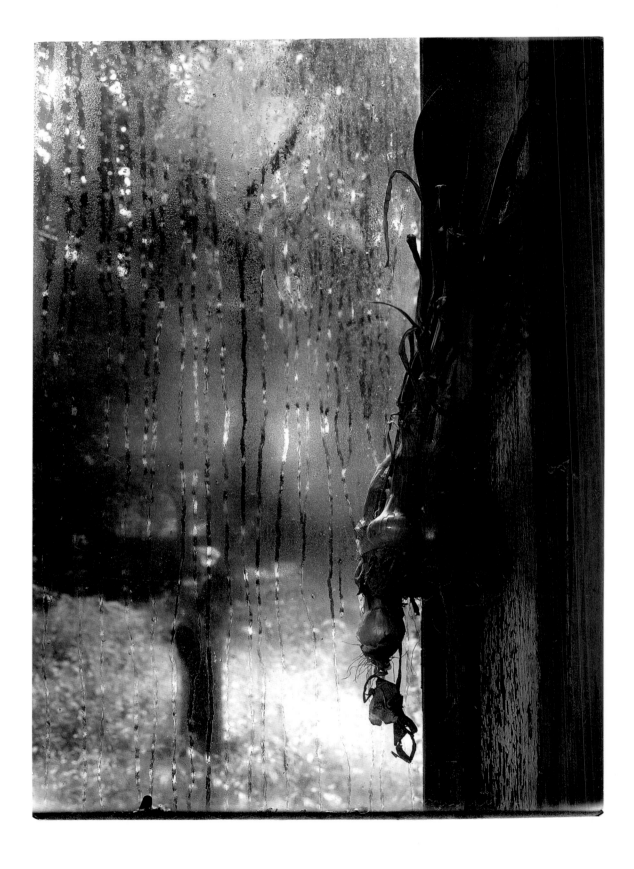

In the Studio, In the Garden:
Variations of Light and Magic

—

BY MAIA-MARI SUTNIK

In 1939 Josef Sudek retreated into his small studio situated in the back courtyard of Újezd Street in Prague's Malá Strana quarters. At the age of forty-three he was widely considered one of Czechoslovakia's leading photographers. Already recognized for his modernist leanings in beautifully delineated photographs, and working in affiliation with *Družstevní práce* – a collective of artists, writers and designers – he was now in the midst of many successful commercial and artistic projects. Through his involvement with several Czech photographic societies and organizations, Sudek had formed important friendships with many artists, writers and poets whom he admired. It was these connections that contributed to his professional and personal outlook, inspired his curiosity to explore, helped advance his technical skills and, above all, shaped his values around creative integrity. Strong-willed in overcoming obstacles, Sudek pursued his independence, enjoyed recognition and was even "rich," as Anna Fárová noted.[1]

In 1927 Sudek began living in his studio, while his sister Božena Sudková worked as his assistant. Invariably described as a space chaotically brimming with paintings, statues, books, music recordings, souvenirs, memorabilia, his large view camera and photographic equipment, the studio also featured two important windows. For nearly a decade and a half, these windows sustained his spirit and tenacity, offering a spatial plane for his artistic outlet and a surface that at least symbolically shielded threats from the outside. The windows formed and preserved the cultivated atmosphere of his studio, and their seasonal permutations shaped his inner vision. The views became consolation, hope and art. As the subject of his prodigious concentration, they revealed views which were as much dreamlike as they were at once impenetrable and transparent.

Amid the political break-up of Czech territories and the advancement of the Nazi regime's occupying forces, personal freedoms were constrained across the country. It was difficult for Sudek to work freely during the war years, as he encountered inevitable suspicion when carrying a large camera outside. The loss of friends to concentration and labour camps brought sorrow to his life, and the subsequent Communist rule that followed the war ushered in its own harsh realities. Ironically, it was the tragedy of two world wars that prompted Sudek to discover new artistic paths, each one leading to phases of work that were unparalleled among other photographers of the era.

The consequence of losing his right arm on the Italian Front in World War I made it necessary for Sudek to find a new life-long occupation. While convalescing at Invalidovny, a home for war veterans, he was inclined to pursue photography. Using a small camera and a tripod, he captured images of shadow-like veterans going through the motions of day-to-day living. He also explored the picturesque countryside and urban scenes with his friend Jaromír Funke, who was himself an aspiring photographer. Over the course of their friendship, they were both awakened to new aesthetic ideas. The influences of European art movements, the Soviet avant-garde and the ideals of various splinter groups combined to create a vibrant art scene in Prague during this period. In a self-directed statement that revealed his nuanced approach, Sudek remarked: "Everything around us, dead or alive, in the eyes of a crazy photographer mysteriously takes on many variations, so that a seemingly dead object comes to life through light or by its surrounding, and if the photographer has a bit of sense in his head maybe he is able to capture some of this – and I suppose that's lyricism."[2]

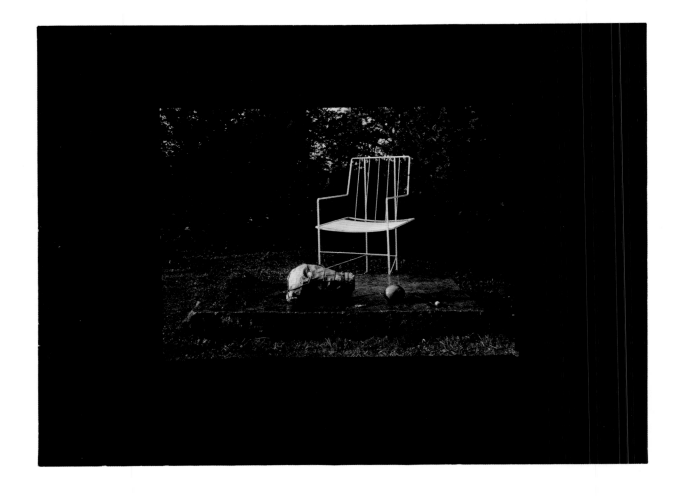

Sudek's awareness of the potency of light and his immersion into its spectrum to materialize the subject were not new to photography. The very beginnings of this art form were born out of experiments with the properties of light. Yet Sudek's goal was to make light the very subject of transformation – not merely to capture the subject in light, but to employ its variances as a new all-encompassing life force. This early preoccupation with light is evident in his Kolín Island, Stromovka Park and Invalidovny photographs, where figures appear not so much "out of focus" as they do a sum of ghostly impressions. The cast shadows of picnickers, unfolding layers of light, shimmers of filtered sunshine streaming through trees, and the spectre of veterans against beams of light emitted through windows – such otherworldly and dreamlike moments demonstrated Sudek's instinct regarding the central role that light would occupy in his photographs.

Sudek has called St. Vitus's Cathedral the place of his awakening: "That's where it began. That's where I experienced the epiphany."[3] In the summer of 1924, with its majestic scale, an atmosphere that emerged out of lengthy shadows cast by monuments and pillars, and airborne dust flickering in rays of light bending over coils of rope, scaffolding and workers' tools, the cathedral evoked what he saw as the spiritual harmony of place. Inaugurated in 1344, the Cathedral's history of ongoing repairs and restorations captivated Sudek's vision and interpretation, and culminated in his first significant publication. *Svaty Vit (St. Vitus's Cathedral)* contained fifteen carefully executed original photographs from rarely seen vantage points, alongside contrasting intimate details of sculpture. Sudek's interpretations of the cathedral possessed an inner illumination that led to the portfolio's success. The portfolio – which included a contribution by the poet Jaroslav Durych noting that "St. Vitus's is a whole realm of light and shadows, which the nation started building at the dawn of its history…and the richness of its forms are as inexhaustible as the nation's own"[4] – also marked the tenth anniversary of Czech independence. The aura of St. Vitus's remained with Sudek for years afterward. His assistant recalled that, following the war, at the sign of sunlight entering the darkness, they waved cloths to raise ancient dust for Sudek "to see the light."[5]

The concept of light with inexhaustible permutations and variations seemed intuitively embedded in Sudek's artistic path. The epiphany of St. Vitus's would again reveal itself, this time in a much more humble environment – Sudek's own studio. One of the windows in his studio framed a garden with a bent apple tree, the other a garden patch leading to a wall of tenement buildings. From inside the studio, Sudek would turn his camera towards these windows, perceiving them as both sources of inspiration and expressions of an "inner world" of emotion. Each window became a prolonged visual poem of meditation, streaming with abstract formations on the glass panes – rain, steam, frost, mystical light – which mediated the dread of the external world and the wistfulness of his inner self.

Sudek was not the first to employ the window motif. Jan Vermeer's precisionist interiors, painted as far back as the mid-seventeenth century, sparked new interest in the 1890s, while among the nineteenth-century Romantics, windows provoked notions of longing, loss and memory. More pragmatically, they were seen as a compositional device for spatial extension by modern painters, a frame of reference representing an interplay between the literal here and now and the mysterious beyond. One would not have thought at the time that a wholly new concept dedicated to this motif would emerge. One can surmise that Sudek was acquainted with such painterly sources. Yet he turned to photography's own legacy of light to express a compelling theme in a unique style all his own.

W. H. F. Talbot (1800–1877), *Oriel Window*
Lacock Abbey, Lacock, England
Paper negative, August 1835
Museum of New Media, Bradford, England
(formerly the National Museum of Photography,
Film & Television)

W. H. F. Talbot (1800–1877), *Windowseat*
Salt print, May 1840
Lacock Abbey, Lacock, England

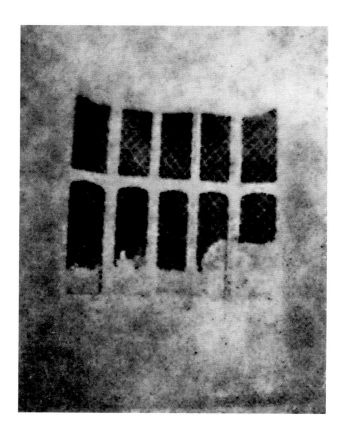

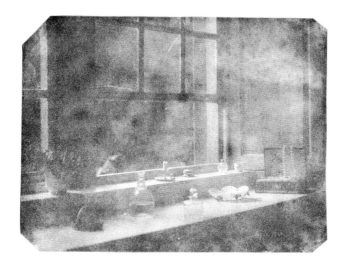

The chromatic fusions of light framed by a window also evoke the pioneering images of William Henry Fox Talbot in England in the late 1830s. Talbot experimented with the properties of light as it shone through the windows of his Lacock Abbey manor onto sensitized paper, recording the resulting patterns for up to an hour. His engagement in inventing pragmatic images of permanence was bound to the transforming quality of light. The traces of light give physical presence to the photographic surface, defining objects and effecting an atmospheric quality in his images. Arthur Ollman, among others, has noted: "[Talbot] recognized the poetic metaphor of light entering his eye to enlighten the sensitized mind and soul, and the light flooding through the oriel window.[6] In summarizing his intention, Talbot said: "I do not profess to have perfected an art, but to have commenced one, the limits of which it is not possible at present exactly to ascertain. I only claim to have based this act on a secure foundation."[7]

Sudek never denied the influence of others, but for him it was more a question of where the work of others would lead him and "how to master the technique, that I did not know yet."[8] The search for new possibilities and discoveries was intense in artistic circles. When his friend Funke wrote in 1940 about the aesthetics of the cameraless photogram, he may as well have been writing a prelude to Sudek's camera-captured window photographs: "Opaque form is recorded through contour, a rich lace pattern presents itself in black and white like an exotic beauty, glass has pleasant nuances, trifling objects imbued in various ways evoke new impressions and enigmatic, apocalyptic form of quotidian life."[9] As nuanced reflections in Sudek's mind, the "magic" of light was essential. Anna Fárová states that the intensification of the window was the fixed frame of reference that revealed Sudek's "doppelgänger and twin"– the mourning tree, to which he felt a profound inner alliance, which was obscured through the window as if veiled.[10] The symbol of this crocked tree prefigures the many visits Sudek would later make to the Mionší Forest in the Beskid mountains, where the dying trees appeared to Sudek as "vanished statues." The artist's retreat into his studio was partly emotional, but may have also been based on a need to summon all his potential in order to create something wholly new at a time when work in commissions was limited to photography for reproduction and it was difficult to publish personal work. Working solely within the surroundings of his self-contained studio gave him an original project which he could pursue.

Sudek's window photographs exemplify simplicity, yet are daring in their complicated relationship with the camera lens, which observes beyond the glass and acts as a constant mediator between outside and inside. Capturing the views required vigilant observation and chance encounters – in morning light, daylight, evening light and at night. While Talbot succeeded at ultimately taming the source of light, Sudek embraced the conditions of unexpected illumination between the obscure and the luminous, shifting light to appear as a flow of time penetrating the surface, the glass, and then photographed with his view camera. As Fárová noted, Sudek had created an artwork out of natural elements, an artistic concept that was new to photography.[11] Later, in the mid-1950s, objects began to appear on his studio windowsill – an apple, a glass, a flower, an egg – while the window alternates between being closed, slightly ajar, or open to the garden outside, leading to a new cycle of permutations. Simple still lifes then became another emblematic theme of Sudek's creativity, which was always expanding and transforming as he sought new ways of representing his world.

It is evident that the photographs in Sudek's *The Window of My Studio* series do not follow any specified sequence or order. He determined the beginning of the series to be 1940 and its end as 1954, yet everything in between is part of an opus consisting of hundreds of views, each print an independent window view integral to the series or cycle to which many of his extended works refer. Occasionally Sudek inscribed a date on a print for editorial and reproduction purposes, and dedications (often to Dr. Joseph V. Brumlik) also appear, but clues to the succession of dates are speculative.

While Sudek confined himself to solitude, he discovered a counterpart to his studio in the garden of architect Otto Rothmayer, which was often described as "strange," but its dense vegetation was magical to Sudek's unerring instinct. Sudek, who had been asked to photograph Rothmayer's designs of chairs, found in him an inspirational collaborator and a close friend. The evolving theme of *A Walk in the Magic Garden* was not so much a walk as "theatre"– a staged world of old trees, branches, elegant white chairs, craggy stones, heads of statues, myriad lamp lights, a pool surrounded by foliage and "wandering" glass eyes in unusual juxtapositions – revealing an alliance to a "Surrealist-inspired" bizarre world that Sudek returned to and photographed again and again. The results are enigmatic, but at the same time invitational – "do enter," these views seem to beckon. Yet Sudek's photographs of Rothmayer's garden are permeated with artistic riddles – they are puzzling, secreted in meaning and playfully mysterious. It is no wonder Sudek referred to this place as a "magic garden." With Rothmayer's death in 1966, however, Sudek's poetic cycle of otherworldly "walks" came to an end.

Sudek's thematic concept materialized into exquisitely high-quality photographs. It is apparent that, from 1940 onward, he generated prints solely by straight contact of the negative onto variant grades of papers, always maximizing the purity of the image quality. Though he left his early enlargements exactly as they were – perfectly executed – Sudek reprinted the negatives of much of his earlier work. These images often float within white or stark black borders that extend to the edge of the paper, an aesthetic decision which Sudek adhered to throughout his career. Even when he produced prints from negatives taken with his large format cameras, each equally large negative rendered a unique imprint.

Sudek's understanding of photographic materials and his alliance to the techniques he employed enabled him to imbue his prints with rich tonal qualities that spoke of the "lyricism" with which his photographs are often upheld. The praise bestowed on his photography is more than the sum of the sheen of beauty and depth with which his prints resonate. His remarkable insight into light and dark and his aptitude for using the medium of photography as a way of expressing his life in an artistic form are key to the appreciation of his work. His compelling thematic concepts, personal sensibilities and carefully executed photographs are undeniably engaging, but perhaps even more significant is the sense of humanity that is communicated through them, which connects us with these images. While his photographic viewpoint is anything but simple, his ability to turn the tumultuous complexity of his life into photographs of unaffected clarity distinguishes the genuine artistry by which we may contemplate Sudek's legacy.

1. Anna Fárová, *Josef Sudek: The Window of My Studio,*
 Prague: Torst, 2007, p. 9.

2. Sonja Bullaty, *Sudek,* New York: Clarkson N. Potter, Inc.,
 1978, p. 27.

3. Josef Moucha, "Touched by Mystery,"
 in *Josef Sudek – St. Vitus's Cathedral.* Prague: Torst, 2010, p. 7.

4. Anna Fárová, quoting Jaroslav Durych,
 in *Josef Sudek: Poet of Prague – A Photographer's Life,*
 New York, N.Y., Aperture, in association with
 the Philadelphia Museum of Art, 1990, p. 75.

5. Sonja Bullaty, *Sudek,* p. 14.

6. Arthur Ollman, "Henry Talbot, The Man Who Tamed
 Light," in *First Photographs: William Henry Fox Talbot and
 the Birth of Photography,* New York, N.Y.: Powerhouse Books,
 in association with the Museum of Photographic Arts,
 San Diego, 2002, p. 15.

7. Ibid. Note Talbot's fascination with light: of his 42
 published scientific papers, 32 deal with the subject
 of light.

8. Sonja Bullaty, *Sudek,* p. 25.

9. Jaromír Funke, "From the photogram to emotion,"
 in *Photography in the Modern Era: European Documents
 and Critical Writings 1913–1940,* New York, N.Y., Aperture,
 in association with The Metropolitan Museum of Art,
 1989, p. 325.

10. Anna Fárová, *The Window of My Studio,* p. 7.

11. Ibid. See "Contemplation," pp. 7–10.

Josef Sudek Chronology and Select Solo Exhibitions
—

BY ANNA FÁROVÁ

Josef Sudek: Life in Dates

1896 MARCH 17: Born in Kolín, Bohemia, the second child of Václav and Johanna Sudek. Their first child, Josefin, died April 12, 1895, the day after she was born.

1897 OCTOBER 16: Josef's sister Božena is born in the historic town of Nové Dvory, where the Sudek family had settled. In 1914 she apprentices in the Kolín studio of her cousin Bohumila Bloudilová, a photographer and retoucher. In spring 1930, Božena becomes an assistant to Josef in his Prague studio.

1898 JANUARY 1: Josef's father Václav dies of pneumonia. Attends primary school in the Baroque manor at Nové – 1908 Dvory.

1902 Gets accepted to a two-year course at the Royal
–1908 Bohemian Trade School in the town of Kutná Hora.

1910 JULY 15: Registers for a three-year apprenticeship with Prague bookbinder František Jermann. He begins to take photographs in Prague in 1911.

1913 AUGUST 12: Receives his journeyman's certificate from the Guild of Bookbinders, Box-makers, and Case-makers in Prague. Lands his first job as a bookbinder's assistant in the town of Nymburk.

1915 DECEMBER 15: Enlists in the Bohemian town of Žatec (Saaz) a few months after the start of the First World War.

1916 JANUARY 21, 1916: Gets transferred to Kadaň, where he meets other soldiers who are amateur photographers.

Puts together a small album of 156 original 3.5 × 5 cm photos of Prague and the Bohemian countryside, taken over the previous two years. He continues photography as a reservist in a jäger regiment, after leaving for the Italian front in July.

1917 LATE MAY: Gets hit in the shoulder by friendly fire (Austrian shrapnel), leading to the amputation of his right arm in Graz about one month later. Three albums containing 154 of his small original photographs of military life have been preserved from the war years.

1918 In the early part of the year, he transfers from hospitals in Kolín, Kutná Hora and Prague to veterans' hospitals and homes in Prague – Letenská pláň, Pohořelec and eventually Karlín, where he makes the *War Veterans' Hospital and Home* series (1922–27). In the post-war years, he would frequently visit his native Kolín, where he came to know the photographer Jaromír Funke. From here he would explore and photograph the countryside along the River Elbe.

1919 FEBRUARY 28: The Czechoslovak Republic (which had been declared only a few months earlier) awards him a full pension for employment disability. The deputy director of the Bohemian Office for War Invalids, Václav Nedoma, becomes Sudek's patron, introducing him to the Czech Amateur Photographic Association in Prague, which awards him a scholarship (1920–22) and gives him access to a darkroom.

1920 Refuses an offer of a white-collar job, preferring the career of a photographer despite the uncertainty. He still lacked an apprenticeship certificate, the prerequisite for a trade license, needed to operate a professional studio.

1921 FEBRUARY 10: Deregisters himself from the Roman Catholic Church, though he had not lost his faith in God. During a members' exhibition at the Czech Amateur Photographic Association in Národní třída, Prague, he receives First Prize in the landscape category. The Czech-American Drahomír Josef Růžička introduces him to the purist pictorialism practised in America, which would have an influence on Sudek's photographs. At Nedoma's urging, he applies to the College of Graphic Arts to train in photography with Karel Novák, and is accepted the following year.

Sudek's work in the 1920s comprises portraits, genre photographs, Prague architecture and the play of light on landscape.

1922 JUNE 26: Quits the Czech Amateur Photographic Association due to a clash between the old and young generations.

JULY 3: Helps found his next place of refuge – the Prague Photography Club.

1923 Travels to Ghent for a reunion of war veterans, and also visits Paris.

1924 Sends examples of his work to leading exhibition organizers all over the world.

JUNE 27: Graduates from the College of Graphic Arts. The amount of his disability pension is officially reduced by 20 percent.

JULY 9: Is excluded from the Czech amateur photographic movement for criticizing the work of an insignificant amateur photography club. He makes preparations for the founding of the Czech Photographic Society (*Česká fotografická společnost*) together with two other expellees – Funke and Adolf Schneeberger.

Begins to photograph the completion of St. Vitus's Cathedral in Prague. "That's where it began," Sudek said. "That's where I experienced an epiphany."

1926 Begins working with the up-and-coming publishing house *Družstevní práce* (Co-operative Work), for which he makes numerous advertisements in a Functionalist spirit, in collaboration with the industrial designer Ladislav Sutnar.

Participates in the first Members' Exhibition of the Czech Photographic Society.

Leaves for a two-month trip to Slovenia and, ultimately, Italy, where he visits the place where he suffered the injury that cost him his arm during World War I.

1927 JUNE 1: Signs a lease for a garden studio in the courtyard at Újezd No. 432, the Lesser Town, Prague. Becomes friends with the painter František Tichý, whom he provides financial and moral support, as Sudek did with other artists.

1928 JANUARY 30: Becomes a member of the Society of Photographers of the Prague Chamber of Trade and Commerce. He establishes his own company, and is soon receiving a wide range of orders while publishing an increasing number of photos in magazines. He is also much sought after as an expert in advertising, portraiture, architecture and photography of paintings and sculpture.

Starts to collect fine art – from 1930 to 1945, his collection grows to more than 1,000 paintings, drawings, sculptures and prints, focusing on the work of František Tichý, Jan Benda and Andrej Bělocvětov.

JULY 6: Becomes a member of *Družstevní práce,* in which he would publish, at the instigation of the painter and graphic artist Emanuel Frinta, *Svatý Vit (St. Vitus's Cathedral)*, a limited-edition portfolio of 15 original photographs with text by the outspoken Roman Catholic writer Jaroslav Durych, to mark the tenth anniversary of the Czechoslovak Republic.

1929 Publishes his first album of photographs concerning Czech life and institutions.

1930 Gets invited by the photographer Alexandr
–1931 Hackenschmied to take part in the *New Photography Exhibition,* the first group show of avant-garde photographers in Prague. The 1931 calendar of the Orbis publishing house uses some of his photographs.

1932 His first solo exhibition, comprising 64 works, is held in the Krásná jizba, the commercial gallery of *Družstevní práce* in Prague. The head of the publishing house commissions Sudek to select 26 of his own photographs to be used in a calendar for the coming year.

NOVEMBER 1: Becomes a member of the Art Society (*Umělecká beseda*).

1933 Participates in the *Social-Documentary Photography Exhibition,* organized by Lubomír Linhart as part of the Cinema and Photography Group of the Left Front.

1936 Shows photographs in the International Photography Exhibition at the Mánes Artists' Association in Prague. The Association would introduce a photography section soon after. As a member, Sudek comes to know another circle of artists.

1938 An exhibition is held featuring the work of six members of the Mánes Artists' Association photography section, including 86 works by Sudek from 1918 to 1937.

1939 His work is included in the important retrospective *A Hundred Years of Czech Photographs* at the Museum of Decorative Arts in Prague. During the war, he provides asylum in the form of an apprenticeship to the medical student Jaroslav Kysela and to the artists Vladimir Fuk and Václav Sivko. In November 1945, Sonja Bullaty would take their place.

During the German Occupation of Czechoslovakia, from March 15, 1939, to May 9, 1945, friends regularly gathered in Sudek's Újezd studio on Tuesdays to listen to recordings of classical music. This ritual continued until Sudek moved to a house on Úvoz near Prague Castle in the late 1950s.

1940 Switches from modern photography done on commission to photography done strictly for himself with his own choice of subject matter and interpretation. Starts working with large-format cameras (as big as 30 × 40 cm). He also begins his key series *The Window of My Studio* (1940–54), which gradually develops into intimate still lifes with sometimes bizarre arrangements.

1941 JANUARY 18: Offers Sfinx Publishers 100 photographs for the album *Pražský hrad (Prague Castle)*, which could not be published until the autumn of 1945 because of the German Occupation. In 1947, the album was reprinted in Czech and also published in English.

1943 Contributes to a portfolio of original photographs called *Moderni česká fotografie (Modern Czech Photography)* – which includes an introduction by the avant-garde theorist Karel Teige – and also to *Pražske zahrady (Prague Gardens)*, published by Václav Poláček.

1944 MARCH 27: Emmanuel Poche, an expert on Prague architecture, invites Sudek to work with him on a book about Charles Bridge.

1945 MARCH 22: Jaromír Funke (born 1896) dies.

By the end of the 1940s, Sudek gradually publishes many of his earlier and current Prague-themed photographs in solo and multiple-artist albums. Jiří Toman joins Sudek in his photographic work, eventually assisting him with about a quarter of the photographs for *Praha panoramatická* (1959), which was published in English as *Prague Panoramic* (1992).

1947 In contrast to prevailing trends, Sudek returns to the carbon process, which enables him to "defamiliarize" the print. He also begins to contribute to the group publication *Pražské ateliéry (Prague Studios)* (1947–53).

DECEMBER 18: The Mánes Artists' Association re-establishes its photography section, which, after the Communist takeover in February 1948, would become a platform to legalize freelance status.

1948 JANUARY 15: His membership in the Mánes Artists' Association is confirmed.

FEBRUARY 12: The Chamber of Trade and Commerce in Prague makes a note highlighting the twenty-year existence of his photography business.

In the editorial offices of Svoboda Publishers, Sudek meets Jan Řezáč, who would become editor of many of his books, curator of his exhibitions, and a promoter of his work. They begin their collaboration with the coffee-table book *Praha* (Prague), which includes 128 photographs and a selection of verse by the leading contemporary Czech poet Vítězslav Nezval.

The home of modern architect Otto Rothmayer inspires Sudek to develop the series *A Walk in the Magic Garden* (1948–64) and many other photographs from the contemporaneous set *Memories*. He also makes his first photographs for the *Labyrinths* series (which is not given its name until 1963), and continues to develop this idea for the next ten years.

1949 JANUARY 7: His membership in the Union of Czechoslovak Fine Artists is confirmed, enabling him as an artist rather than a businessman to prevent the nationalization of his studio.

1950 Begins work on the book *Janáček-Hukvaldy,* comprising photographs of Hukvaldy, Moravia, the birthplace of the composer Leoš Janáček.

1951 Presents photographs for the album *Chrám svatého Víta* (St. Vitus's Cathedral), which was to be published by Orbis, but, as Sudek writes in a letter to Sonja Bullaty three years later, Orbis decided "not to publish it, because it's a church."

1952 Visits the Mionší primeval forest at Jablunkov, in the Beskid Mountains. This leads to his collection titled *Zmizelé sochy* (Vanished Statues) (1952–70) and his largest-ever expression of love for a single region.

1953 Sudek is hit hard by the death of his mother, Johanna Sudková, at the age of 84, and the death of his friend, the painter Emil Filla (born 1882).

After the Communist Party of Czechoslovakia introduces a currency reform, Sudek says his standard of living declined to what it was when he was just starting out in the business a quarter of a century earlier.

1955 The March issue of *Československá fotografie* includes a short article about Sudek written by Jiří Jeníček. The article brings Sudek to the attention of readers of this periodical, published by the Ministry of Culture "for the ideological and professional training of people working in photography."

He receives the 1954 Prize of the Central National Committee of Prague.

1956 FEBRUARY 26: Remarks jokingly about his *Praha panoramatická* (*Prague Panoramic*), which was about to go to press: "Made 242 'sausages' of Prague so far; at least 60 more left to make."

To mark his 60th birthday, his first major monograph is published, containing 232 photogravure plates of photographs from 1915 to 1955. It has a print run of 30,000 and is extensively reviewed. The preface is written in a Socialist Realist spirit by the Marxist critic Lubomír Linhart.

1957 Begins a six-year period of taking photographs near the town of Most in northern Bohemia, an area devastated by war, coal mining and heavy industry. The book is posthumously published as *Smutná krajina* (*Sad Landscape*, 1999). The publication of *Karlův most* (*Charles Bridge*), which had been ready since the early 1950s, is delayed until 1961, and the publication of his collection of photographs of Janáček's native Hukvaldy is also postponed until 1971. His two series *St. Vitus's Cathedral* and *The Bohemian Massif* (*České středohoří*) have still not been published as independent sets.

1958 An exhibition is held in Aleš Hall of the Umělecká beseda in Prague, which features 82 works that Sudek had made strictly for himself during the past four years; the exhibition later moved to the Brno Art Centre.

He has 176 photographs published in the catalogue *Lapidarium Národního musea* (The Sculpture Gallery of the National Museum).

Sudek is appointed to the editorial board of the art photography department of *Státní nakladatelství krásné literatury, hudby a umění* (SNKLHU, State Publishers of Literature, Music and Art), founded by Jan Řezáč, the editor-in-chief, after the success of Sudek's monograph.

1959 JANUARY: *Praha panoramatická* (*Prague Panoramic*) is published, again thanks to Řezáč, with 284 plates of works by Sudek. The book also included poems by Sudek's friend, Jaroslav Seifert, while Rothmayer was responsible for its jacket, binding and overall layout.

APRIL 20: Gets assigned a flat at Úvoz No. 160, near Prague Castle. Sudek's sister remains in the studio where he has his darkroom.

SOLO EXHIBITIONS
Výstava fotografií Josefa Sudka, Fotografický cabinet Domu umění města Brna v Domě pánů z Poděbrad, Brno

Josef Sudek, Fotografie, Okresní galerie, Vysoké Mýto

1960 Sivko organizes the exhibition *Josef Sudek in Fine Art* at the Fronta Gallery, Prague, which comprises 114 portraits of Sudek by 22 artists.

1961 MARCH 18: On his 65th birthday, he becomes the first photographer to be awarded the "Artist of Merit" by the Czechoslovak government for his lifelong body of work. SNKLHU publishes the album *Karlův most* (*Charles Bridge*).

SOLO EXHIBITIONS
Josef Sudek, Slezské museum, Opava

Jaroslav Seifert – Josef Sudek. Básníkova Praha, Památník národního písemnictví, Prague

1962 SOLO EXHIBITION
Vystava fotografií Josefa Sudka, zasloužilého umělce, Kulturní středisko, Pardubice

1963 The imaginative side of his work is exhibited in the gallery of the Czechoslovak Writers' Union in Prague. The framing and mats by Rothmayer emphasize the surreal quality of Sudek's portrayal of his subject matter. However, most of the public does not understand these works.

SOLO EXHIBITIONS
Josef Sudek, Výstavní síň nakladatelství Československý spisovatel, Prague

Josef Sudek: Mostecká krajina, Rudý koutek Báňských staveb, Most

1964 Artia publishes *Sudek*, a monograph for export with a foreword by Řezáč and 96 plates of works that Sudek had made strictly for himself; the publication helps him gain international renown.

SOLO EXHIBITIONS
Výstava J. Sudeka, zasloužilého umělce – fotografa, Regionální museum, Kolín

Fotografie Josef Sudek, Oblastní galerie, Olomouc

1966 The February issue of *Československá fotografie* contains a special section to mark Sudek's 70th birthday. The Czechoslovak government awards him the Order of Labor.

OCTOBER 31: He is awarded the Artists' Union prize for applied art and industrial design.

SOLO EXHIBITION
Josef Sudek, Severočeské museum, Liberec; Kultur- und Informationszentrum der ČSSR, Berlin

1967 Gets invited by Anna Fárová to take part in *7 + 7*, a contemporary comparative exhibition in the Václav Špála Gallery in Prague.

1968 MAY: Americans began to take serious notice of his work. Michael McLoughlin at the University of Nebraska invites him to be included in the Free Photographers exhibition, along with Eikoh Hosoe of Tokyo, Bill Brandt of London, Ray K. Metzker of Philadelphia, and John Wood of New York.

1970 The Féderation Internationale de l'Art Photographique confers the title of "Excellence" upon him. The amateur photographic movement, which had systematically excluded him since the early 1920s, would now come forward in support of his work.

1971 MARCH 17: Bullaty mounts an invitation-only exhibition of Sudek's work in the Bullaty-Lomeo Studio in New York City.

1972 MARCH 17: Marjorie Neikrug makes his work accessible to the general public, mounting the first solo exhibition of his work in the US in her New York City gallery.

1974 As his career slowly comes to a close, he takes stock of his life's work and makes new contact prints from earlier negatives.

SOLO EXHIBITIONS
Josef Sudek: A Retrospective Exhibition, International Museum of Photography, George Eastman House, Rochester, New York

Josef Sudek, Light Gallery, New York City

Josef Sudek, Galleria Il Diaframma, Milan

Josef Sudek, The Corcoran Gallery of Art, Washington, DC

1976 MARCH: *Československá fotografie* runs a profile of Sudek by Anna Fárová titled "Z tvůrčí dílny Josefa Sudeka osmdesátiletého" ("From the workshop of the 80-year-old Josef Sudek"); the April special issue of *Camera*, published by C.J. Bucher, includes an interview and articles by Fárová and *Camera* editor-in-chief Allan Porter (who worked with Sudek for 10 years).

Three retrospectives are held to mark Sudek's 80th birthday: 1) Anna Fárová's *Fotograf Josef Sudek*, Museum of Decorative Arts, Prague; 2) Antonín Dufek's *Josef Sudek, Souborná vystava fotografického díla*, Moravská galerie, Brno; and 3) Werner Lippert and Petr Tausk's (Ministry of Culture) *Josef Sudek*, Neue Galerie Sammlung Ludwig, Aachen; Museum Bochum; Kunsthaus, Zürich; and Kunstlerhaus, Vienna.

SEPTEMBER 15: Dies in Prague; Seifert writes Sudek's obituary.

SEPTEMBER 23: His funeral is held at the Strašnice Crematorium in Prague, and the urn with his ashes is buried in the family grave in Kolín.

His estate – comprising 21,660 prints, 54,519 negatives and 618 other works of art (pictures, drawings, sculptures and prints) – is catalogued from 1976 to 1985 by Fárová, the executor of his will. In compliance with the wishes of Sudek and his sister Božena, Fárová gradually distributes it among the following institutions: the National Gallery in Prague; the Museum of Decorative Arts in Prague; the Institute of Art History at the Academy of Sciences in Prague; the Moravian Gallery in Brno; the Regional Gallery of Fine Art in Roudnice nad Labem; the Regional Museum in Kolín; and the Bibliothèque nationale de France in Paris.

Posthumous Solo Exhibitions

1976 *Fotografie Josefa Sudka:* Divadlo hudby, Olomouc

1977 *Josefa Sudka: Beskydy,* Dům kultury, Frenštát pod Radhoštěm

1977 *Josef Sudek Retrospective, 1896–1976,* International Center of Photography, New York; Vienna; Graz

1978 *Josef Sudek 1896–1976,* The Photographic Museum of Finland, Helsinki

1978 *Josef Sudek,* Canon Photo Gallery, Geneva

1978 *Josef Sudek,* Allan Franklin Gallery, Chicago

1979 *Fotografie Josefa Sudka z jeho pozůstalosti, kterou darovala UPM umělcova sestra Božena Sudková,* Uměleckoprůmyslové museum (Museum of Decorative Arts), Prague

1980 *Fotografen Josef Sudek,* Kunstindusrimuseet, Copenhagen

1981 *Josef Sudek,* Parakapas Gallery, New York City

1981 *Josef Sudek,* Daytona Beach Community College Gallery of Fine Arts, Daytona Beach, Ohio

1981 *Josef Sudek/Zahrady,* Uměleckoprůmyslové museum, Prague; Malá výstavní síň okresního kulturního střediska, Liberee

1981 *Josef Sudek,* Stephen White Gallery, Los Angeles

1981 *Josef Sudek,* Prakapas Gallery, New York City

1981 *Josef Sudek,* Galerie Municipale du Château d'Eau, Toulouse

1982 *Josef Sudek 1896–1976,* Jacques Baruch Gallery, Chicago

1982 *Josef Sudek,* Preus fotomuseum, Horten

1982 *Josef Sudek, Cykly fotografií 1: Praha,* Státní zámek Kozel, Šťáhlavy

1983 *Josef Sudek, Cykly fotografií 2: Okno mého ateliéru, Moje zahrádka, Zátiší, Poznámky Portréty,* Státní zámek Kozel, Šťáhlavy

1983 *Saudek/Sudek. Images from Czechoslovakia,* The University of Iowa Museum of Art, Iowa City

1983 *Fotografie Josefa Sudka a Jana Svobody: Komparace I,* Oblastní galerie výtvarného uměmi, Roudnice nad Labem

1984 *Josef Sudek, Cykly fotografií 3: Kouzelná zahrádka, Vzpomínky,* Státní zámek Kozel, Šťáhlavy

1985 *Josef Sudek, Cykly fotografií 4: Krajiny,* Státní zámek Kozel, Šťáhlavy

1985 *Výstava uměleckých fotografií Josefa Sudka,* The Pushkin Museum of Fine Arts, Moscow

1986 *Josef Sudek, Cykly fotografií 5: Kontrasty, Labrinty,* Státni zámek Kozel, Šťáhlavy

1988 *Josef Sudek: Prague,* Centre Georges Pompidou, Paris

1988 *Josef Sudek,* Jan Kesner Gallery, Los Angeles

1988 *Josef Sudek: Fotografien,* Fotoforum, Frankfurt am Main

1988 *Josef Sudek,* Museum of Modern Art, San Francisco; Art Institute of Chicago

1989 *Josef Sudek – Fotografie,* Dům kultury ROH, Frenštát pod Radhoštěm

1989 *Josef Sudek,* Műcsarnok, Budapest

1989 *Josef Sudek, sběratel českého moderního umění – dar*
–1990 *Boženy Sudkové roudnické galerii,* Oblastní galerie výtvarného uměni, Roudnice nad Labem; Galerie výtvarného uměni, Most; Východočeská galerie, Pardubice

1990 *Josef Sudek, Poet of Prague, Photographs 1921–1976,*
–1991 Burden Gallery Aperture Foundation, New York; Philadelphia Museum of Art, Philadelphia

1991 *Josef Sudek intimní,* Uměleckoprůmyslové museum, Prague

1992 *Josef Sudek, Praha panoramatická,* Rudolfinum, Prague

1993 *Josef Sudek Panoramiques,* Musée des Beaux-Arts, Nantes

1993 *Josef Sudek: Photographs,* Museum of Fine Arts,
–1994 Houston

1994 *Josef Sudek, Les tirages pigmentaires 1947–1954,* XXVᵉ Rencontres Internationales de la Photographie, Arles

1995 *Josef Sudek, Die Pigmentdrucke 1947–1954,* Kulturstiftung Stadtsparkasse Köln, Cologne

1995 *Josef Sudek, Rétrospective,* Musée de l'Elysée, Lausanne

1995 *Josef Sudek: Severní krajina (1957–1962), Fotografie ze sbírky Moravské galerie,* Moravská galerie, Brno

1995 *Josef Sudek doma,* Galerie Josefa Sudka Uměleckoprůmyslového musea, Prague

1995 *Ke knize Josef Sudek (Anna Fárová – Torst 1995),* Galerie Václava Špály, Prague

1996 *Růže pro Josefa Sudka 1896–1976,* Letohrádek královny Anny Pražského hradu, Prague

1996 *Josef Sudek, The Pigment Prints 1947–1954,* International Center of Photography, New York; Museum of Art, New Orleans; Watari-um Museum of Contemporary Art, Tokyo

1996 *Josef Sudek, Sedmá strana kostky,* Galerie U bílého jednorožce, Klatovy

1996 *Tichý heretic Josef Sudek: Fotografie ze sbírky Moravské galerie,* Moravská galerie, Brno

1996 *Josef Sudek: Cyklus Svatý Vít*, Galerie Josefa Sudka Uměleckoprůmyslového musea, Prague

1996 *Josef Sudek: Fotografie s rastry*, Galerie Josefa Sudka Uměleckoprůmysloveho musea, Prague

1997 *Josef Sudek fotografie: Ze sbírek Moravské galerie v Brně*, Oblastní galerie Vysočiny, Jihlava

1997 *Josef Sudek, Nordböhmen: Tote Landschaft*, Tschechisches Zentrum, Berlin

1998 *Josef Sudek (1896–1976), An Overview: Sixty Pigment Prints from the Artist's Estate*, Salander-O'Reilly Galleries, New York City

1998 *Sivko/Sudek*, Galerie Ztichlá klika, Prague

1998 *Josef Sudek, Nordböhmen. Fotografien von 1940–1970 aus der Mährischen Galerie*, Vereinten Versicherungen, Munich

1998 *Josef Sudek: Das stille Leben der Dinge. Fotografien aus dem Besitz der Moravská galerie, Brünn*, Kunstmuseum Wolfsburg

1998 *Une rose pour Josef Sudek (1896–1976)*, Palais des Beaux-Arts, Charleroi

1998 *El silencio de las cosas. Josef Sudek. Fotografías de los anos
–1999 1940–1970 de la colección de la Moravská galerie de Brno*, Fundación "la Caixa," Barcelona; Sala de Exposiciones de la Universidad de Salamanca; Sala San Esteban, Murcia

1999 *Josef Sudek. Nordböhmen*, Galleri Image, Arhus

1999 *Josef Sudek 1940–1970*, Suomen valokuvataiteen museo – The Finnish Museum of Photography, Helsinki

1999 *Josef Sudek*, Musée Verlaine, Juniville

1999 *Josef Sudek, Otto Rothmayer*, Galerie Josefa Sudka Uměleckoprůmyslového musea, Prague

2000 *Josef Sudek*, Atelier Josefa Sudka, Prague

2001 *Josef Sudek. Fotografie 1940–70. Z fotografické sbírky Moravské galerie*, Moravská galerie, Brno

2001 *Romantik Josef Sudek*, Galerie Josefa Sudka Uměleckoprůmyslového musea, Prague

2001 *Josef Sudek*, Atelier Josefa Sudka, Prague

2002 *Svět tance Jiřího Jašky a Josefa Sudka*, Dům umění, Ostrava; Muzeum Prostějovska, Prostějov

2002 *Prague panoramique*, Maison Européenne de la Photgraphie, Paris

2003 *The Flash of Design: Josef Sudek and Družstevní práce*, Alvar Alto Museum, Jyväskylä

2004 Josef Sudek – reklama, Galerie Josefa Sudka Uměleckoprůmyslového musea, Prague

2004 *Sudek – Filla*, Dům U Zlatého prstenu, Galerie hlavního města Prahy, Prague

2004 *Josef Sudek/The Dance/Tanec*, Atelier Josefa Sudka, Prague

2004 *Josef Sudek, Smutná krajina, Severozápadní Čechy
–2005 1957–1962*, Cisařská konírna, Prague

2004 *Josef Sudek und Družstevní práce*, Tschechisches
–2005 Zentrum, Berlin; Tschechisches Zentrum, Munich

2005 *Josef Sudek, Praha 20. let*, Galerie Josefa Sudka Uměleckoprůmyslového musea, Prague

2006 *Josef Sudek + Družstevní práce*, Atelier Josefa Sudka, Prague

2006 *Josef Sudek & Pavel Vácha – Photographs*, ART…on paper, 20th century art books & gallery, Lugano

2006 *Josef Sudek's Photographs from the Art Collection of PPF Financial Group/Fotografie Josefa Sudka ze sbírky uměni finanční skupiny PPF*, Atelier Josefa Sudka, Prague

2006 *Josef Sudek. Dialog z cisza/Dialogue with Silence*, Zacheta, Warsaw

2006 *The Unknown Josef Sudek: Vintage Prints 1918–1942/
–2007 Josef Sudek neznámý: Salonní fotografie 1918–1942*, Moravská galerie, Brno

2007 *Josef Sudek's Photographs from the Art Collection of PPF Financial Group/Fotografie Josefa Sudka ze sbírky uměni finanční skupiny PPF*, Atelier Josefa Sudka, Prague

2007 *Jiří Toman a Josef Sudek*, Východočeská galerie, Pardubice

Published by permission of Torst, Prague, Czech Republic. Sources: Anna Fárová's monograph *Josef Sudek* (1995) and *Josef Sudek – The Window of My Studio* (2007), published by Torst (www.sudekbooks.com).
© Estate of Anna Fárová, 2012.

Josef Sudek's production, imagination and discipline were all central to the realization of his photographic vision. He was an explorer and photographed relentlessly, using several cameras fitted to negative sizes – 4.5 × 6 cm, 6 × 14 cm, 13 × 18 cm and 30 × 40 cm, among others – and an outmoded 10 × 30 cm Kodak Panoramic camera (see page 254). Prior to the 1940s, he made prints in various sizes, some printed specifically to client requirements, others cropped to the most effective composition (compare *Forgotten Lane,* pages 222 and 223) for reproduction and display. Yet from 1940 onward, with few exceptions, Sudek printed by direct negative contact onto a variety of black-white photographic papers. The characteristics of this paper ranged in contrast grades and in surfaces from matte thin-ply to semi-gloss to a heavier "pearl," a finish with some sheen or luster. (For a time Agfa brovira paper was favoured, but preferred varieties were not always available after the war).

His individual approach formalized a "Sudek style" print: using the entire sheet of paper, allowing for large black borders within which the contact image floated. The photographic print was an object seen in its entirety. This did not deter Sudek from continuing to experiment with techniques calling for nuanced interpretive treatment. The same subject appears in a range of tints and tonalities (i.e. *Kinsky Gardens,* pages 226 and 227), each eliciting a different emotional response. Sudek's keen interest in a range of materials for exhibiting was inventively revealed in the way he embellished (in 1963) his prints in old frames, with gilt or textured backings (named *vetěs*), and in glass held with thin lead strips (named *púridlo*). The materiality of papers was a consistent curiosity, possibly stemming from his first vocational interest in bookbinding. Even earlier, from the late 1940s to about 1954, he was fascinated to have found old textured hand-made papers, with rough and uneven surfaces. These inspired him to revisit early non-silver techniques, in which he had acquired absolute mastery.

In 1917, during the early years of his photography career, he was introduced to pigment materials (gum bichromate, charcoal, bromoil), for small impressionistic contact prints. Then around 1947 he explored the labour-intensive carbon print process,[1] which was also dependent on the contact negative. Returning to a non-silver process led to his reinterpretation of images in a range of colours, shifting from sepia, rustic ambers and greens to deep black, rendering impressions of nearly indiscernible subjects (i.e. *Stone and Ceramic – Still Life in the Style of Navrátil,* page 131) wherein the nocturnal atmosphere creates a sense of mystery. The antiquated papers, imprinted with views of parks and gardens, and compositions of simple still life arrangements, which were reversed in the pigment process from original black and white silver prints (i.e. *Still Life with Bread,* pages 140 and 141), proclaimed a new kind of poetic form, a revival of the antiquated through Sudek's modernist sensibility.

1. Originally patented in 1855 by Alphonse Louis Poitevin, carbon printing was made practical in 1864 by Joseph Wilson Swan. Its underlying principle is that gelatin containing potassium bichromate and pigment become insoluble when exposed to light. The mixture is spread on a piece of paper, placed under and in contact with a negative, and exposed proportionally to the amount of light absorbed. Through a set of soak procedures the image is transferred to a second sheet of paper, reversed and contoured in slight relief. Carbon prints have a light gloss, and a range of colours are possible with various pigments. Carbon printing enjoyed popularity until about 1915. (Thanks to Kate Whitman, Conservator of Photography at the AGO, for her contribution.)

The titles and dates of Sudek's photographs are complex and manifold in the ways he formalized his subjects into series, themes and cycles of "memory," "remembrances," "walks" and "notes." Central to his concept and intention was that the image would communicate observations made over an extended time period. While there is rationalization of a series explored over time – from a declared beginning to its date of termination – the two dates include all the negatives exposed in between, with only minor variances. For instance, it is commonly acknowledged that *The Window of My Studio* series ended in 1954; however, earlier signed and dated prints differ from the formal end date. Such inconsistencies are mostly due to Sudek storing negatives, as well as prints, for long periods before they would be made available for circulation. Titles on the other hand are more complex. Revisions were made by Sudek himself for different purposes, such as variants on a theme, dedications[2] and re-issuing contact prints from earlier small negatives on larger papers (i.e. *Stromovka Landscape,* page 231). Certain series contain overlapping themes, such as the ideas that arose out of Rothmayer's Magic Garden and more than twenty years of photographing in the archaic Mionší Forest region. Editorial liberties taken by publications along with translations from Czech into other languages have confounded the intent and order that Sudek envisioned, were he here to reclaim his prerogative to his dates and titles.

Titles in this publication are English translations from Czech inscriptions on the individual photograph, often as written by Sudek. From time to time, he made title modifications to similar images in order to distinguish context and, when he saw a new vitality in an image, overlapping it into another theme in his mind's eye. Such changes will appear in variance to the descriptions used in several existing published sources, which we deem reliable. All titles and dates in this book appear as attributed on the actual prints by either Sudek, Anna Fárová or Božena Sudková, while attributions made by an "unknown hand" are also noted. Even so, there will be occasional inconsistencies, as Sudek himself often wrote a "shorthand" to position the print into its series or thematic context.

Maia-Mari Sutnik

2. Sudek had written on the backs of photographs his intense correspondences with Dr. J.V. Brumlik, a friend of his from the 1930s who was well known among arts circles in Prague. Their correspondence increased while Brumlik lived in New York City, at which time their exchanges included, among other things, gramophone records sent by Brumlik that were unavailable in Czechoslovakia. Sudek's love for music lasted throughout his life.

List of Photographs

4 Unknown Czech
Josef Sudek with Camera in the Beskid, 1960s
23.0 × 22.5 cm
Purchase, donated funds in memory of Eric Steiner, 2008
2008/2

6 *Studio Garden, Evening Still Life*, 1965
VERSO: Foto Sudek stamp
29.8 × 23.8 cm
2005/510

10 *Prague, Hradčany Viewed from Charles Bridge*, 1946–1955
VERSO: inscribed by Sudek: "Dear Doctor, for Christmas
I wish you a happy mood, good spirits and health in the
year 1967, and with a happy mood…Sudek, 18/XII,'66"
12.0 × 16.6 cm
2000/1135

13 *Prague, National Theatre across the River*, 1950–1960
VERSO: titled by Sudek
29.1 × 23.1 cm
2000/1044

15 *Prague, View with the National Theatre*, 1924
VERSO: Foto Sudek stamp
23.9 × 17.8 cm
2000/1012

17 *Prague (Hradčany), Early Evening*, 1922–1924
pigment print
VERSO: titled and dated (BS)
23.4 × 17.6 cm
2000/261

19 *Gardens of Troia Castle*, 1953
pigment print (carbon)
RECTO: signed by Sudek;
VERSO: Foto Sudek stamp
15.3 × 19.4 cm
2000/926

21 *Prague Street (Tram)*, 1958
RECTO: dated and signed by Sudek;
VERSO: inscribed "Fotog zerzecan na Kjerde";
Foto Sudek stamp
23.7 × 17.8 cm
2000/785

25 *The Window of My Studio – Spring in My Garden*,
1940–1954
VERSO: titled by Sudek
22.9 × 17 cm
2000/1034

27 *The Window of My Studio*, 1940–1954
VERSO: titled and "Sudek" (UH)
29.9 × 24.0 cm
2000/653

29 *The Window of My Studio*, 1944–1953
VERSO: titled and dated by Sudek
23.7 × 17.0 cm
2000/654

30 *The Window of My Studio*, 1940–1954
VERSO: titled and dated (AF)
29.7 × 24.0 cm
2000/958

31 *The Window of My Studio*, 1940–1954
VERSO: publication print notations
28.2 × 22.3 cm
2000/969

32 *The Window of My Studio (Fall Evening)*, 1940–1954
VERSO: titled by Sudek
17.8 × 11.8 cm
2000/634

33 *The Window of My Studio (Uneasy Night)*, 1940–1954
VERSO: titled by Sudek
17.2 × 12.3 cm
2000/645

35 *The Window of My Studio*, 1950–1954
pigment print
VERSO: Foto Sudek stamp
24.7 × 18.3 cm
2000/939

37 *Angel at St. Vitus's*, c. 1939
VERSO: inscribed by Sudek: "Dear Doctor (J.V. Brumlik),
today only shortly…thank you for your wish on my
name day Josef. And I too send a wish to you – a happy
name day. In a longer letter, I will write all I received
from you. For now, I simply thank you. Your Sudek,
4/III,'75"
11.4 × 16.1 cm
2000/1134

39 *St. Vitus's Cathedral, flying buttresses above the chapels
of the south aisle*, 1926–1927
VERSO: Foto Sudek stamp
29.9 × 24.0 cm
2000/391

41 *St. Vitus's Cathedral, scaffolding in the transept and choir*,
1926–1927
VERSO: Foto Sudek stamp
28.7 × 23.5 cm
2000/390

42 *St. Vitus's Cathedral, building materials in the central
vessel*, 1927
VERSO: titled and dated by Sudek; Foto Sudek Újezd
studio stamp
30.7 × 29.5 cm
2000/392

Photographs are in the collection
of the Art Gallery of Ontario, Toronto,
Anonymous gift, 2000.

All photographs are gelatin silver prints,
unless otherwise indicated. Height
precedes width (cm) in all dimensions.

Abbreviations –
AF: Anna Fárová
BS: Božena Sudková
UH: Unknown Hand

Numbers in the margin refer to page
numbers of each image.

43 *St. Vitus's Cathedral, a quiet corner by the large window
of the transept, in the triforium of the south transept,* 1939
(tracery by Kamil Hilbert in 1908; stained glass
by Max Švabinský – installed 1937–39)
VERSO: dated (AF); Foto Sudek stamp
28.0 × 17.9 cm
2000/389

45 (left) *St. Vitus's Cathedral, light illuminating the central vessel
from the south side,* 1926–1927
gelatin silver print (postcard variant)
VERSO: Kltd postcard imprint, Foto Sudek stamp
14.9 × 9.0 cm
2000/370

45 (right) *St. Vitus's Cathedral, light illuminating the central
vessel from the south side,* 1926–1927
gelatin silver print (postcard variant)
VERSO: Wellington postcard imprint; Foto Sudek stamp
14.9 × 9.0 cm
2000/369

47 *St. Vitus's Cathedral, south aisle and part of the central
vessel, looking down from the triforium,* 1926–1927
VERSO: Foto Sudek stamp
25.3 × 20.3 cm
2000/376

48 *St. Vitus's Cathedral, plaster of Paris model for monument
(Karel Pokorný) to the war dead, installed 1921,* 1924–1928
VERSO: Foto Sudek stamp
25.3 × 19.1 cm
2000/377

49 *St. Vitus's Cathedral, segment of jambs,* 1924–1928
gelatin silver print (postcard)
VERSO: Foto Sudek stamp
14.0 × 9.0 cm
2000/371

50 *St. Vitus's Cathedral, still life with a jug at a pier,* 1925
gelatin silver print (postcard)
VERSO: titled and dated by Sudek
13.3 × 8.6 cm
2000/1073

51 *St. Vitus's Cathedral, still life with a jug at a pier,* 1925
VERSO: Foto Sudek stamp
39.7 × 29.8 cm
2000/397

52 *The 3rd Courtyard of the Castle, Viewed from the Tower
of St. Vitus's Cathedral,* 1936
VERSO: Kltd postcard imprint; Foto Sudek stamp
13.8 × 8.9 cm
2000/341

53 *The 3rd Courtyard of the Castle, Viewed from the Tower
of St. Vitus's Cathedral,* 1936
VERSO: Foto Sudek stamp
13.8 × 9.0 cm
2000/340

55 *The 3rd Courtyard of the Castle, Viewed from the Tower
of St. Vitus's Cathedral,* 1936
VERSO: Foto Sudek stamp
24.0 × 16.3 cm
2000/287

56 *Prague, Charles Bridge, Sunset View of Hradčany,* 1946–1955
VERSO: Foto Sudek stamp
17.9 × 28.9 cm
2000/788

57 *Prague Evening,* c. 1953
VERSO: titled by Sudek; Foto Sudek stamp
28.8 × 23.8 cm
2000/852

59 *Prague Night,* 1950
VERSO: titled by Sudek; Foto Sudek stamp
29.8 × 23.6 cm
2000/891

60 *Prague, The National Theatre at Night,* 1958
RECTO: dated and signed by Sudek
23.9 × 17.7 cm
2000/1088

61 *Prague, The Amusement Fair ("Looping"),* 1958
RECTO: dated and signed by Sudek;
VERSO: titled and dated by Sudek
23.7 × 17.8 cm
2000/729

62 *A Path in Prague Castle Gardens,* 1950–1954
pigment print
RECTO: signed by Sudek
13.4 × 18.1 cm
2000/930

63 *Urn (in Prague Castle Gardens),* 1942–1952
pigment print
RECTO: signed by Sudek;
VERSO: titled and dated by Sudek
18.9 × 13.5 cm
2000/1037

65 *Prague, Palm in Castle Gardens,* 1942
RECTO: signed by Sudek; inscribed by Sudek:
"To Dr, J, V, Brumlik 1965"
17.7 × 23.6 cm
2000/1058

67 *Prague Castle, Hradčany from Lobkovic Gardens,* 1950s
pigment print
RECTO: signed by Sudek;
VERSO: titled, signed and noted by Sudek:
"pigment on paper from circa 1914"
18.4 × 24.4 cm
2000/1144

69 *A Walk in Chotek Gardens*, 1942 (?)
VERSO: titled and dated (illegible) by Sudek;
Foto Sudek stamp
29.6 × 25.7 cm
2000/879

71 *From the Kinsky Gardens*, 1952
pigment print
RECTO: titled, dated and signed by Sudek
23.2 × 18.2 cm
2000/1039

72 *River Landscape with Bench and Table*, 1967
VERSO: dated 1967 (UH)
25.5 × 29.2 cm
2000/1046

73 *Prague Winter, View of the National Theatre*, 1950s
RECTO: signed by Sudek
22.8 × 29.0 cm
2000/1043

74 *Chotek Gardens*, c. 1960
VERSO: titled (UH); Foto Sudek stamp
23.7 × 29.5 cm
2000/877

75 *Stratov Gardens, Springtime*, 1960
RECTO: titled, dated and signed by Sudek
29.6 × 34.5 cm
2000/1049

77 *Prague Street View*, 1930s
VERSO: Foto Sudek stamp
17.0 × 22.8 cm
2000/290

78 (top) *Prague after Bombing – Clock Tower with Fountain
in the Foreground*, 1945
VERSO: Foto Sudek stamp
17.0 × 22.7 cm
2000/772

78 (bottom) *Prague after Bombing – Street Scene, Clock Tower
and Cathedral in the Background*, 1945
VERSO: Foto Sudek stamp
17.0 × 22.7 cm
2000/773

79 (top) *Prague after Bombing – City Square*, 1945
VERSO: Foto Sudek stamp
17.0 × 22.8 cm
2000/771

79 (bottom) *Prague after Bombing – City Square*, 1945
VERSO: Foto Sudek stamp
17.0 × 22.8 cm
2000/769

81 *(Group working at) Družstevní práce (Cooperative Work)*, 1930
VERSO: Sudek and Družstevní práce
copyright credit stamp
27.7 × 17.6 cm
2000/972

83 *Advertising, Metal and Glass*, 1932
VERSO: Foto Sudek stamp
29.5 × 23.3 cm
2000/999

85 *Bowl and Chrome Tray*, c. 1931
VERSO: Foto Sudek stamp
11.6 × 17.1 cm
2000/993

87 *Advertisement, Glassware by Ladislav Sutnar*, 1930–1931
VERSO: Foto Sudek stamp
12.0 × 17.9 cm
2000/986

89 *Advertisement, Film Strip*, 1932–1936
VERSO: Foto Sudek stamp
12.3 × 17.0 cm
2000/990

90 *Woman Reflected on Table Surface*, 1931
gelatin silver print (postcard)
VERSO: Foto Sudek stamp
13.6 × 8.9 cm
2000/344

91 *Advertising, Table with Reflecting Surface*, 1931–1932
VERSO: Foto Sudek stamp
39.5 × 29.9 cm
2000/350

92 *Toy Blocks*, 1930s
VERSO: Foto Sudek stamp
16.8 × 11.8 cm
2000/997

93 *Orbis (advertising)*, 1931–1936
VERSO: Foto Sudek stamp
23.3 × 17.0 cm
2000/971

94 (left) *"dp" 1931 agenda design*, 1930–1931
VERSO: Foto Sudek stamp
23.8 × 17.9 cm
2000/314

94 (right) *Calendar (Kalendar Družstevní práce 1933.
27 fotograffie Josefa Sudka)*, 1933
VERSO: Foto Sudek stamp
23.9 × 17.9 cm
2000/315

95 (left) *Tea and Coffee Service Set, Chinaware Designed by Ladislav Sutnar*, 1931
gelatin silver print, with tissue overlay
VERSO: Foto Sudek and Družstevní práce copyright credit stamp
23.5 × 17.3 cm
2000/291

95 (right) *Tea Service Set, Glassware Designed by Ladislav Sutnar*, 1931
VERSO: Foto Sudek Újezd studio stamp
23.5 × 17.7 cm
2000/307

96 *Advertisement, Shoes for Men*, 1931
7.9 × 23.9 cm
VERSO: Foto Sudek stamp
2000/996

97 (left) *Advertisement, Interior View*, 1930s
gelatin silver print (postcard)
VERSO: Foto Sudek stamp
13.9 × 9.0 cm
2000/329

97 (middle) *Advertisement, Industrial View*, 1930s
gelatin silver print (postcard)
VERSO: Foto Sudek stamp
13.7 × 8.9 cm
2000/330

97 (right) *Advertisement, Industrial View*, 1930s
gelatin silver print (postcard)
VERSO: Foto Sudek Újezd studio stamp
13.8 × 8.9 cm
2000/337

99 *Forest Path Leading to the Lair of the Cunning Little Vixen – Janáček-Hukvaldy*, 1948–1950
VERSO: Foto Sudek stamp
28.6 × 39.0 cm
2000/494

100 *At Veltrus – River Landscape*, 1950s
VERSO: titled (BS)
14.0 × 37.0 cm
2000/586

101 *View of Kampa Island from Shooters*, 1950–1955
VERSO: Josef Sudek/Fárová (AF)
14.9 × 35.5 cm
2000/1097

102 (top) *"New World" (Novy Svet)*, 1950–1955
VERSO: titled by Sudek
9.9 × 29.6 cm
2000/601

102 (bottom) *At the Fairground, Prague*, 1950–1955
VERSO: Josef Sudek/Fárová 1950–55 (AF)
9.9 × 29.9 cm
2000/1107

103 (top) *Fürstenberg Palace*, 1950–1955
VERSO: titled (BS)
8.6 × 29.3 cm
2000/602

103 (bottom) *View of Wenceslas Square from Mustek Street, in the Direction of the Museum*, 1950s
VERSO: technical notes
5.7 × 29.6 cm
2000/599

104 *Morning in the Royal Hunting Park*, 1950–1955
VERSO: titled by Sudek
9.9 × 29.9 cm
2000/605

105 *View of Střelecký and Zidovsky (Jewish, later named Children's) Island, from the Legion Bridge, Prague*, 1950–1955
VERSO: partial title (BS)
9.7 × 29.4 cm
2000/612

106 (top) *Low Mountains (Středohoří series)*, 1948–1955
14.0 × 34.7 cm
2000/588

106 (bottom) from the series *Středohoří Hills*, 1959
14.9 × 39.7 cm
2000/589

107 (top) *Landscape Panorama with Figures*, 1950–1955
VERSO: titled (UH)
14.9 × 30.0 cm
2000/581

107 (bottom) *A Walk in Mionší, Beskid*, 1966–1970
VERSO: titled (AF)
14.0 × 34.7 cm
2000/593

108 *Vanished Statues in Mionší*, 1952
VERSO: technical notes
29.9 × 10.3 cm
2000/596

109 *Landscape with Tree Stumps (Mionší)*, 1948
pigment print
RECTO: dated, titled and signed by Sudek
12.7 × 12.6 cm
2000/1041

111 *A Walk in Mionší*, 1953
VERSO: Foto Sudek stamp
23.3 × 17.8 cm
2000/700

113 (top) *Untitled (Mionší)*, 1966–1970
VERSO: Foto Sudek stamp
17.9 × 23.8 cm
2000/947

113 (bottom) *Untitled (Mionší)*, 1966–1970
gelatin silver print (variant)
17.9 × 23.8 cm
2000/948

114 *Vanished Statue in Mionší*, 1952
VERSO: Foto Sudek stamp
18.0 × 23.7 cm
2000/701

115 *Vanished Statue in Mionší*, c. 1953
VERSO: Foto Sudek Stamp
18.0 × 23.7 cm
2000/702

117 *A Walk in Mionší*, c. 1970
VERSO: Foto Sudek stamp
17.7 × 23.6 cm
2000/693

119 *On the Windowsill of My Studio – Blossom*, 1950–1954
30.0 × 24.2 cm
2000/983

121 *Bud of a White Rose*, 1954
VERSO: titled and dated (AF)
39.9 × 29.8 cm
2000/196

123 *Window Still Life with Glass*, 1950–1954
VERSO: titled and dated (AF)
39.9 × 29.8 cm
2000/981

125 *A Glass*, 1950–1954
VERSO: Foto Sudek stamp
25.7 × 17.7 cm
2000/222

126 *Composition (Glass, Egg, Still Life)*, 1950–1954
VERSO: titled "Composition" and dated (AF)
30.0 × 24.7 cm
2000/185

127 *Still Life with Glass and Egg*, 1950–1954
gelatin silver print (variant)
VERSO: titled and dated (BS); Foto Sudek stamp
21.8 × 16.0 cm
2000/215

128 *Still Life with Egg*, 1950–1954
VERSO: Foto Sudek stamp
23.0 × 17.0 cm
2000/219

129 (top) From the series *Simple Still Lifes (Egg and Glass)*,
1950–1954
VERSO: Foto Sudek stamp
9.1 × 9.2 cm
2000/248

129 (middle) From the series *Simple Still Lifes (Egg and Glass)*,
1950–1954
VERSO: Foto Sudek stamp
9.1 × 9.2 cm
2000/246

129 (bottom) From the series *Simple Still Lifes (Egg and Glass)*,
1950–1954
VERSO: Foto Sudek stamp
9.1 × 9.2 cm
2000/243

130 *Eggshells on Plate*, 1950s
VERSO: titled (AF)
39.9 × 29.7 cm
2000/176

131 *Stone and Ceramic – Still Life in the Style of Navrátil*, 1955
pigment print
RECTO: Foto Sudek stamp
24.4 × 18.6 cm
2000/927

133 *Composition, Glassware by Ladislav Sutnar*, 1931–1932
VERSO: "Sudek" (UH)
39.5 × 29.3 cm
2000/1004

135 *Glass Vase*, c. 1932
gelatin silver print (postcard)
VERSO: Foto Sudek stamp
13.5 × 8.7 cm
2000/989

136 *Still Life, Apple and Pear on My Studio Window*, 1950s
22.3 × 28.2 cm
2000/663

137 *Apple on a Tray*, 1932
VERSO: titled by Sudek
7.0 × 11.6 cm
2000/970

139 *Still Life in My Studio*, 1949–1950
pigment print
RECTO: signed by Sudek
25.7 × 18.7 cm
2000/935

140 *Still Life with Bread*, 1950–1954
VERSO: titled (BS); Foto Sudek stamp
15.9 × 22.0 cm
2000/1003

141 *Still Life with Bread*, 1951
pigment print
RECTO: dated and signed by Sudek
18.1 × 23.3 cm
2000/929

172 From the cycle *Glass Labyrinths*, 1968–1972
VERSO: titled and dated (AF)
39.5 × 29.8 cm
2000/200

173 From the cycle *Glass Labyrinths*, 1968–1972
VERSO: titled and dated (AF)
39.3 × 29.0 cm
2000/206

174 (top left) From the cycle *Glass Labyrinths*,
1968–1972
RECTO: signed by Sudek; VERSO: titled by Sudek
39.3 × 29.7 cm
2000/1111

174 (top right) From the cycle *Glass Labyrinths*,
1963–1970
VERSO: (no.) 7, II
39.8 × 30.0 cm
2000/203

174 (bottom left) From the cycle *Glass Labyrinths*,
1963–1970
VERSO: (no.) 9, IV; titled and dated by Sudek
39.9 × 30.0 cm
2000/205

174 (bottom right) From the cycle *Glass Labyrinths*,
1963–1970
VERSO: (no.) 9, III
39.9 × 30.0 cm
2000/204

175 From the cycle *Glass Labyrinths*, 1963–1970
RECTO: greeting dedicated to Dr. J.V. Brumlik, 1969,
signed by Sudek
29.5 × 22.5 cm
2000/1112

176 *Art Nouveau Still Life* from the cycle *Glass Labyrinths*,
1968
gelatin silver print (variant)
VERSO: titled by Sudek
28.7 × 22.7 cm
2000/202

177 From the cycle *Glass Labyrinths*, 1968
VERSO: dated and titled by Sudek; "Obrazova Prédloha"
press stamp
22.9 × 16.7 cm
2000/977

179 From the cycle *Aerial Remembrances*, 1960–1973
VERSO: titled by Sudek
29.3 × 23.0 cm
2000/178

180 (left) From the cycle *Aerial Remembrances*, 1960–1973
29.6 × 23.4 cm
2000/186

180 (right) From the cycle *Aerial Remembrances*,
1960–1973
29.4 × 23.0 cm
2000/187

181 (left) From the cycle *Aerial Remembrances*,
1960–1973
29.4 × 23.4 cm
2000/190

181 (right) From the cycle *Aerial Remembrances*,
1960–1973
29.6 × 23.0 cm
2000/179

183 *The Cemetery of Malá Strana*, 1940–1946
pigment print
VERSO: Foto Sudek stamp
18.9 × 24.0 cm
2000/931

184 *Birch Trees*, 1950–1954
pigment print
RECTO: signed by Sudek; VERSO: titled by Sudek
Foto Sudek stamp
26.1 × 18.2 cm
2000/937

185 *Window of My Studio*, 1950–1954
pigment print (carbon)
VERSO: technical notes and "carbon"
23.9 × 17.0 cm
2000/923

186 *Springtime in Lobkovic Garden*, 1952
pigment print
RECTO: titled, dated and signed by Sudek
18.7 × 23.7 cm
2000/932

187 *Prague Gardens*, 1950–1954
pigment print
RECTO: signed by Sudek;
VERSO: Foto Sudek stamp
22.7 × 16.5 cm
2000/911

189 *Palm in Prague Castle Gardens*, 1950–1954
RECTO: signed by Sudek
18.2 × 14.0 cm
2000/922

190 *Bread and Egg*, 1950
pigment print
RECTO: signed by Sudek
14.0 × 18.2 cm
2000/921

191 *Shell*, 1950–1954
pigment print
RECTO: Foto Sudek stamp
23.3 × 30.0 cm
2000/934

193 *Still Life with Shell and Glass,* 1951
pigment print
RECTO: signed and dated by Sudek;
VERSO: Foto Sudek stamp and noted "pigment"
24.4 × 18.4 cm
2000/936

195 *Simple Still Life, Egg,* 1950
pigment print
RECTO: signed by Sudek
10.8 × 10.9 cm
2000/920

196 *Window of My Studio with a Blossom,* 1951
pigment print (carbon)
VERSO: dated and noted "carbon" (AF);
Foto Sudek stamp
24.2 × 18.2 cm
2000/925

197 *Window of My Studio with a Blossom,* 1950–1951
pigment print (carbon variant)
RECTO: signed by Sudek
24.6 × 18.6 cm
2000/924

199 *Glass and Rose,* 1951
pigment print
RECTO: dated and signed by Sudek
29.6 × 22.8 cm
2000/933

200 *Portrait of Head (Sculpture),* 1930s
39.4 × 29.6 cm
2000/1130

201 *Death Mask,* 1930s
23.9 × 17.9 cm
2000/917

202 *Head of Baroque Sculpture,* 1936
VERSO: Foto Sudek Újezd studio stamp
22.7 × 17.3 cm
2000/366

203 *Statue of Saint Wenceslas* (detail), 1942–1945
gelatin silver print on transparent parchment paper
VERSO: Foto Sudek stamp
23.9 × 17.7 cm
2000/365

205 (top) *Ceremonial African Mask,* 1935
VERSO: titled and dated (BS); Foto Sudek stamp
16.7 × 11.9 cm
2000/353

205 (bottom) *Ceremonial African Masks,* 1935
VERSO: titled and dated (BS)
16.5 × 12.0 cm
2000/352

207 *Emil Filla,* c.1940
VERSO: titled (AF)
23.6 × 18.0 cm
2000/674

208 *Anna Marie,* 1943
VERSO: titled and dated (UH)
18.2 × 13.6 cm
2000/682

209 *Milena,* 1942
pigment print: 1952
17.8 × 13.0 cm
2000/919

210 *In the Magic Garden – The Coming of Evening,* c.1961
gelatin silver print (line screen paper)
RECTO: signed by Sudek (inscription illegible);
VERSO: titled by Sudek
28.9 × 39.0 cm
2000/558

211 *Z Invalidovny (War Veterans' Hospital and Home),*
1922–1927
VERSO: titled (BS?)
23.5 × 24.0 cm
2000/946

213 *Prague: Street Vendor,* 1920
pigment print
RECTO: signed by Sudek
6.0 × 9.7 cm (image); 23.8 × 18.0 cm (presentation mount)
2000/266

214 (top) *Elbe Landscape,* c.1918
7.3 × 10.7 cm (image)
2000/271

214 (bottom) *Elbe Landscape,* c.1918
VERSO: Foto Sudek stamp
7.3 × 10.7 cm (image); 33.4 × 22.3 cm (presentation mount)
2000/272

215 (top) *Prague: Roofs,* 1918–1920
7.7 × 10.5 cm (image)
2000/273

215 (bottom) *Prague View,* 1918–1920
VERSO: Foto Sudek stamp
7.7 × 10.5 cm (image); 32.5 × 22.5 cm (presentation mount)
2000/274

217 *Winter Scene,* 1918–1920
pigment (carbon print)
RECTO: signed by Sudek;
VERSO: Foto Sudek stamp
7.2 × 8.3 cm (image); 23.5 × 17.7 cm (presentation mount)
2000/264

218 *In Nekázanka Street, Prague,* 1928
VERSO: titled by Sudek; Foto Sudek stamp
8.6 × 8.0 cm
2000/810

219 *Morning in Na poříčí Street*, 1919
VERSO: Foto Sudek stamp
12.9 × 9.5 cm
2000/824

220 (left) *Morning at Prague Bridge*, c. 1925
VERSO: titled (UH); Foto Sudek stamp
13.9 × 8.9 cm
2000/816

220 (right) *Viaduct Zuzkov, Prague*, 1926
VERSO: Foto Sudek stamp
13.7 × 8.5 cm
2000/817

221 *Prague Street (Woman in Archway)*, 1924
gelatin silver print (postcard)
VERSO: Foto Sudek stamp
14.0 × 9.0 cm
2000/813

222 *Forgotten Lane*, c. 1930
VERSO: Foto Sudek stamp
17.8 × 23.8 cm
2000/345

223 *Forgotten Lane*, c. 1930
toned gelatin silver print
VERSO: Foto Sudek stamp
21.6 × 29.5 cm
2000/1013

224 *Mannequin in Studio*, 1953–1957
blue-toned gelatin silver print
VERSO: Foto Sudek stamp
23.9 × 30.0 cm
2000/515

225 *Mannequin in Studio*, 1953–1957
gelatin silver print (variant)
23.8 × 30.9 cm
2000/513

226 *Kinsky Gardens*, 1950–1952
VERSO: Foto Sudek stamp
17.1 × 23.0 cm
2000/791

227 *Kinsky Gardens*, 1950–1952
toned gelatin silver print (variant)
VERSO: Foto Sudek stamp
17.0 × 23.0 cm
2000/792

228 *Window of My Studio (Branch)*, 1940–1954
gold-toned gelatin silver print
VERSO: Foto Sudek stamp
23.2 × 17.0 cm
2000/262

229 *Letna Park Landscape*, 1917
gumbichromate on textured board
VERSO: black pigment of a dwelling with
Foto Sudek stamp
21.0 × 14.5 cm
2000/269

231 *Stromovka Landscape*, 1924–1926
RECTO: signed by Sudek with dedication to
Dr. J.V. Brumlik, 1976
23.3 × 17.1 cm
2000/1093

232 *Prague Gardens*, 1958
RECTO: signed by Sudek;
VERSO: titled by Sudek "P'oznanky Prazske Zahrady";
Foto Sudek stamp
23.4 × 17.4 cm
2000/953

233 *Prague Gardens*, 1958
gelatin silver print (thin-ply mat paper)
RECTO: dated and signed by Sudek;
VERSO: inscribed "Fotograficky zoznam – Kinske to
Zahrany 1958" and titled and dated by Sudek:
Foto Sudek stamp
28.7 × 17.8 cm
2000/764

234 *St. Vitus's Cathedral, statues of saints (by Francis Preiss, 1696)
taken from the piers in the crossings*, 1926–1927
gelatin silver print (variant)
VERSO: Kltd postcard imprint; Foto Sudek stamp
13.8 × 8.7 cm
2000/962

235 *St. Vitus's Cathedral, statues of saints (by Francis Preiss, 1696)
taken from the piers in the crossings*, 1926–1927
VERSO: Wellington postcard imprint; Foto Sudek stamp
14.0 × 9.0 cm
2000/372

236 *In the Workshop of Holovský,
from the series Labyrinths*, 1960–1970
message on image: "Coming immediately!"
VERSO: Foto Sudek stamp
39.9 × 30.0 cm
2000/1033

237 *In My Studio (Újezd)*, also
Still Life at a Photographer's, 1950s
VERSO: "Sudek's studio" (UH)
29.9 × 24.4 cm
2000/942